DRAW-200 ANIMALS

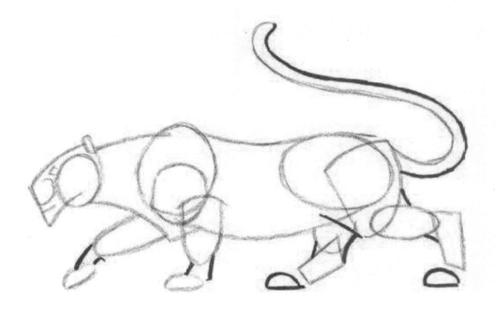

THE STEP-BY-STEP WAY TO DRAW Horses, Cats, Dogs, Birds, Fish, and Many More Creatures

LEE J. AMES

Copyright © 2019 by Jonathan D. Ames and Alison S. Efman.

All rights reserved.
Published in the United States by Watson-Guptill Publications, an imprint of the Crown Publishing Group, a division of Penguin Random House LLC, New York.
www.crownpublishing.com
www.watsonguptill.com

WATSON-GUPTILL and the WG and Horse designs are registered trademarks of Penguin Random House LLC.

This work comprises material originally published in the following volumes by Lee J. Ames: DRAW 50 ANIMALS (New York: Doubleday, 1974), DRAW 50 CATS (New York: Doubleday, 1986), DRAW 50 DINOSAURS AND OTHER PREHISTORIC ANIMALS (New York: Doubleday, 1977), DRAW 50 DOGS (New York: Doubleday, 1981) and DRAW 50 HORSES (New York: Doubleday, 1984).

Library of Congress Cataloging-in-Publication Data Names: Ames, Lee J., author.

Title: Draw 200 animals: the step-by-step way to draw horses, cats, dogs, birds, fish, and many more creatures / Lee J. Ames.

Description: First edition. | California: Watson-Guptill Publications, [2019] | "This work is comprised of material originally published separately as Draw 50 Animals, Draw 50 Cats, Draw 50 Dogs, Draw 50 Dinosaurs and Other Prehistoric Creatures, and Draw 50 Horses by Watson-Guptill Publications, an imprint of the Crown Publishing Group, a division of Penguin Random House LLC, New York."

Identifiers: LCCN 2018048125

Subjects: LCSH: Animals in art-Juvenile literature. | Drawing-Technique-Juvenile literature.

Classification: LCC NC780 .A477 2019 | DDC 743.6--dc23 LC record available at https://lccn.loc.gov/2018048125

Trade Paperback ISBN: 978-0-399-58021-5 eBook ISBN: 978-0-399-58022-2

Printed in China

Design by Sarah Rose Weitzman

1098765

First Edition

To the Reader	6
To the Parent or Teacher	7
Horses	8
Cats	60
Dogs	111
Birds	163
Reptiles & Amphibians	173
Fish & Other Marine Life	176
Insects, Bugs, Spiders & Crawling Critters	184
Mammals	189
Tiny Critters	199
Animals from Long Ago	204

To the Reader,

This book will show you a way to draw a wide variety of animals. You need not start with the first illustration. Choose whichever you wish. When you have decided, follow the step-by-step method shown. *Very lightly* and *carefully*, sketch out the first step. However, this step, which is the easiest, should be done *most carefully*. The next step is added right to the first one, also lightly and also very carefully. The third step is sketched right over steps one and two. Continue this way to the last step.

It may seem strange to ask you to be extra careful when you are drawing what seem to be the easiest first steps, but these are the most important, for a careless mistake at the beginning may spoil the whole picture at the end. As you sketch out each step, watch the spaces between the lines, as well as the lines, and see that they are accurate. After each step, you may want to lighten previous steps by pressing them with a kneaded eraser (available at art supply stores).

When you have finished, you may want to redo the final step in India ink with a fine brush or pen. When the ink is dry, use the kneaded eraser to clean off the pencil lines. The eraser will not affect the India ink.

Here are some suggestions: In the first few steps, even when all seems quite correct, you might do well to hold your work up to a mirror. Sometimes the mirror shows that you've twisted the drawing off to one side without being aware of it. At first you may find it difficult to draw the egg shapes, or ball shapes, or sausage shapes, or just to make the pencil go where you wish. Don't be discouraged. The more you practice, the more control you will develop.

The only equipment you'll need will be a medium or soft pencil, paper, a kneaded eraser, and, if you wish, a pen or brush and ink.

The first steps in this book are shown darker than necessary so that they can be clearly seen. (Keep *your* work very light.)

Remember there are many ways and methods to make drawings. This book shows just one of them. Why don't you seek out other ways from teachers, from libraries, and—most important—from inside yourself?

To the Parent or Teacher,

"David can draw a jet plane better than anybody else!" Such peer acclaim and encouragement generate incentive. Contemporary methods of art instruction (freedom of expression, experimentation, self-evaluation of competence and growth) provide a vigorous, fresh-air approach for which we must all be grateful.

New ideas need not, however, totally exclude the old. One traditional method is the "follow me, step-by-step" approach. In my young learning days, this was so common, and frequently so exclusive, that the student became nothing more than a pantographic extension of the teacher. In those days it was excessively overworked.

This does not mean that the young hand is never to be guided. Rather, specific guiding is fundamental. Step-by-step guiding that produces satisfactory results is valuable even when the means of accomplishment are not fully understood by the student.

The novice with a musical instrument is frequently taught to play simple melodies as quickly as possible, well before he learns the most elemental scratchings at the surface of music theory. The resultant self-satisfaction and pride in accomplishment can be a significant means of providing motivation. And all from mimicking an instructor's "Do as I do..."

Mimicry is a prerequisite for developing creativity. We learn the use of our tools by mimicry. Then we can use those tools for creativity. To this end I would offer the budding artist the opportunity to memorize or mimic (rotelike, if you wish) the making of "pictures." "Pictures" he or she has been anxious to draw.

The use of this book should in no way be compulsory. Rather it should be available to anyone who wants to try another way of flapping his wings. Perhaps he will then get off the ground when his friend says, "David can draw a jet plane better than anybody else!"

-Lee J. Ames

Horses

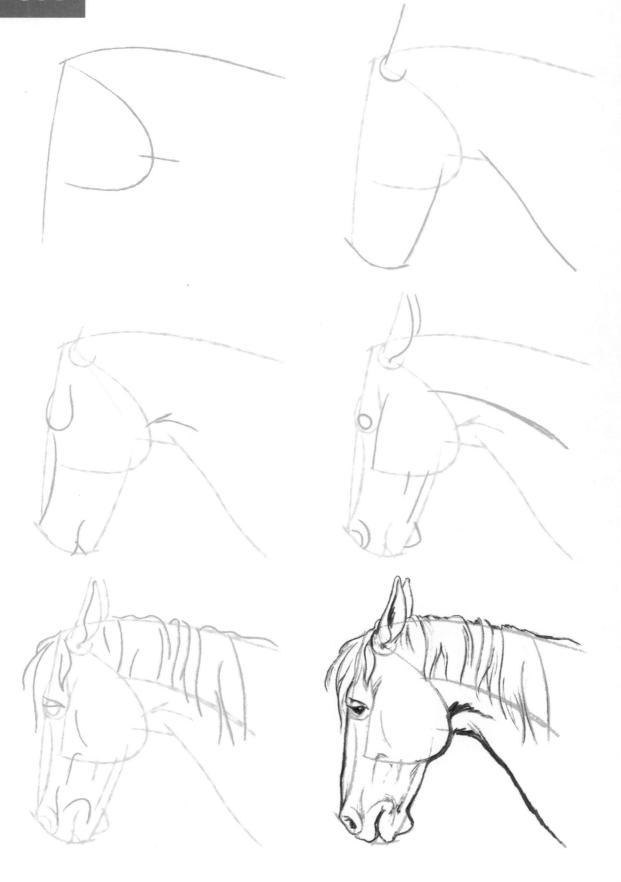

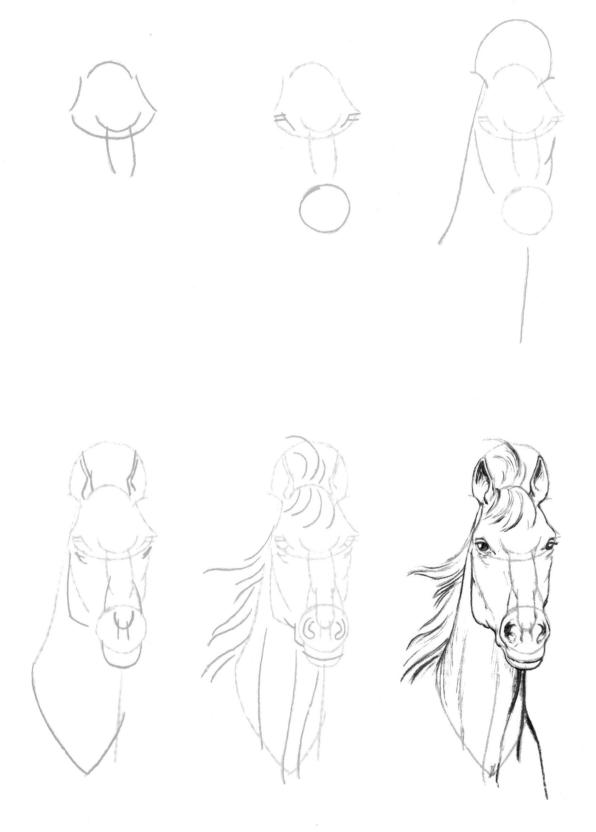

HORSES

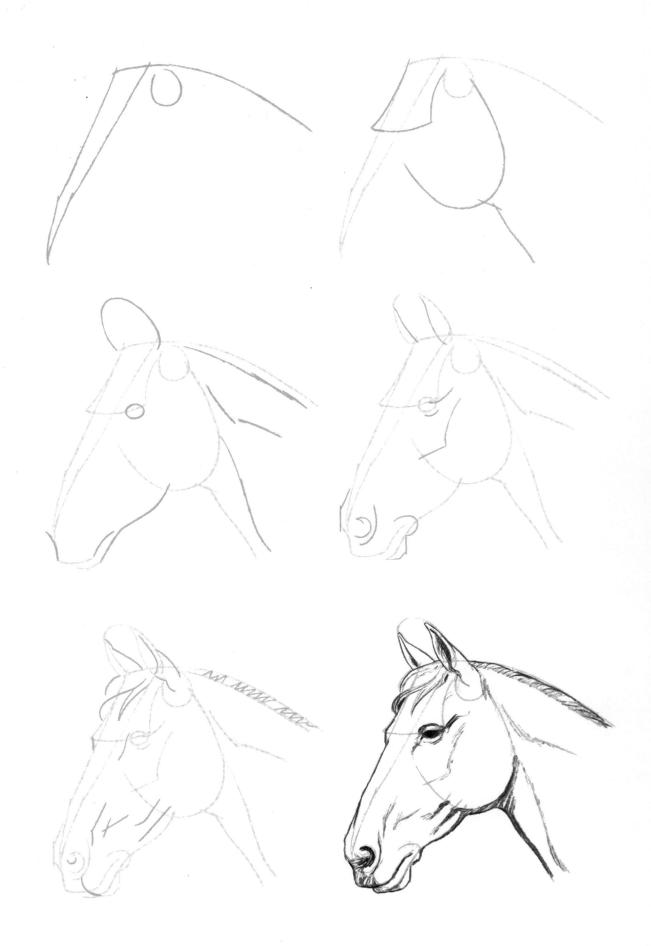

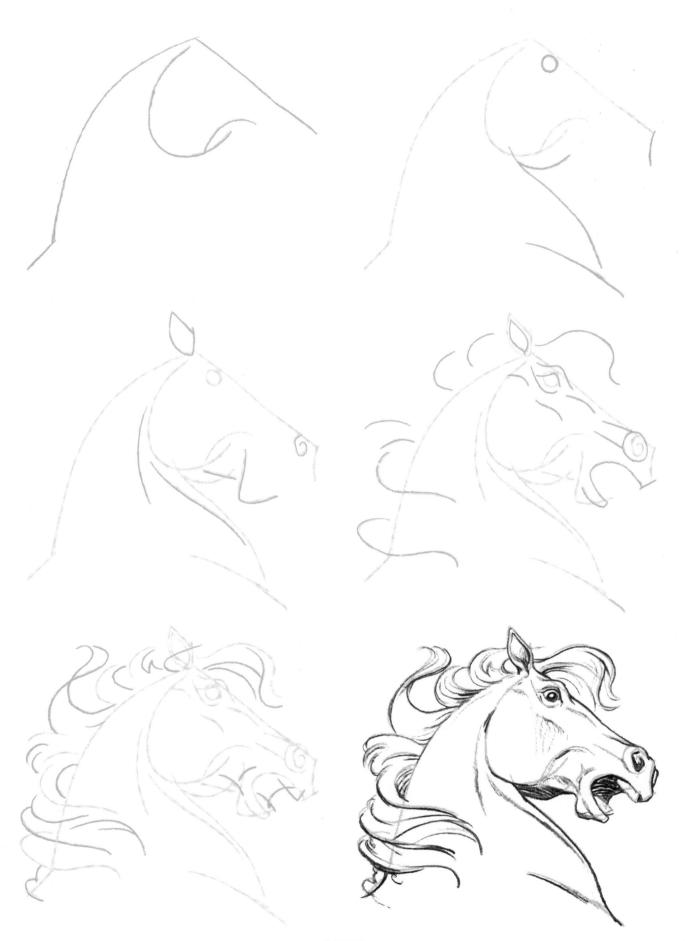

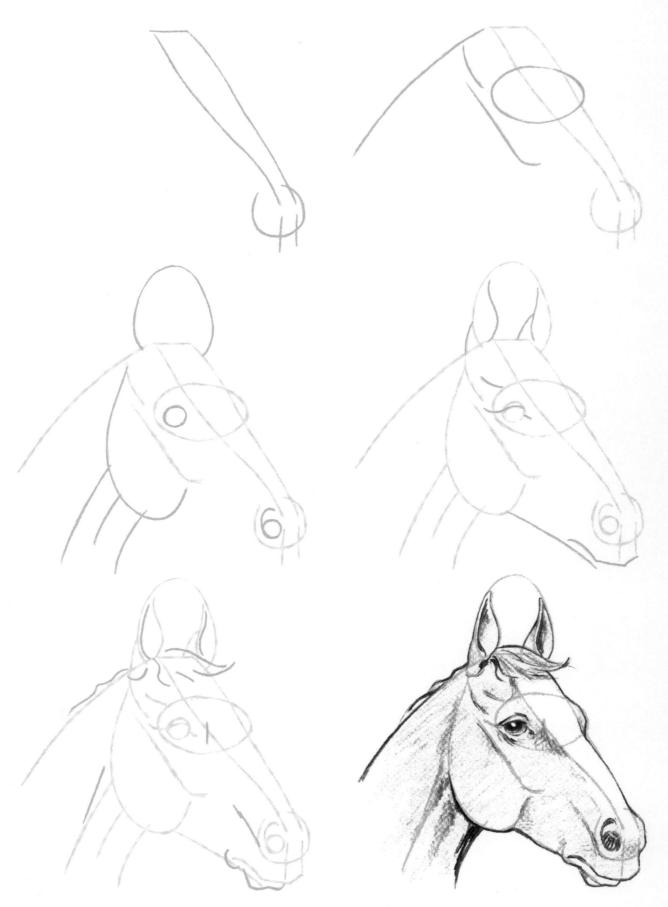

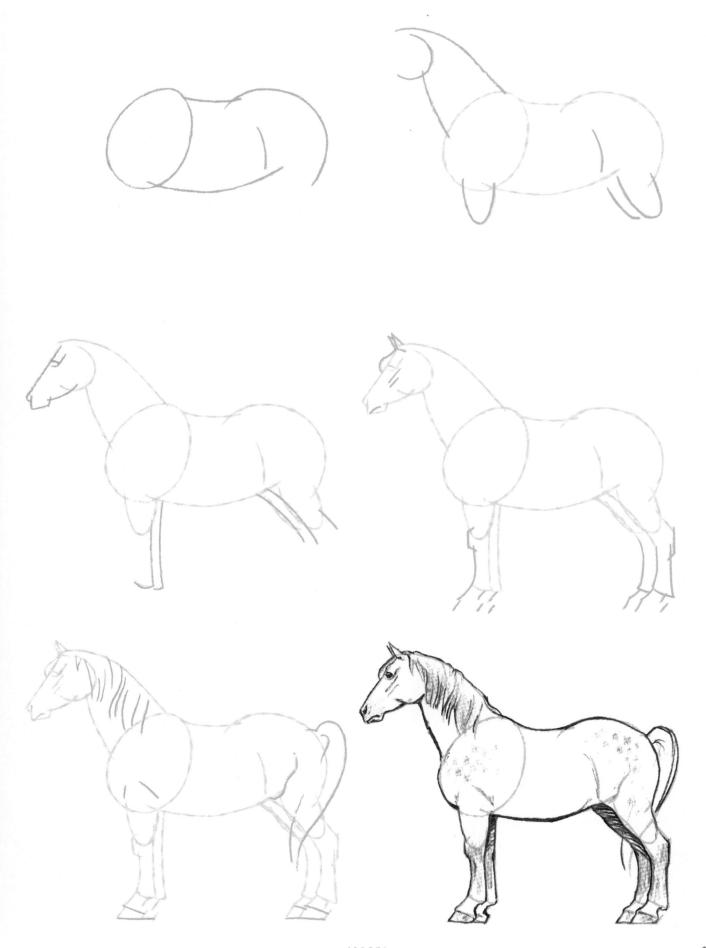

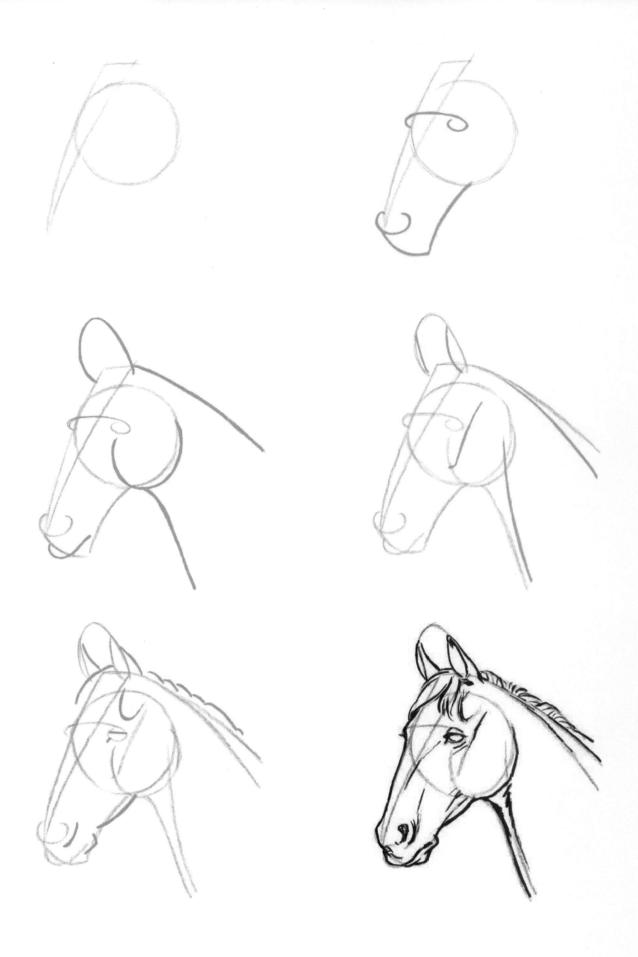

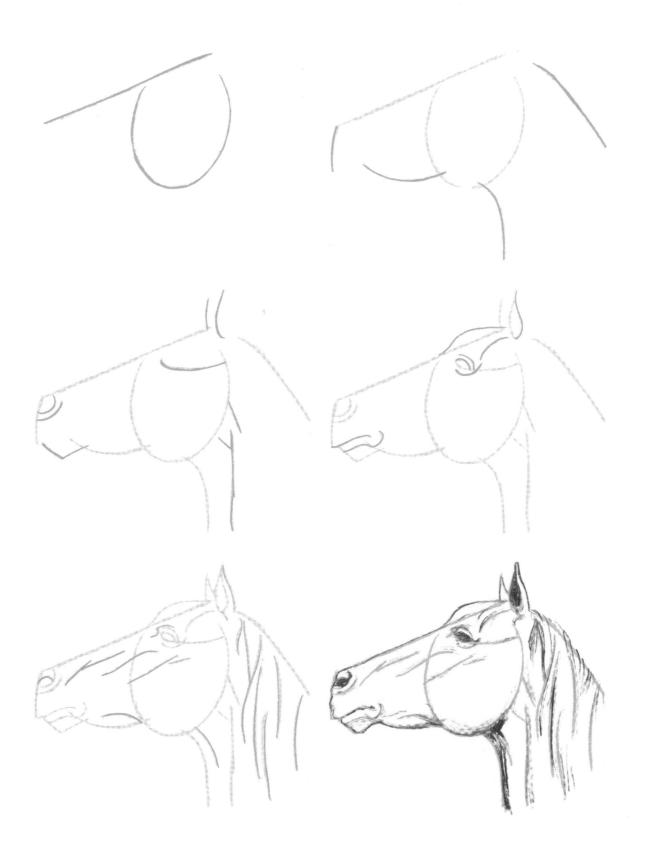

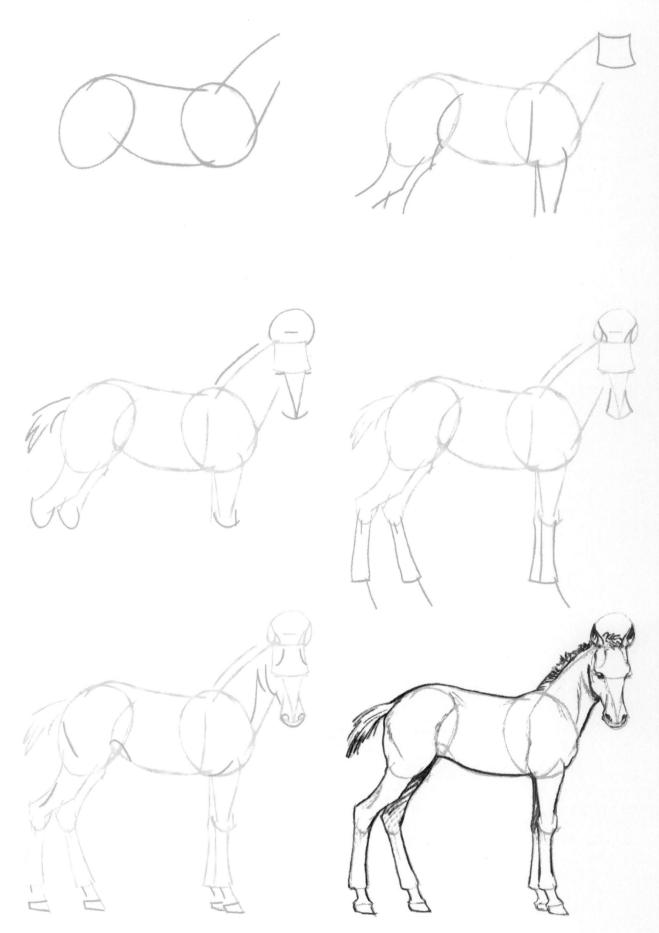

HORSES

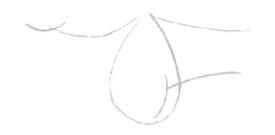

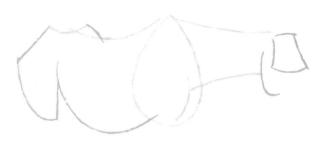

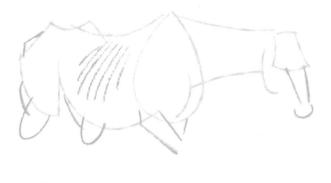

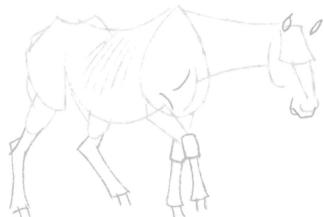

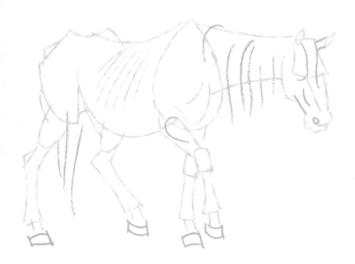

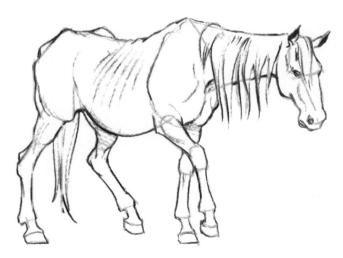

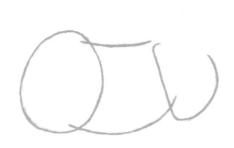

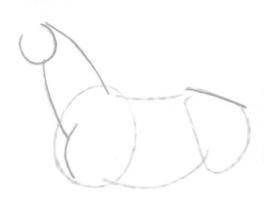

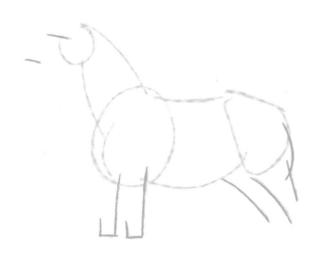

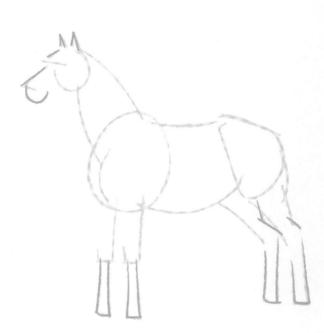

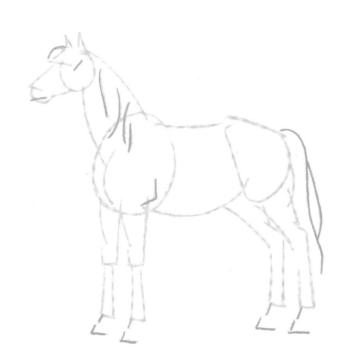

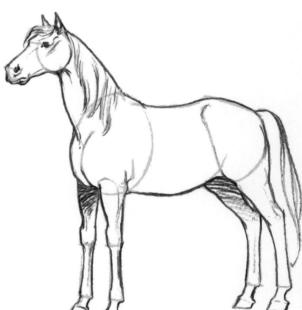

HORSES

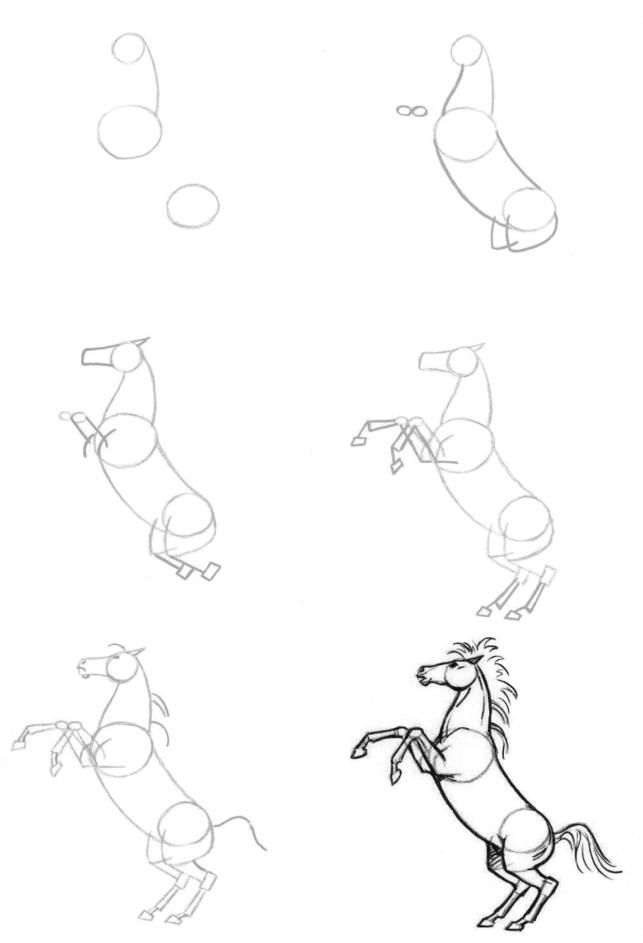

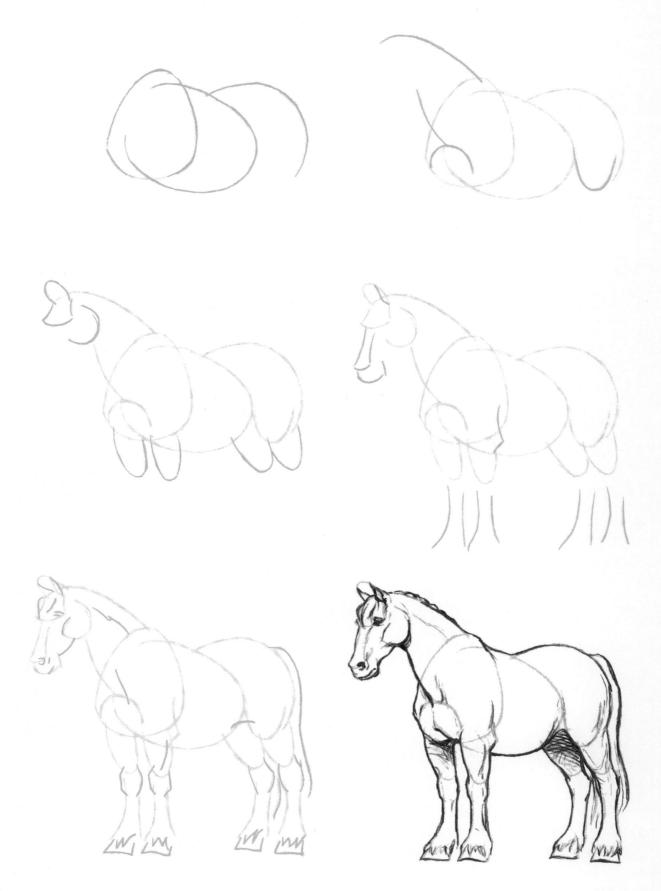

HORSES

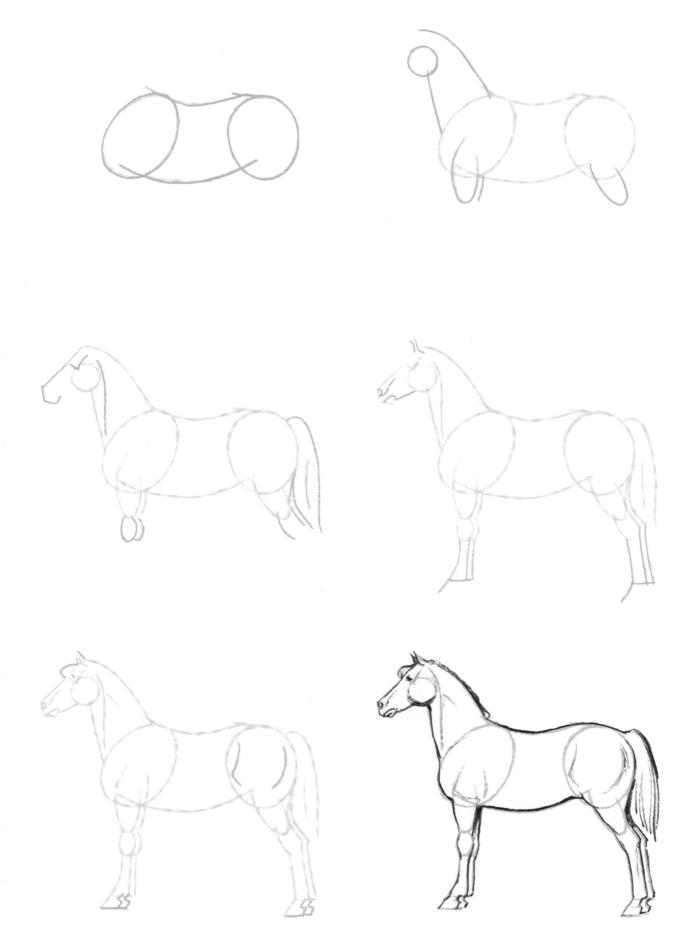

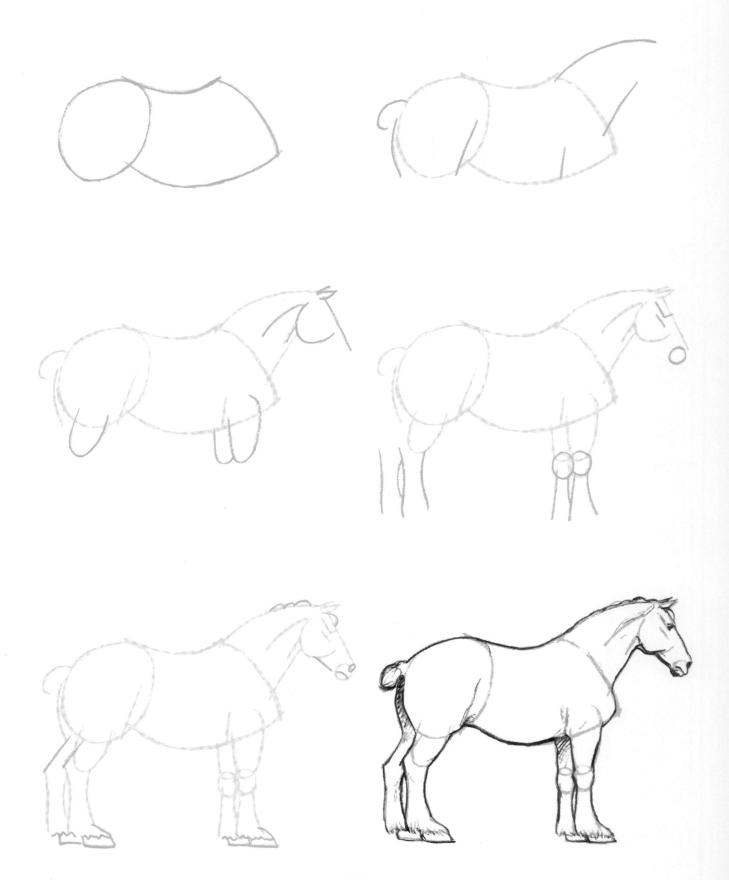

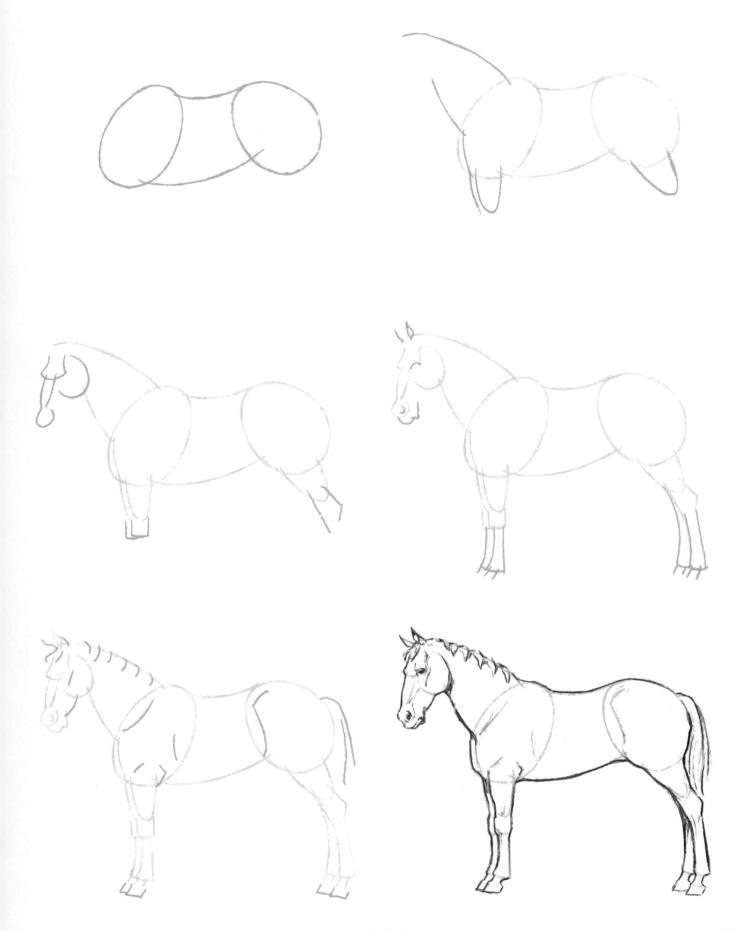

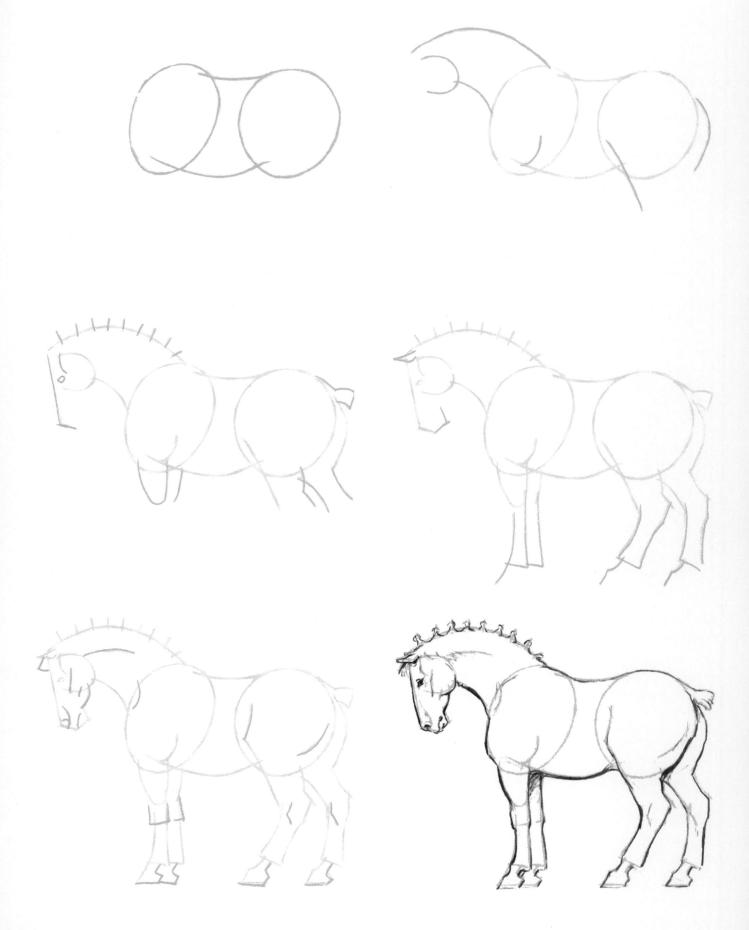

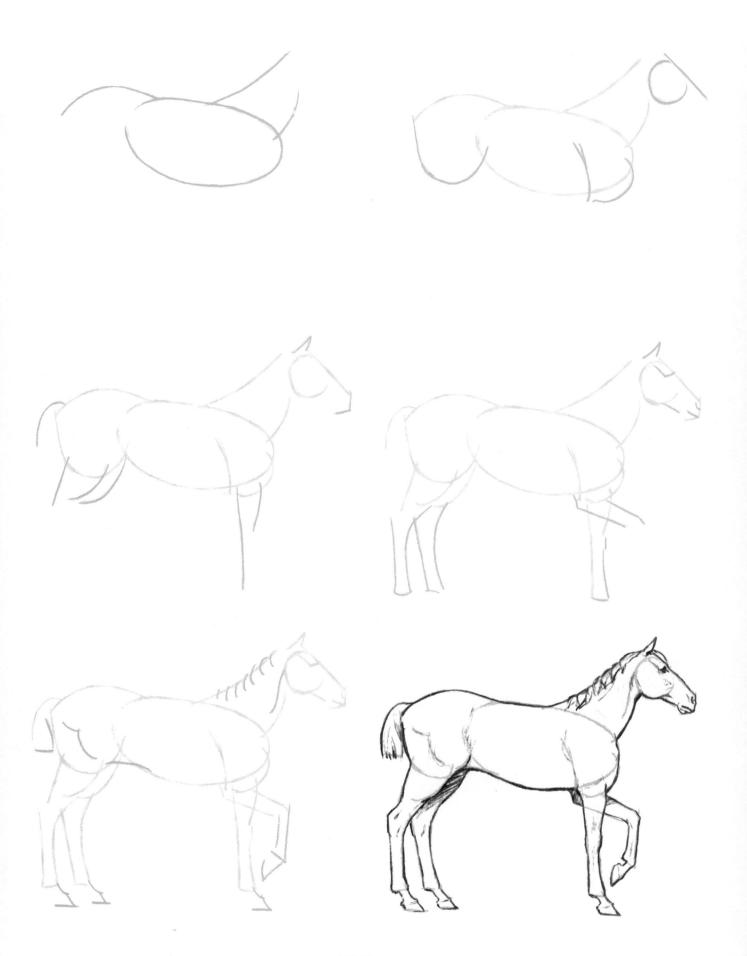

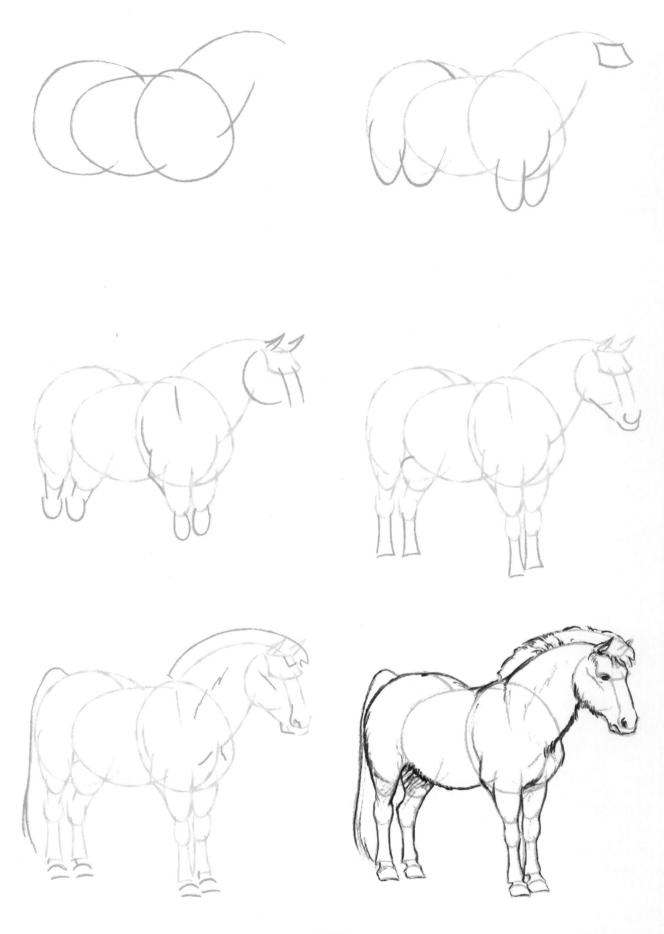

HORSES

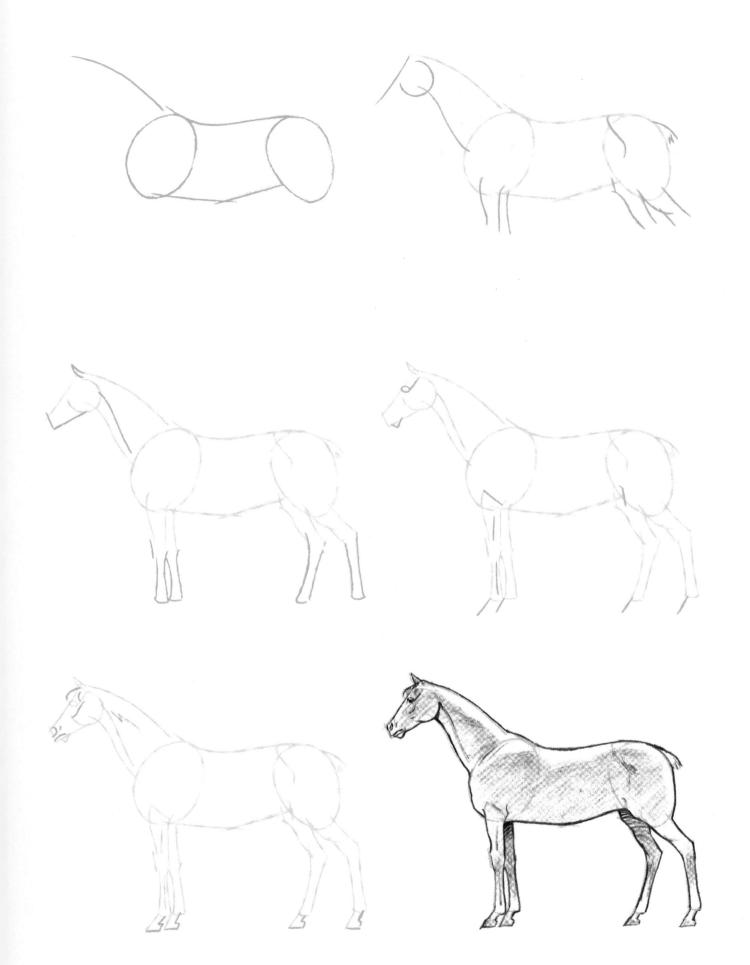

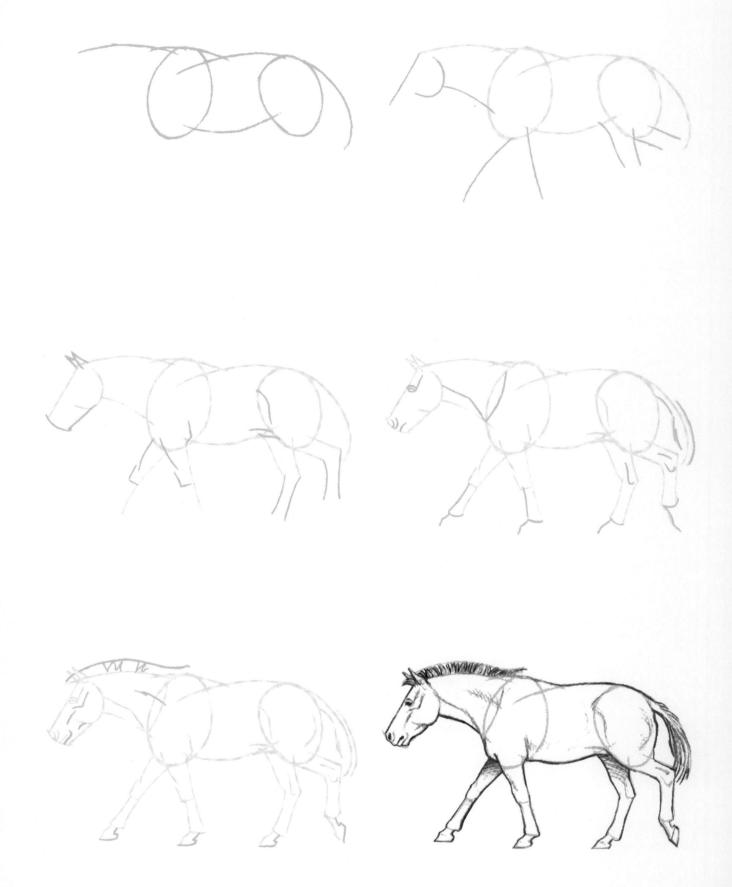

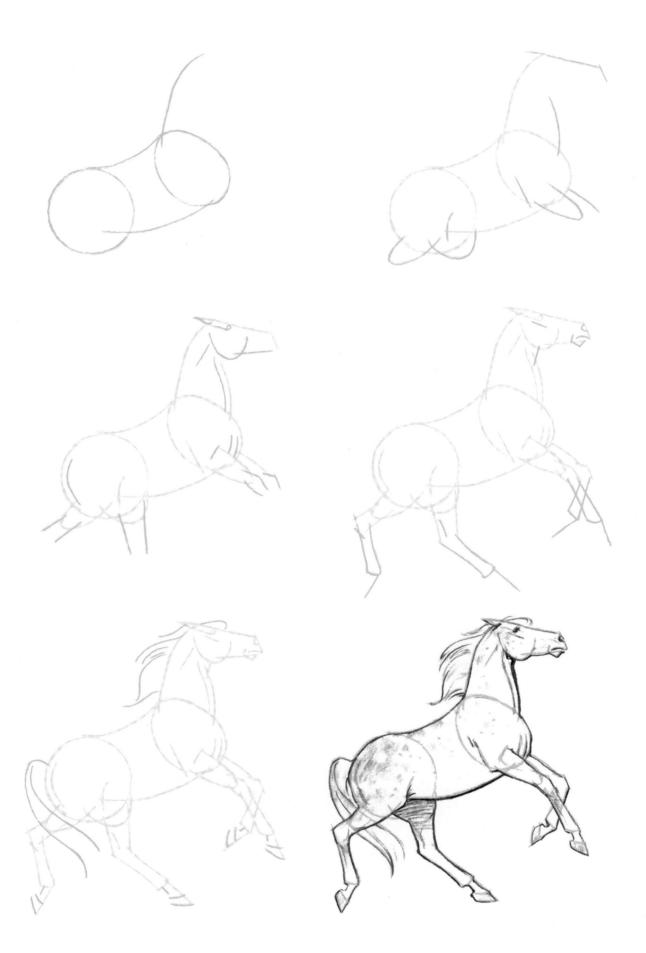

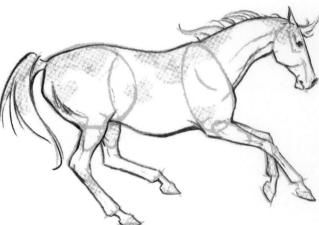

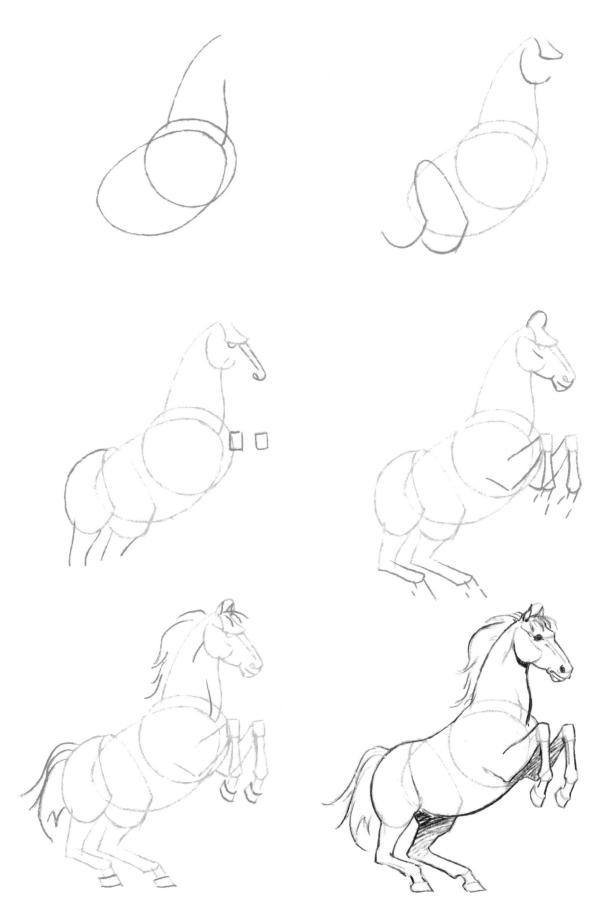

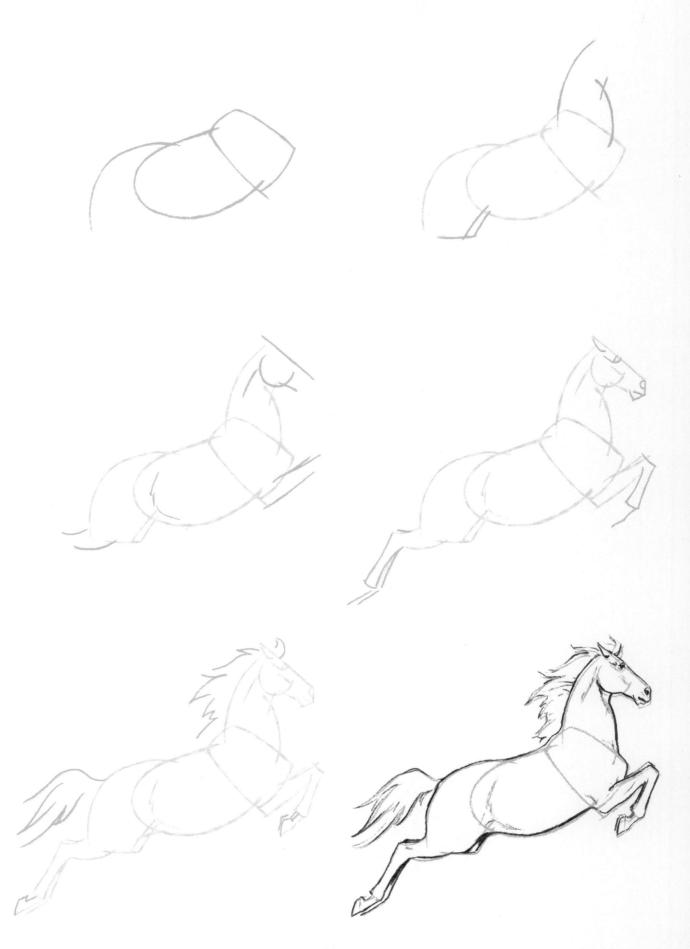

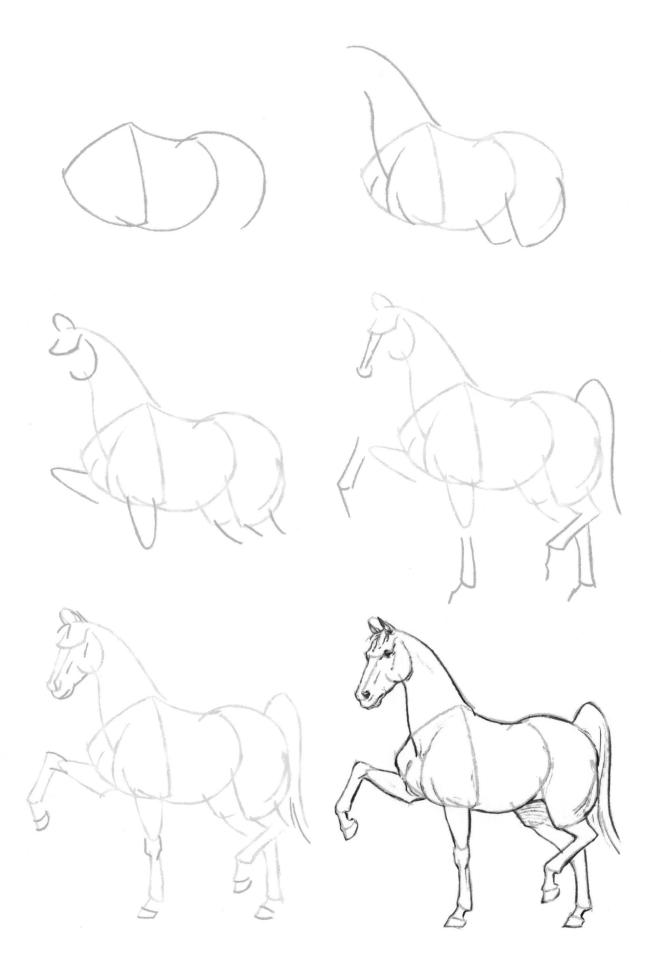

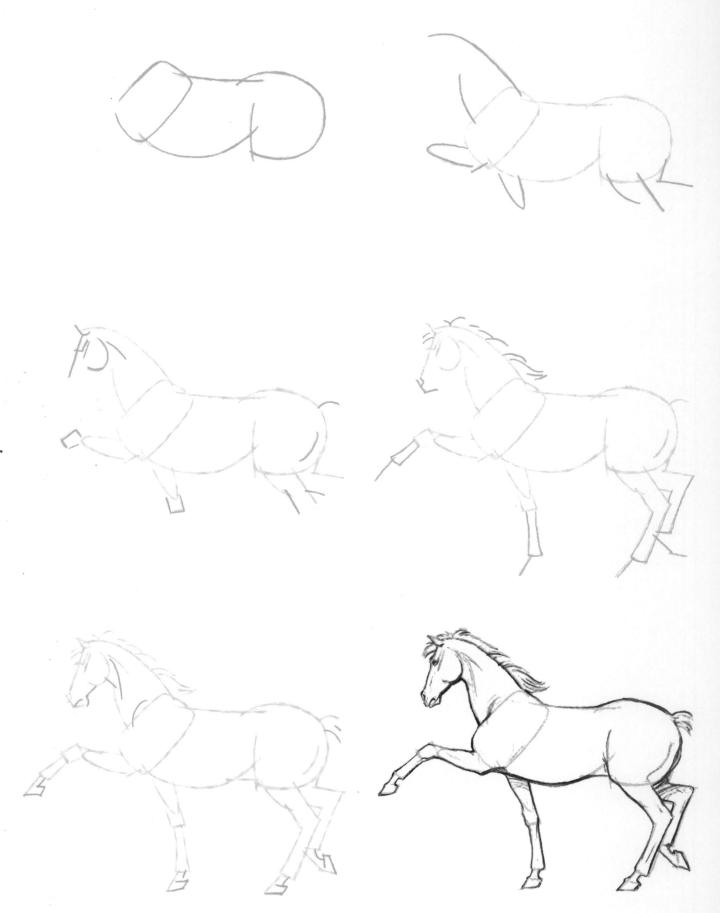

HORSES

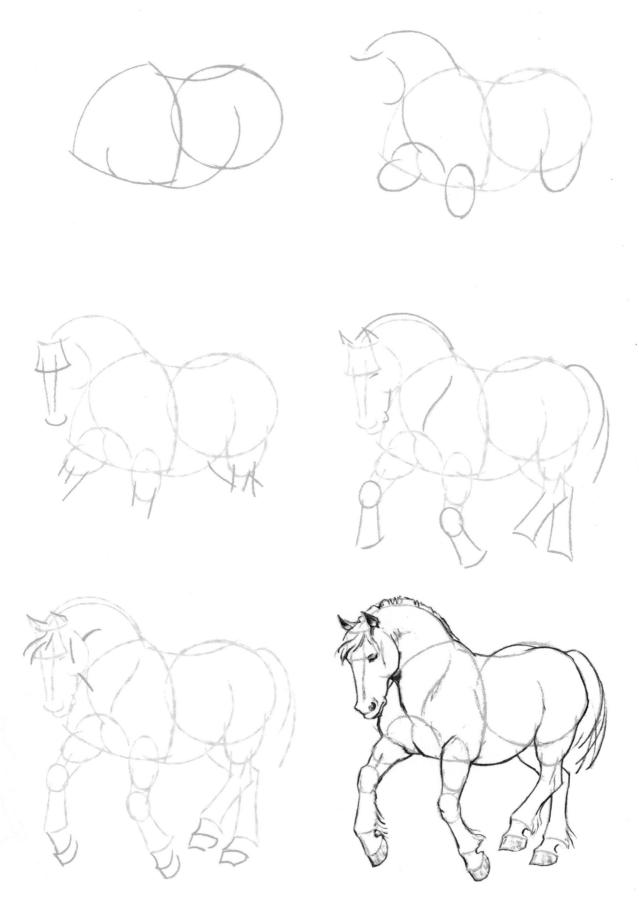

HORSES

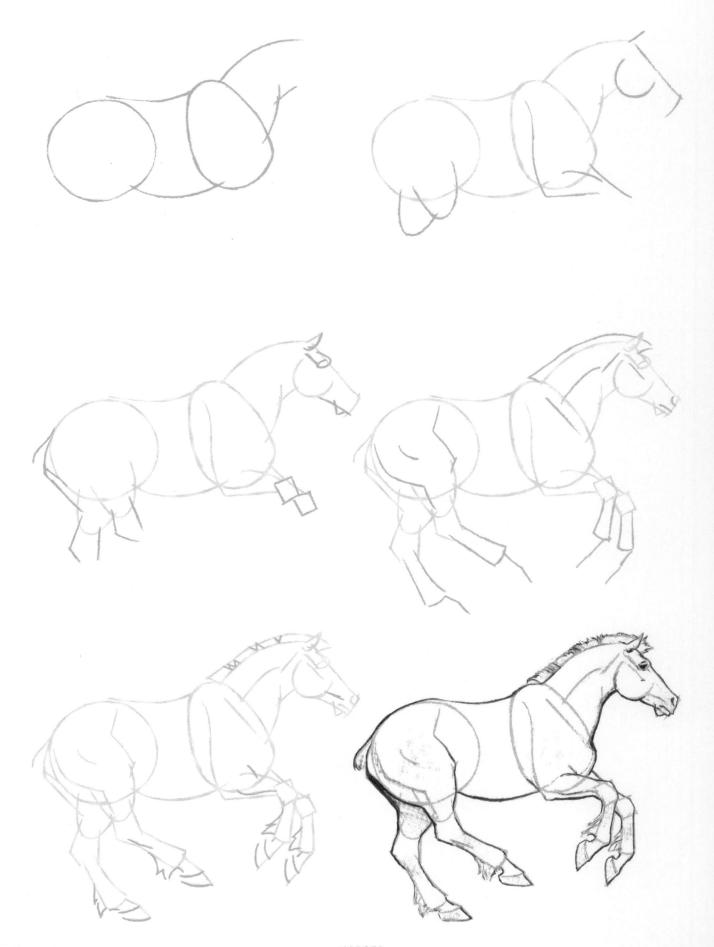

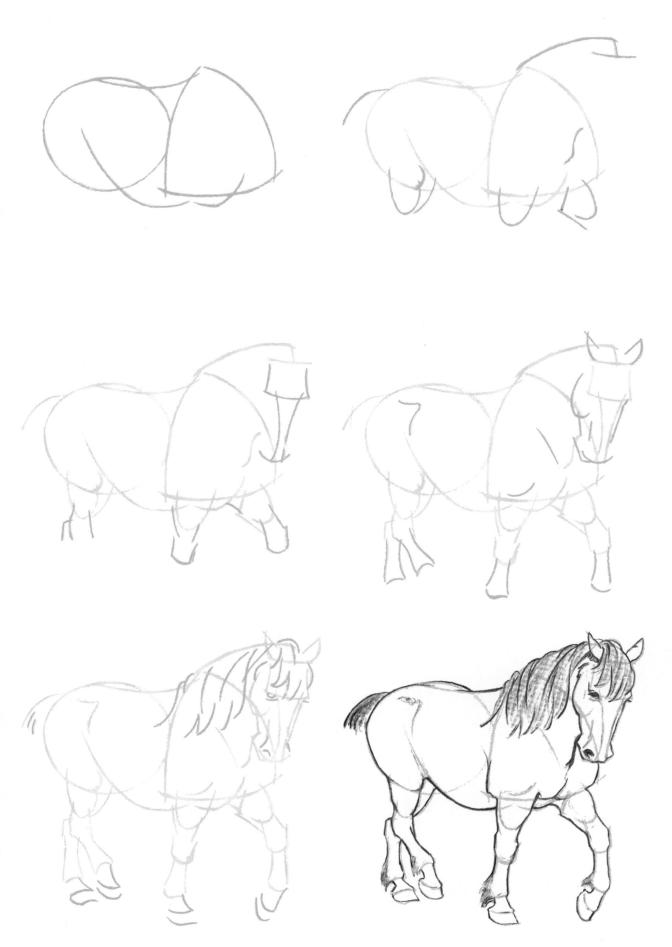

HORSES

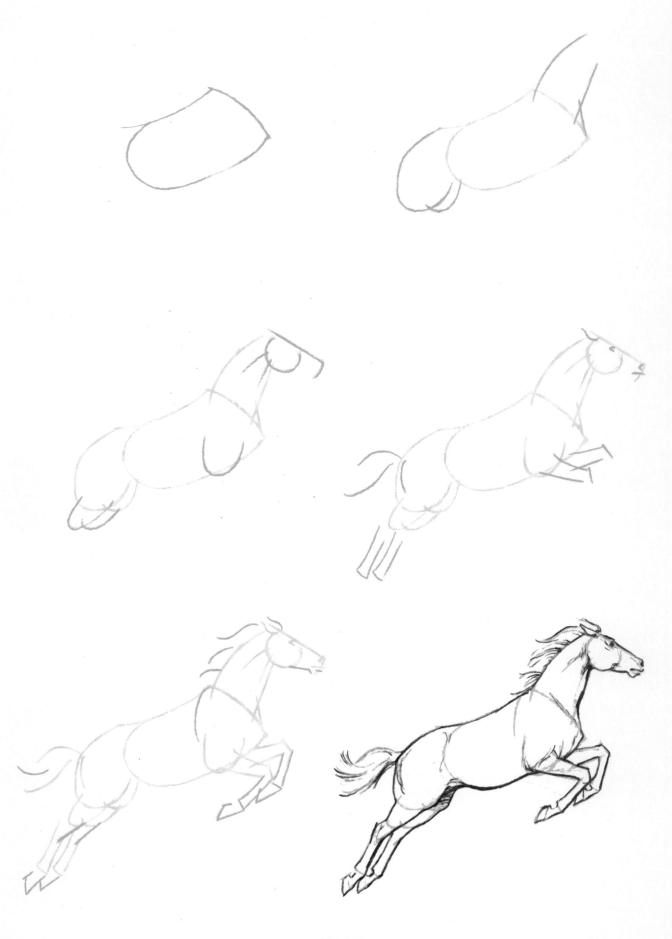

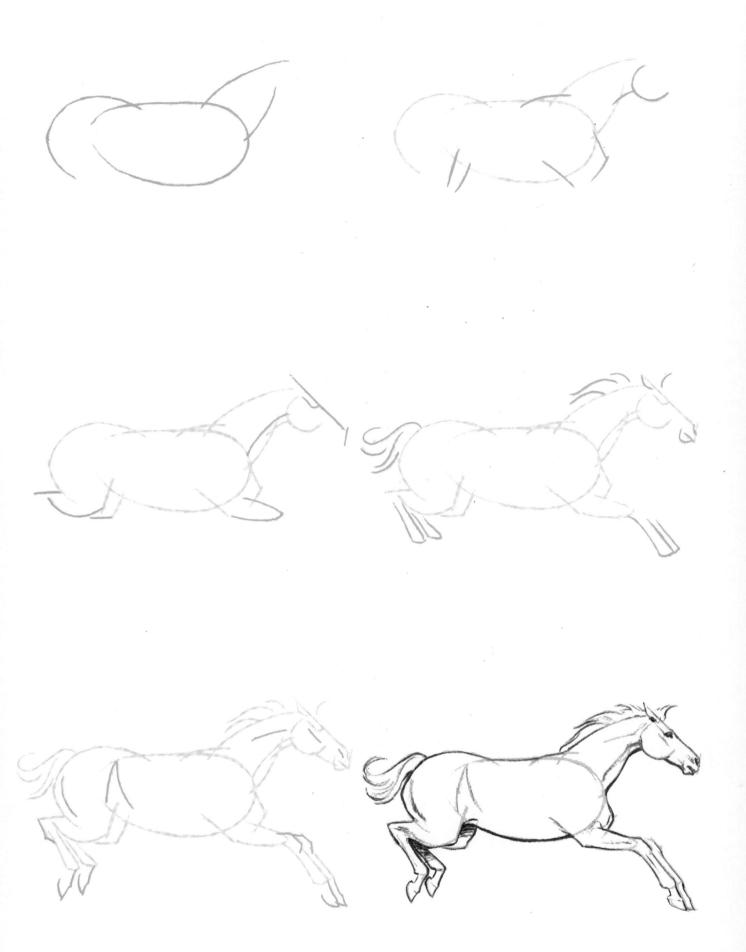

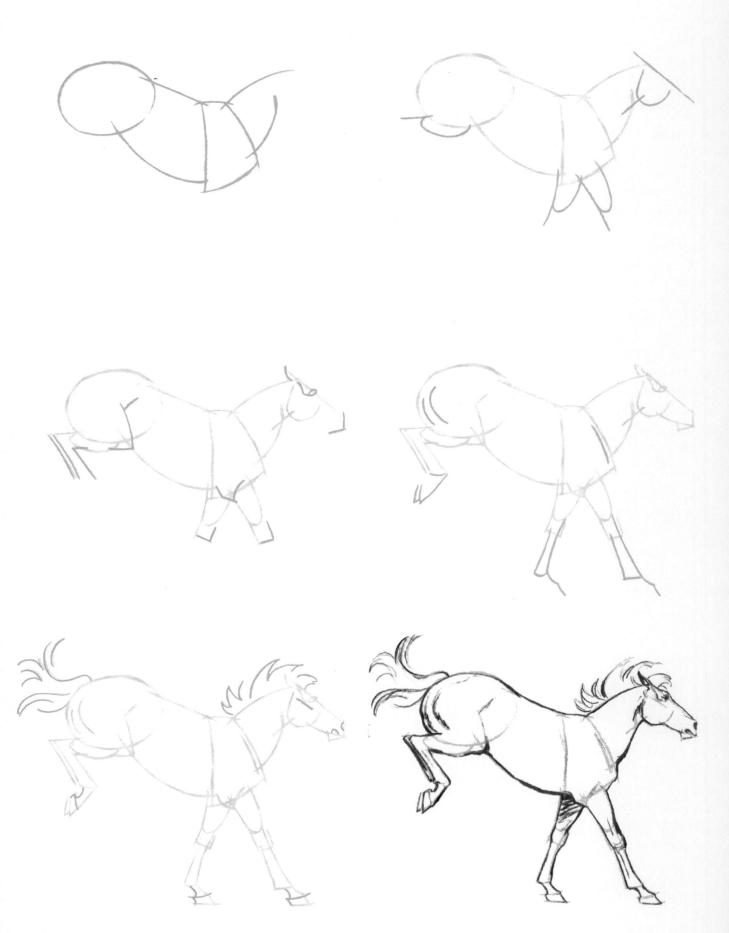

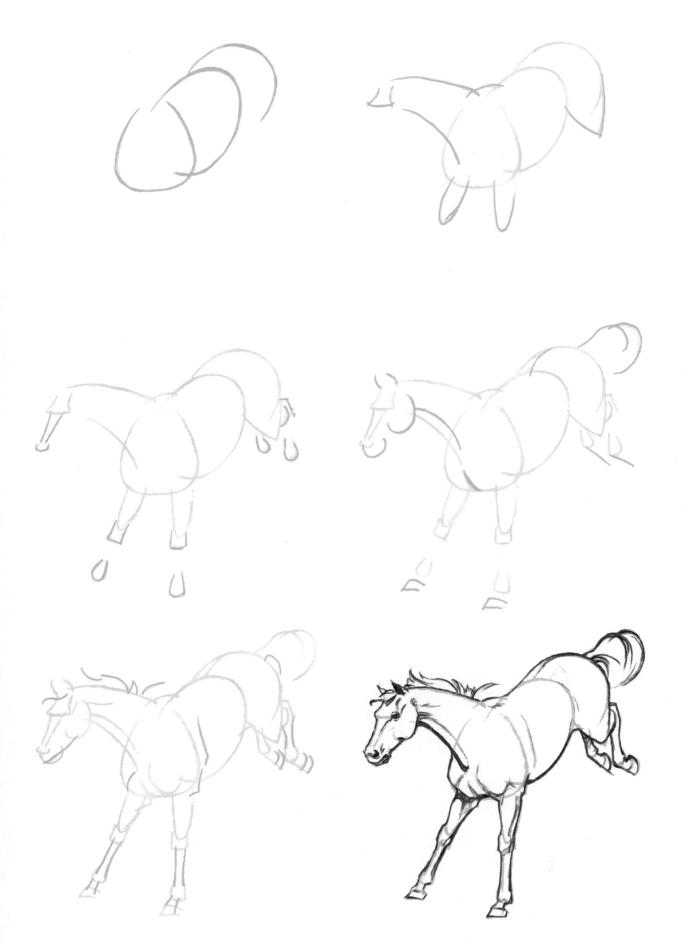

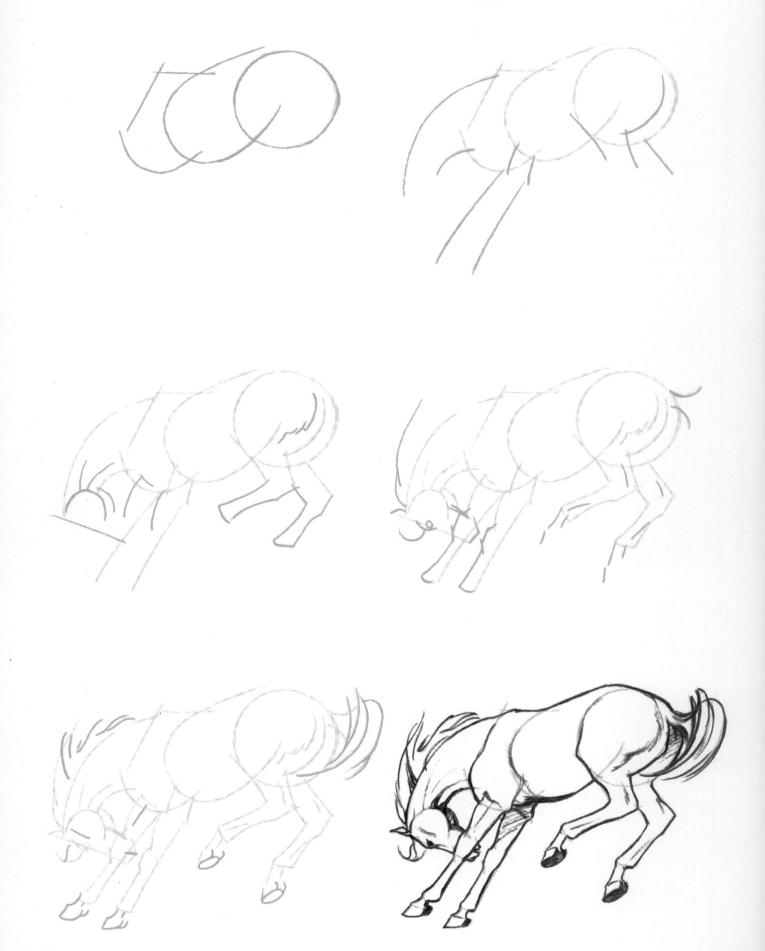

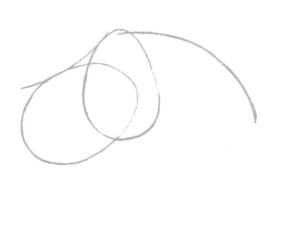

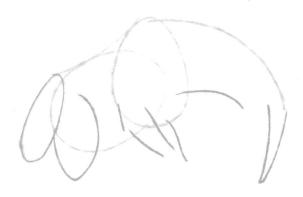

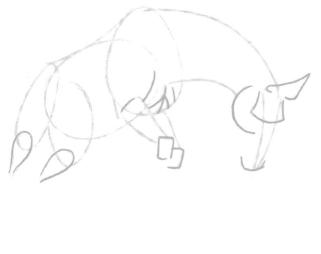

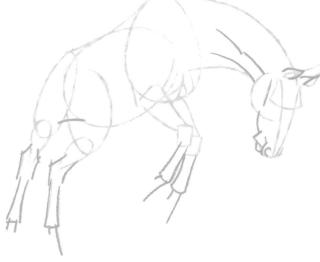

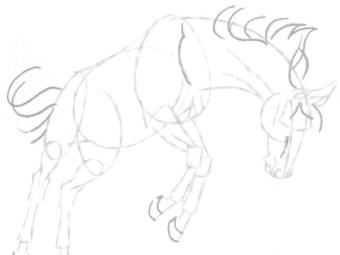

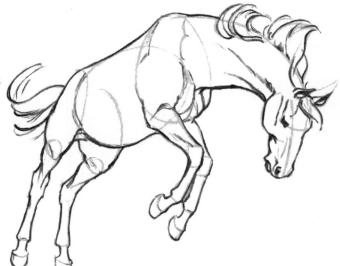

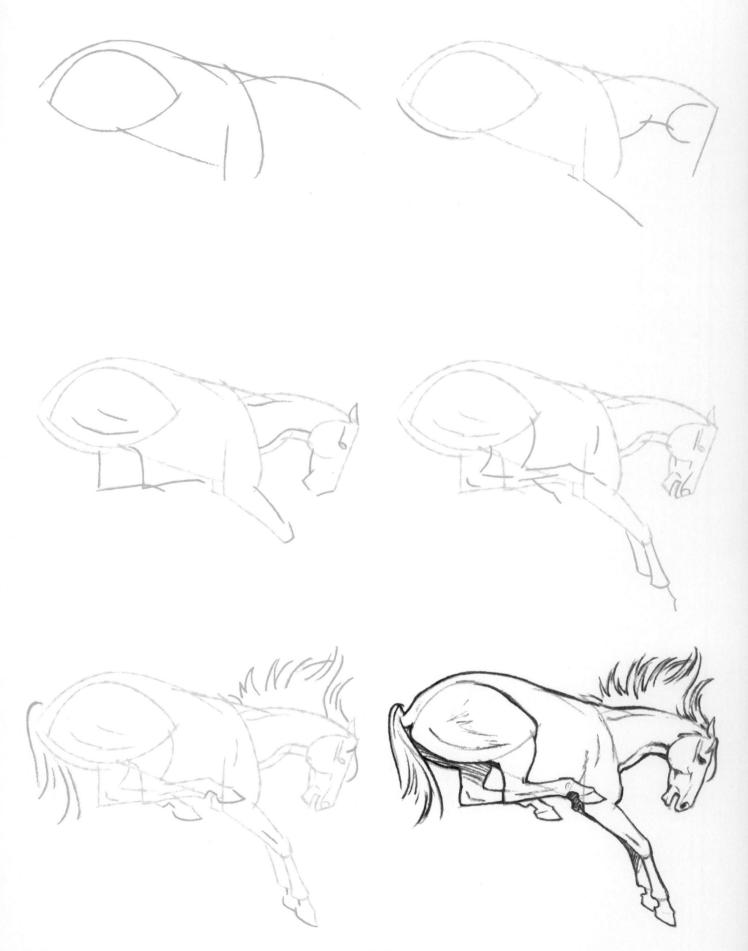

HORSES

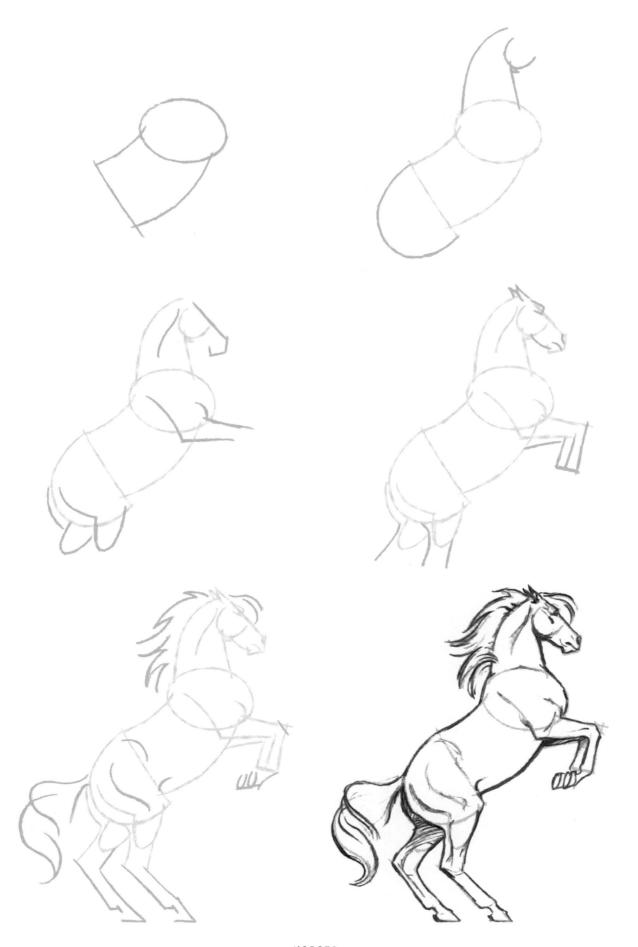

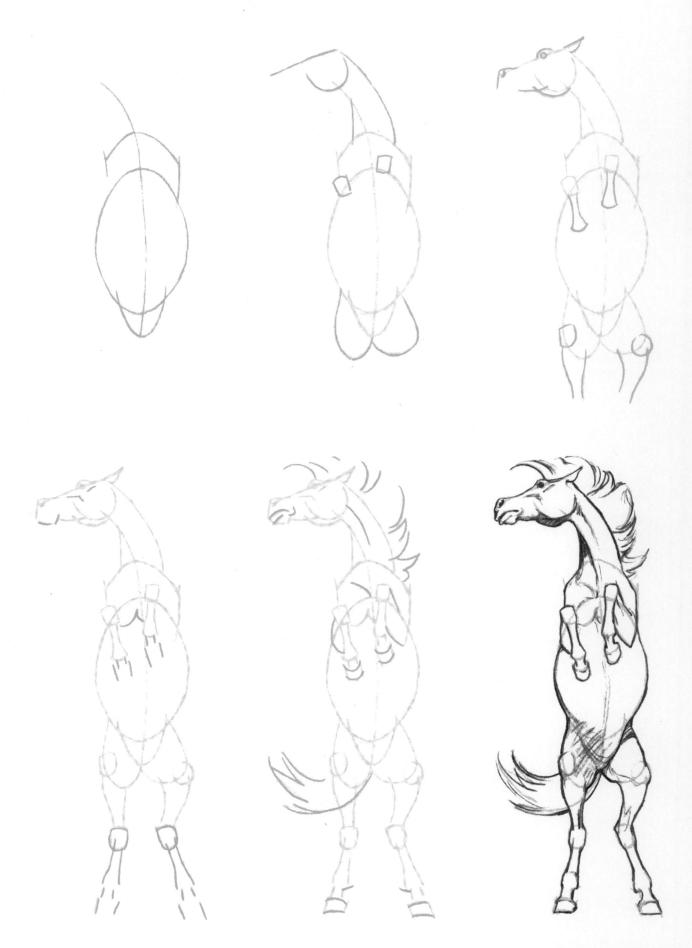

HORSES

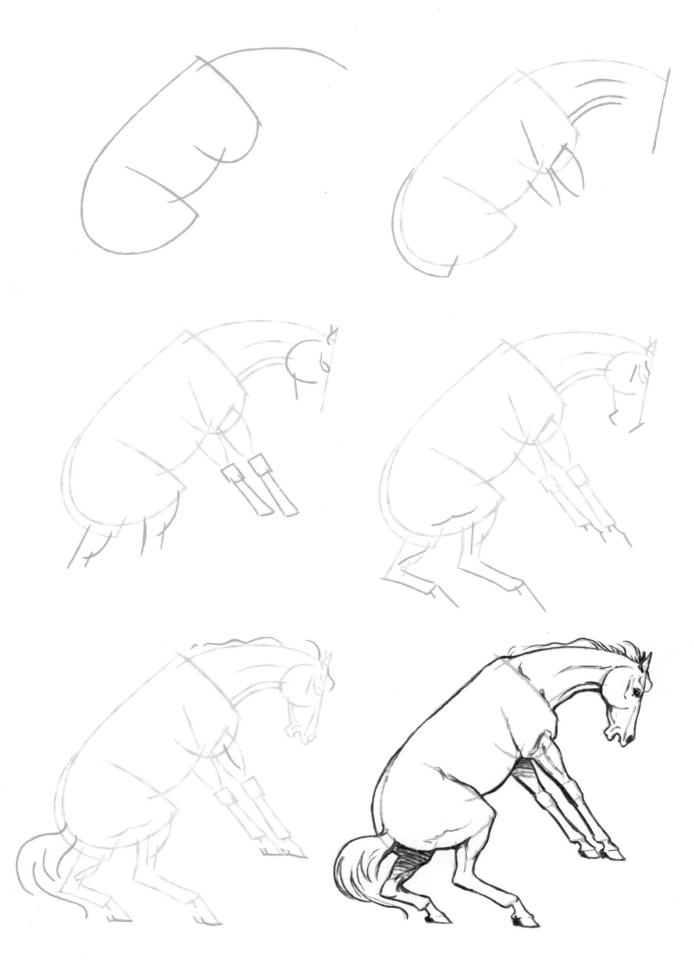

HORSES

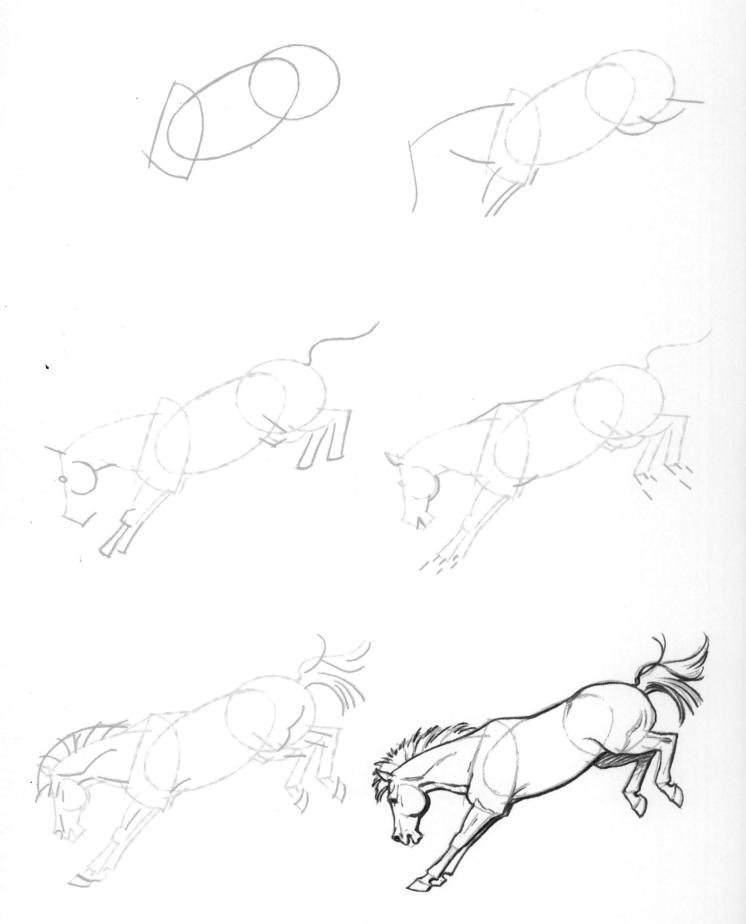

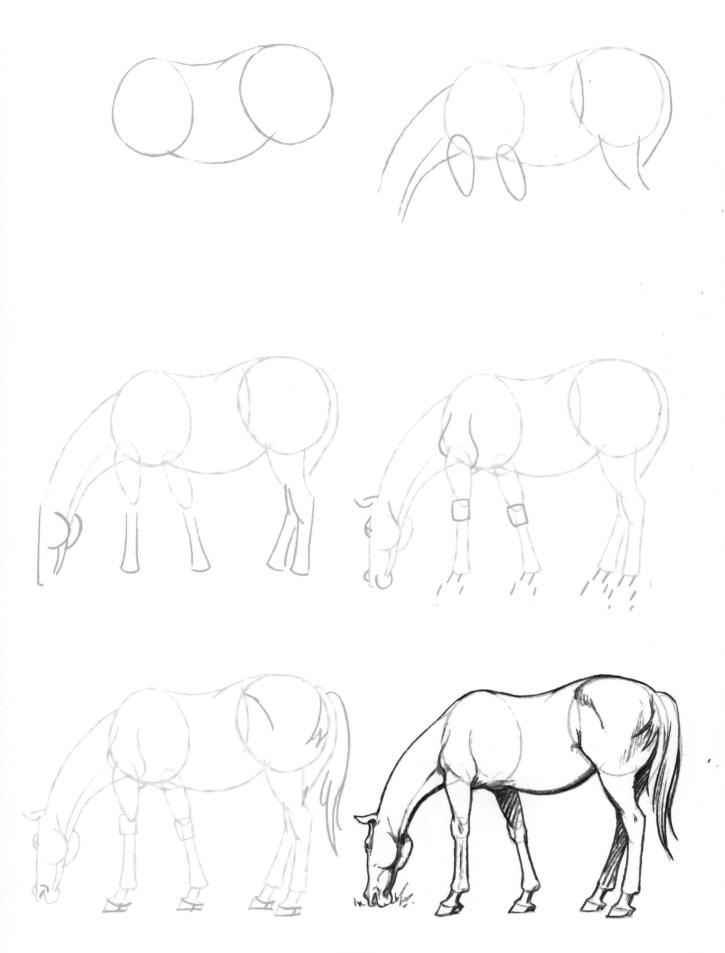

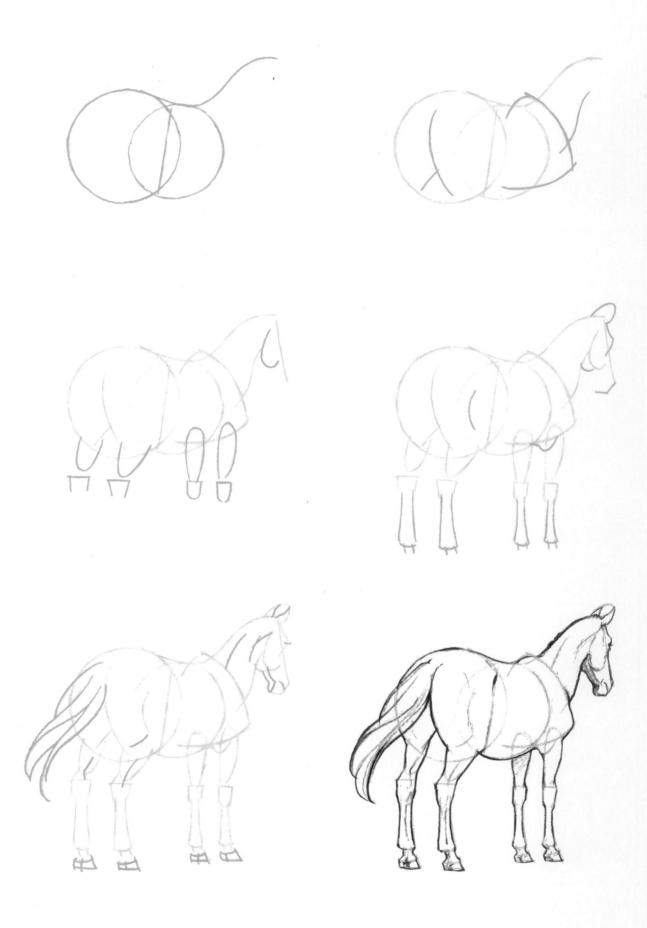

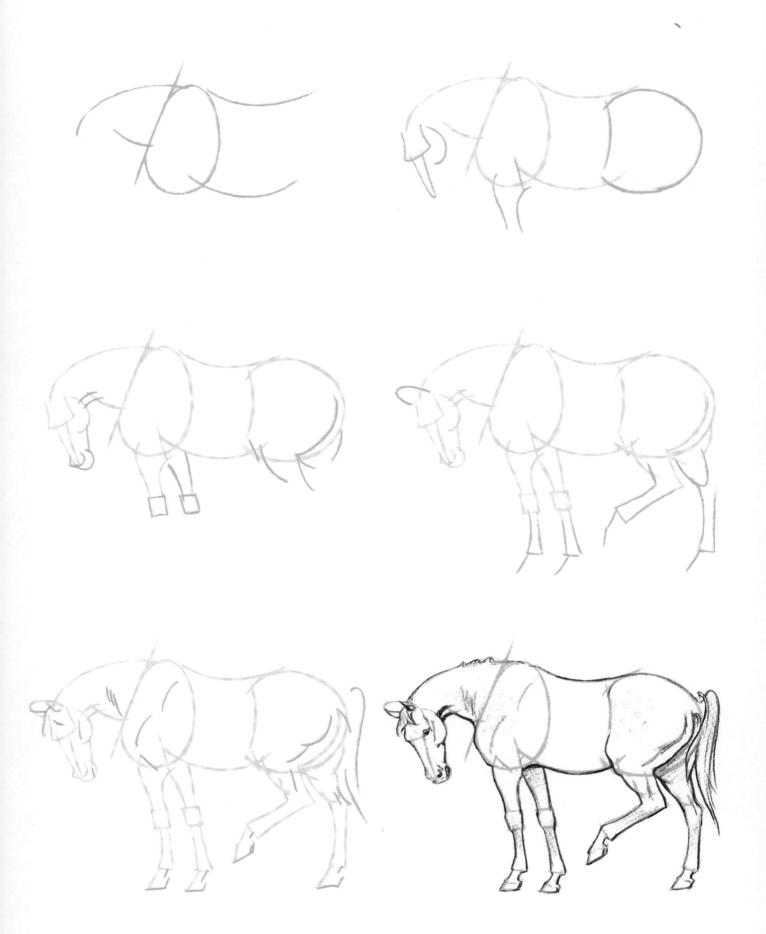

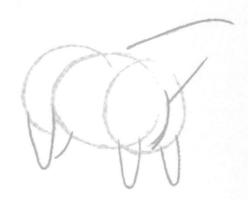

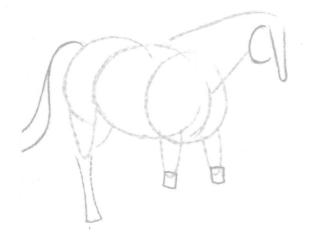

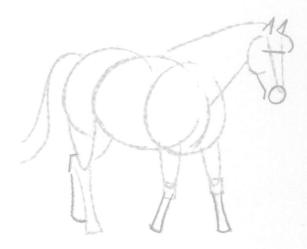

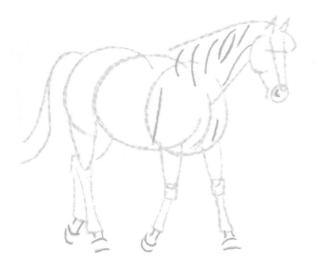

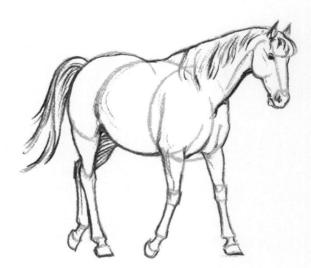

HORSES

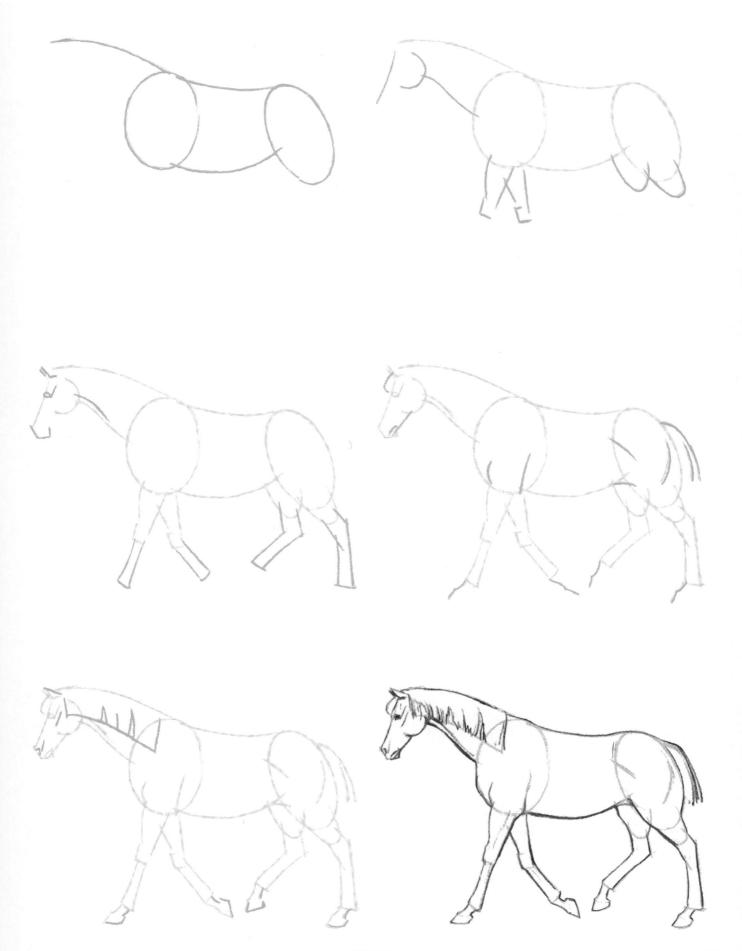

HORSES

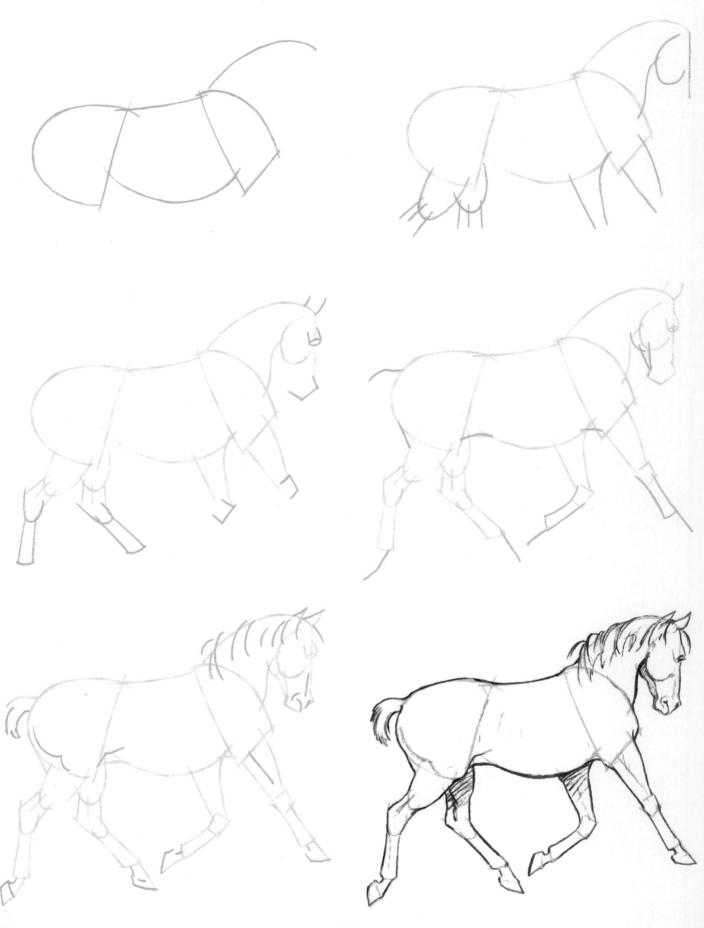

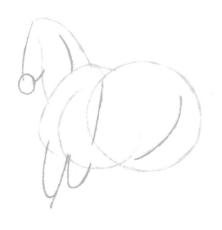

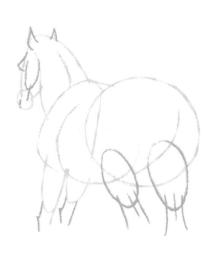

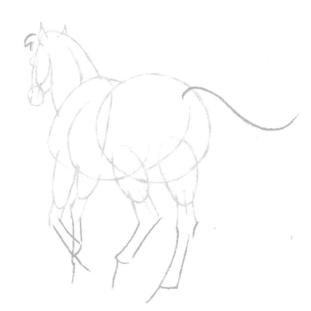

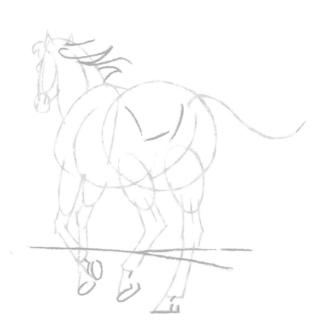

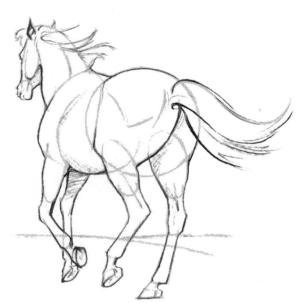

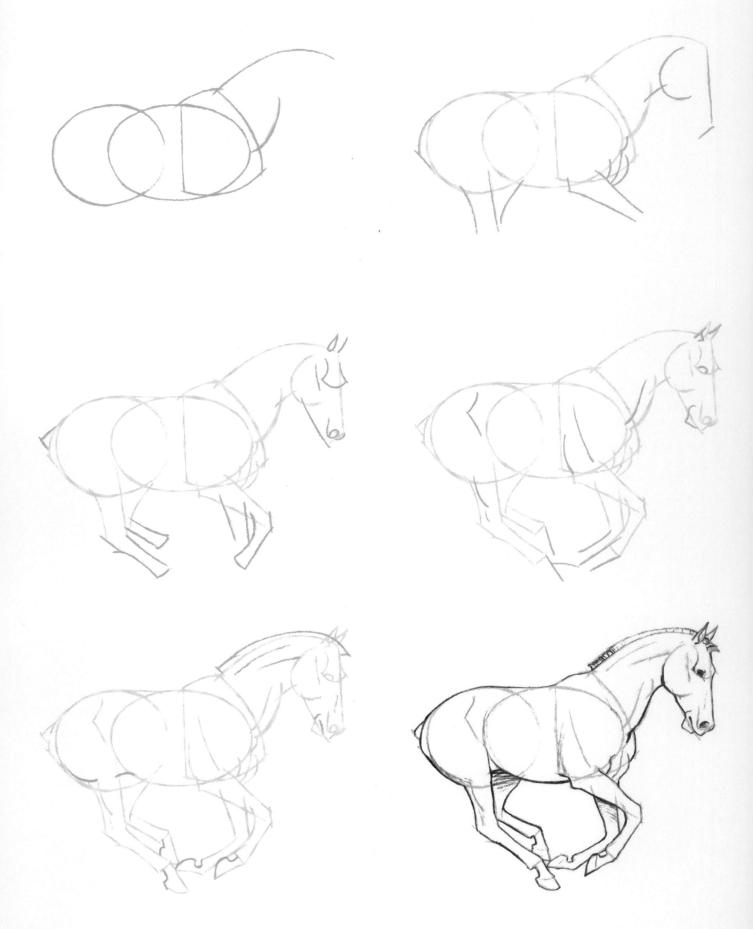

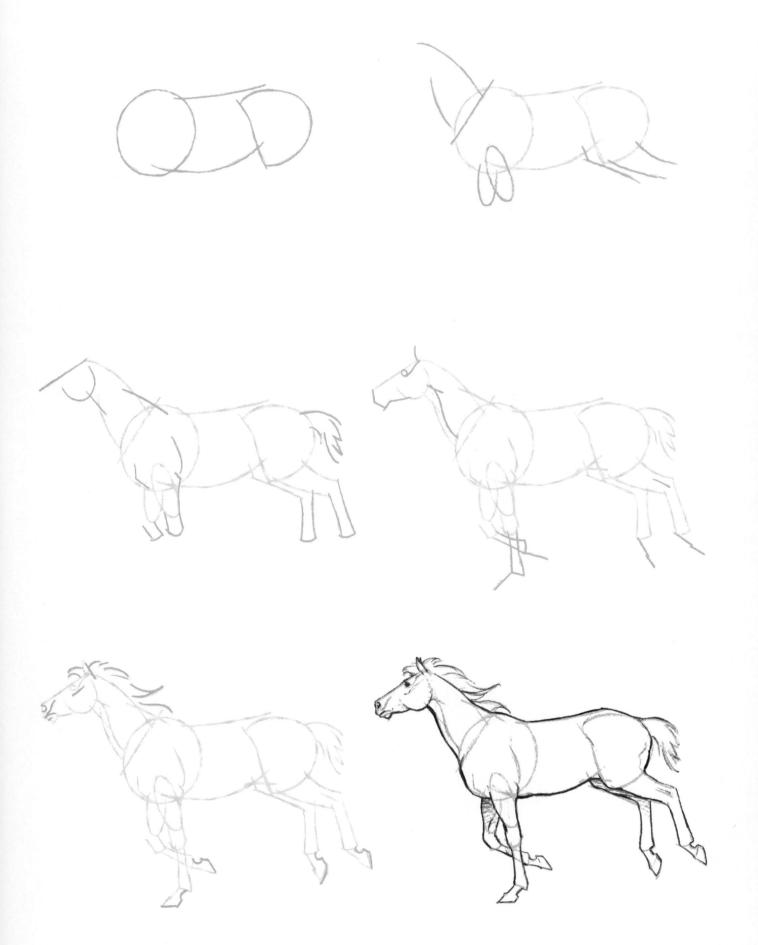

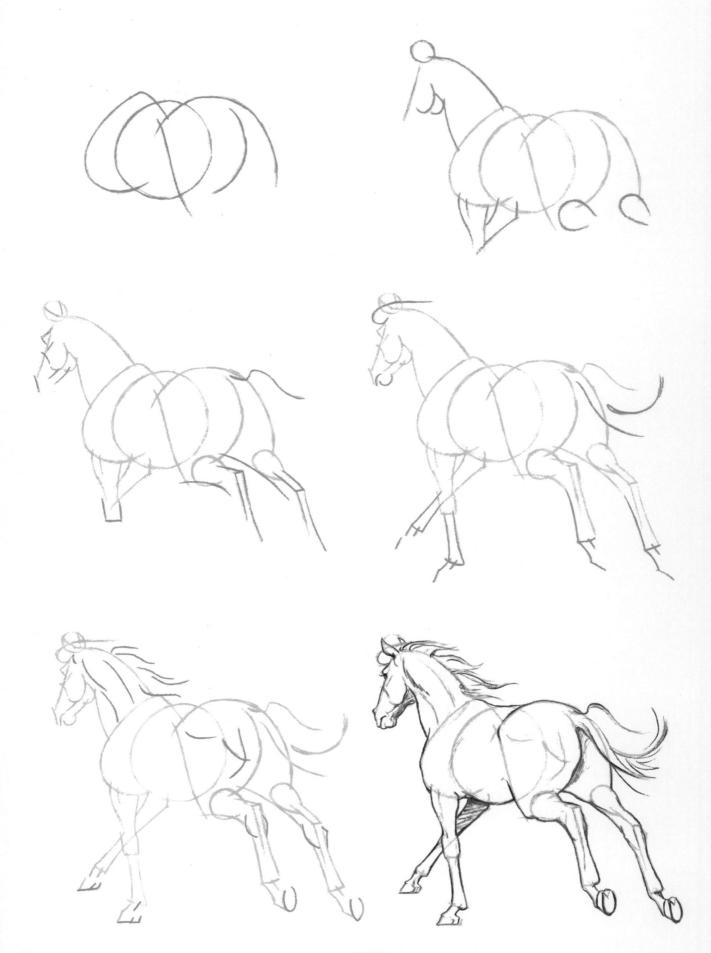

HORSES

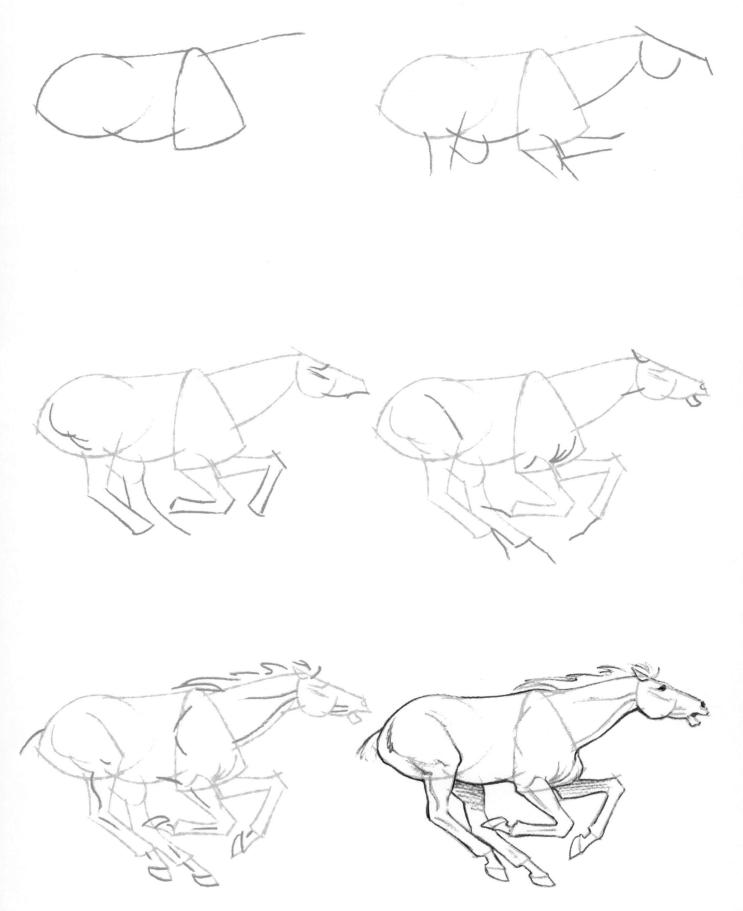

Cats

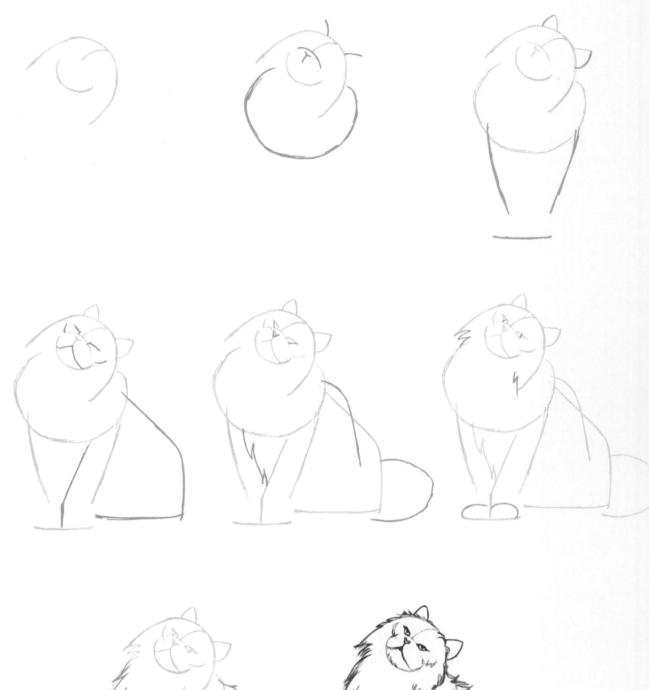

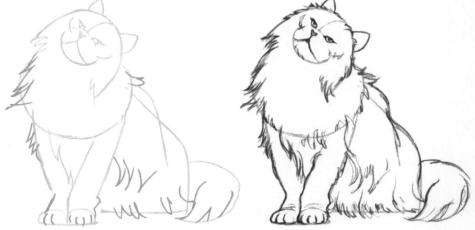

CATS

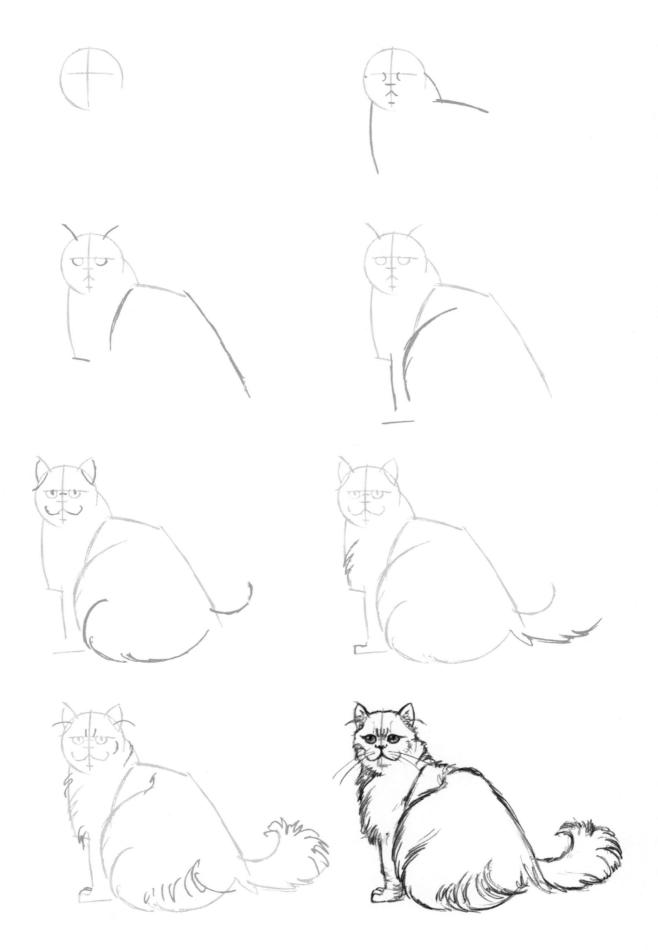

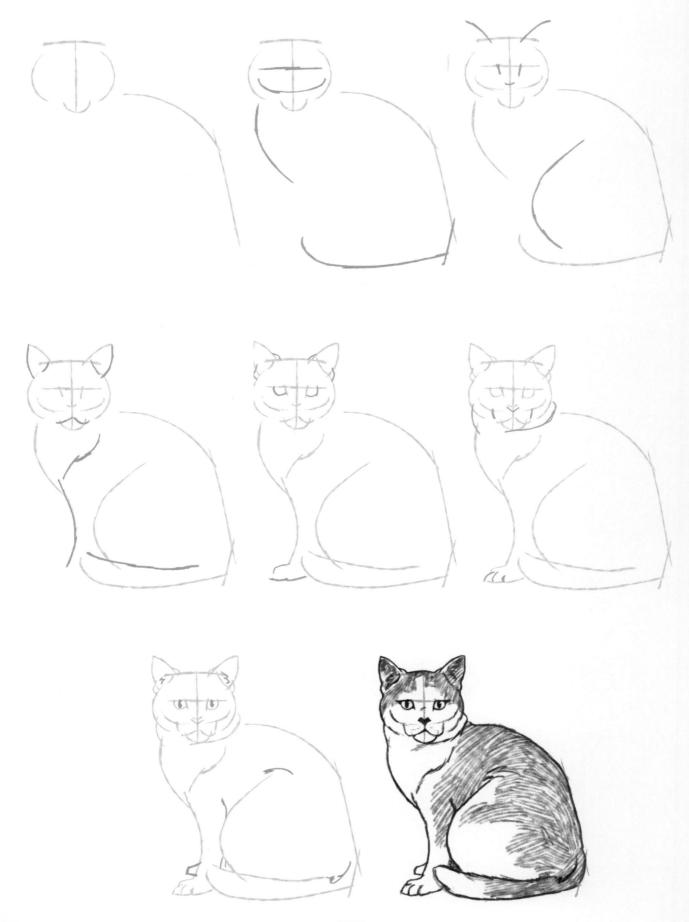

CATS

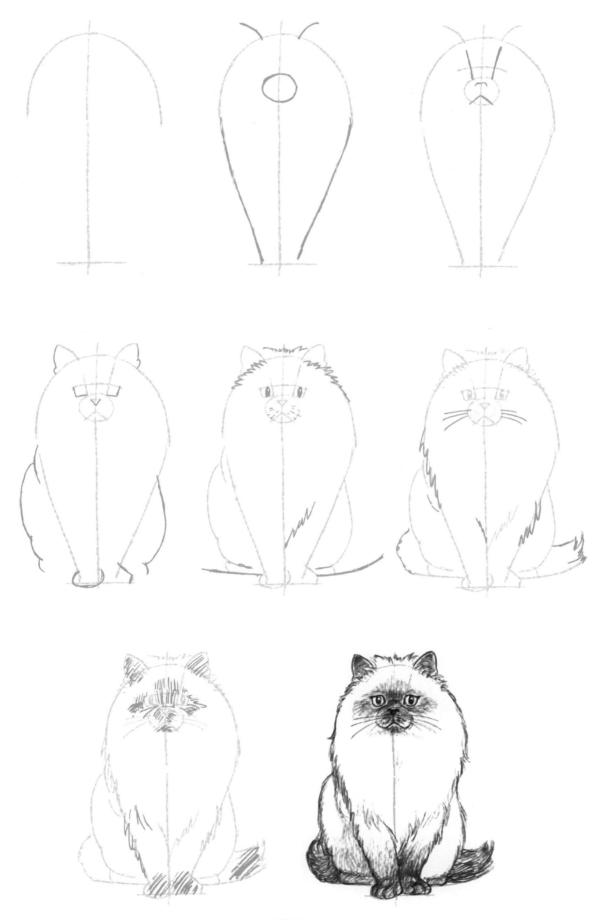

CATS

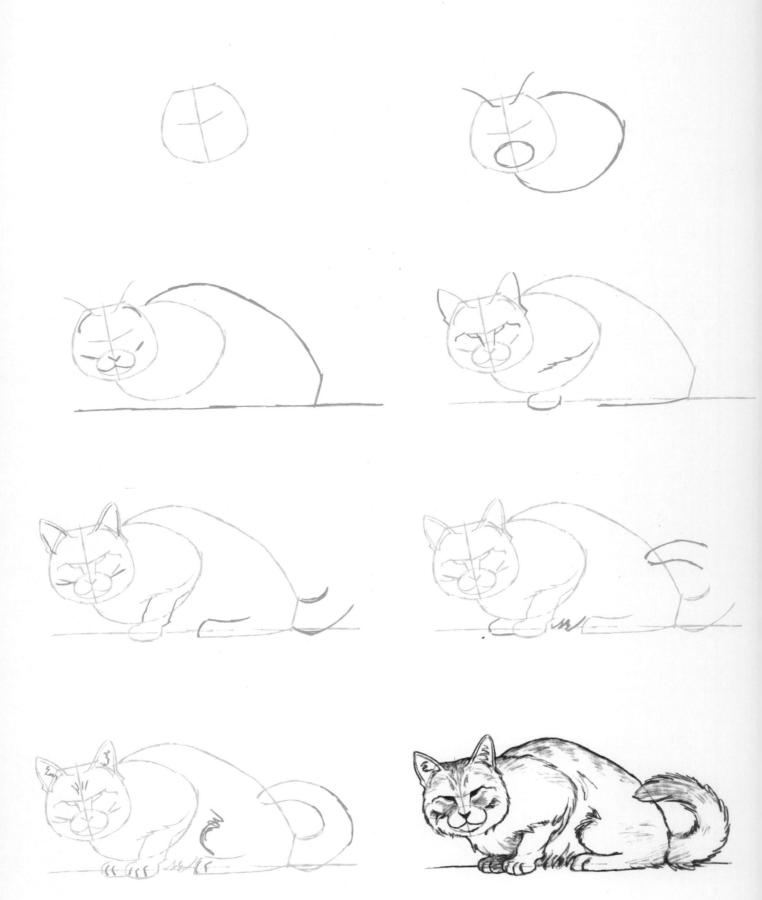

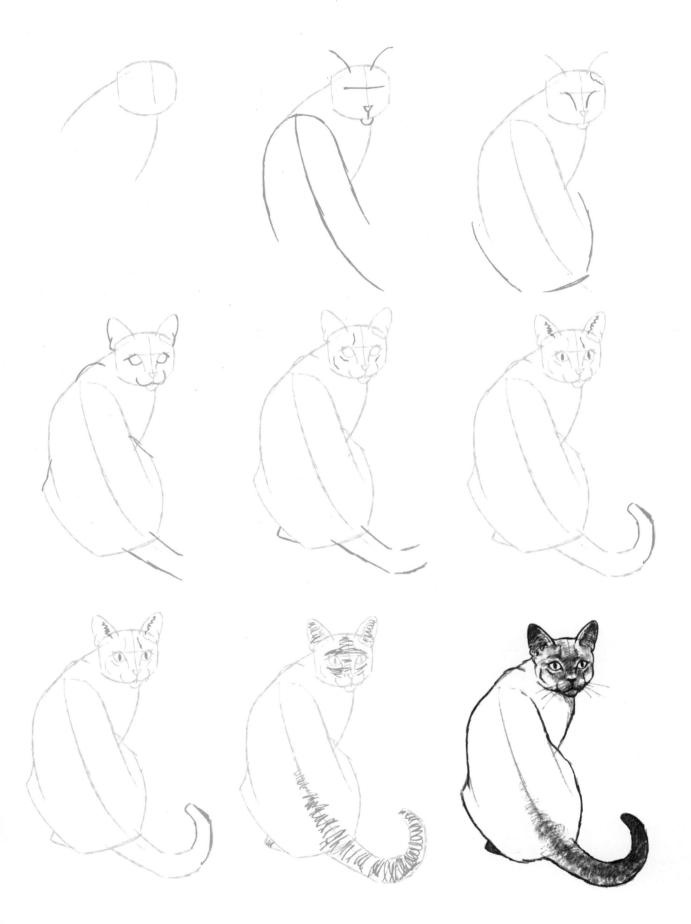

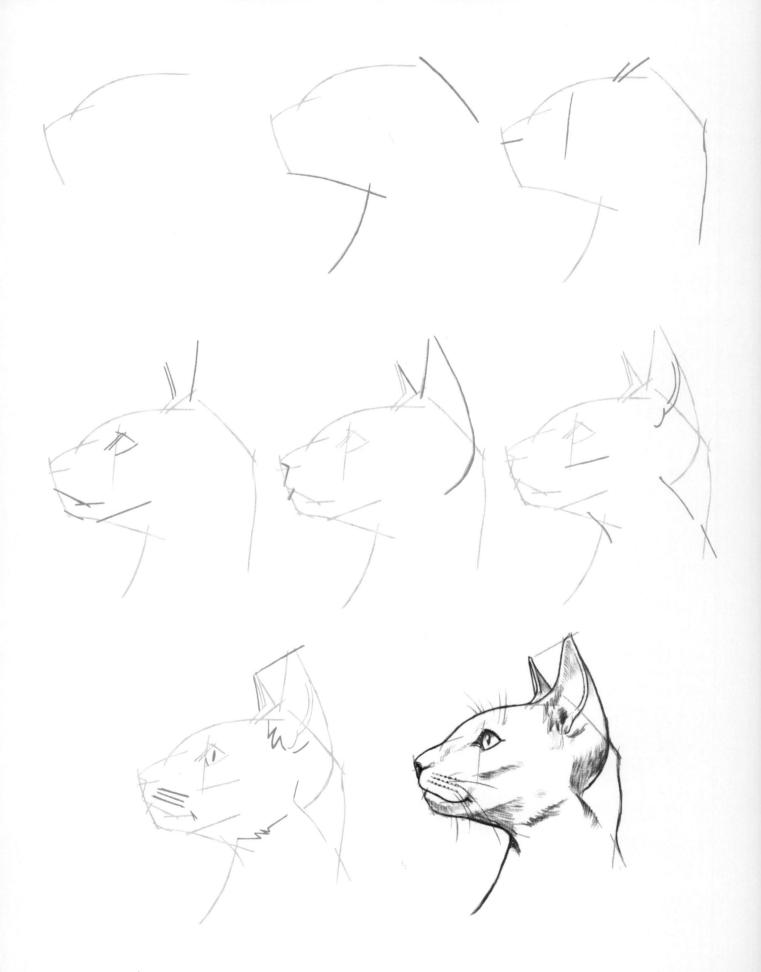

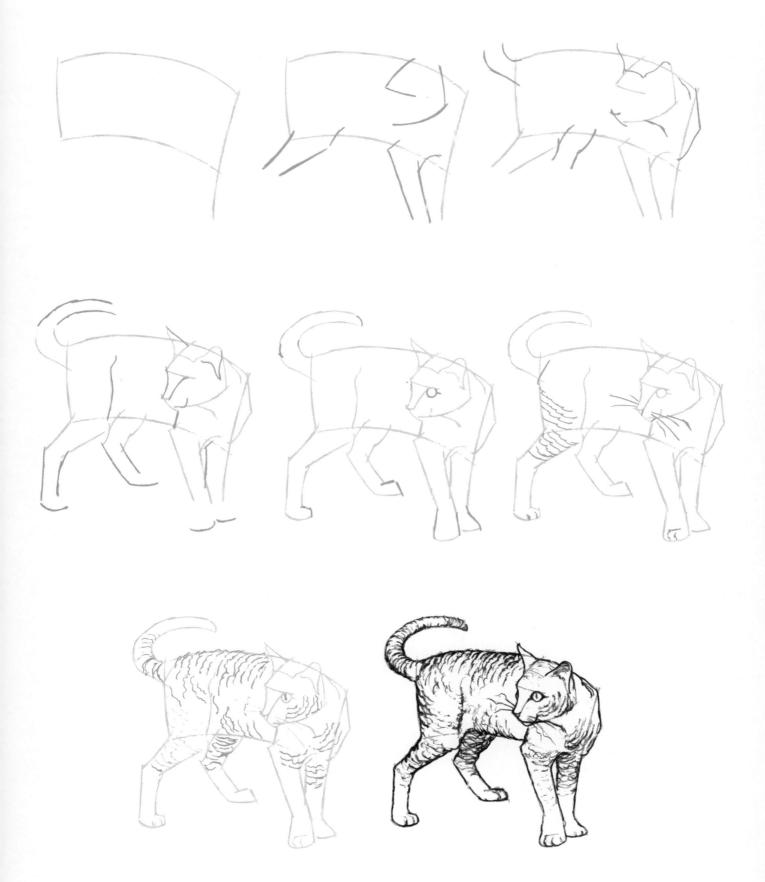

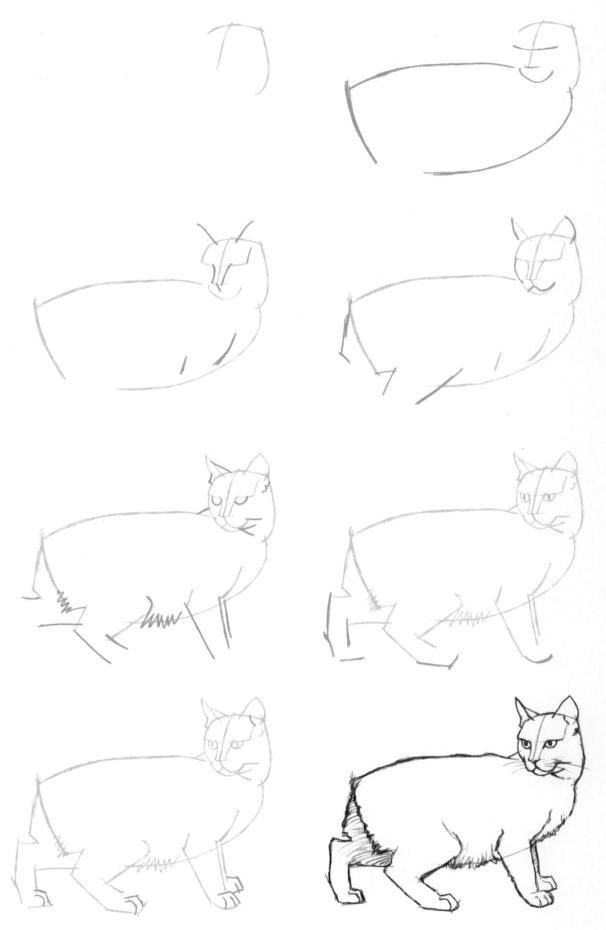

CATS

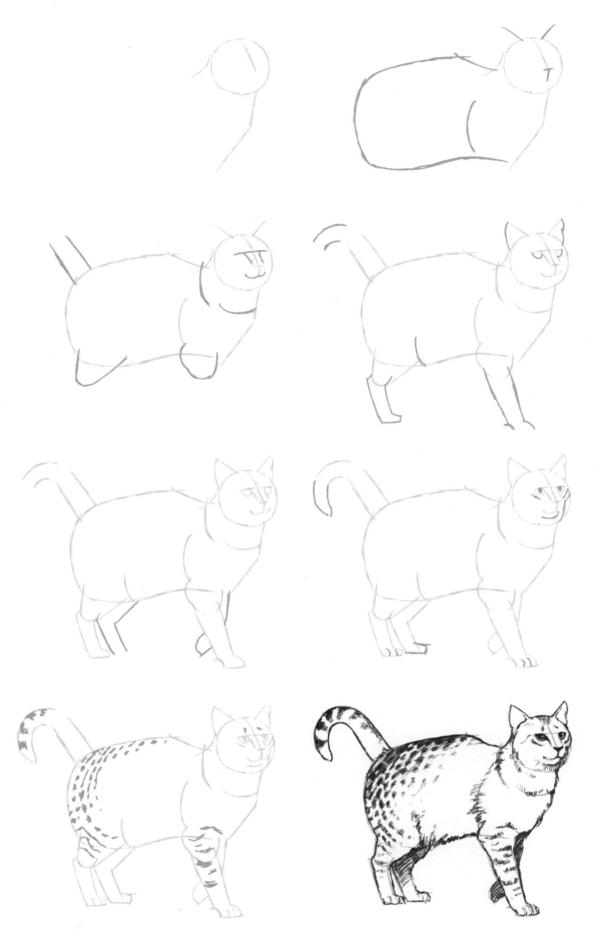

CATS

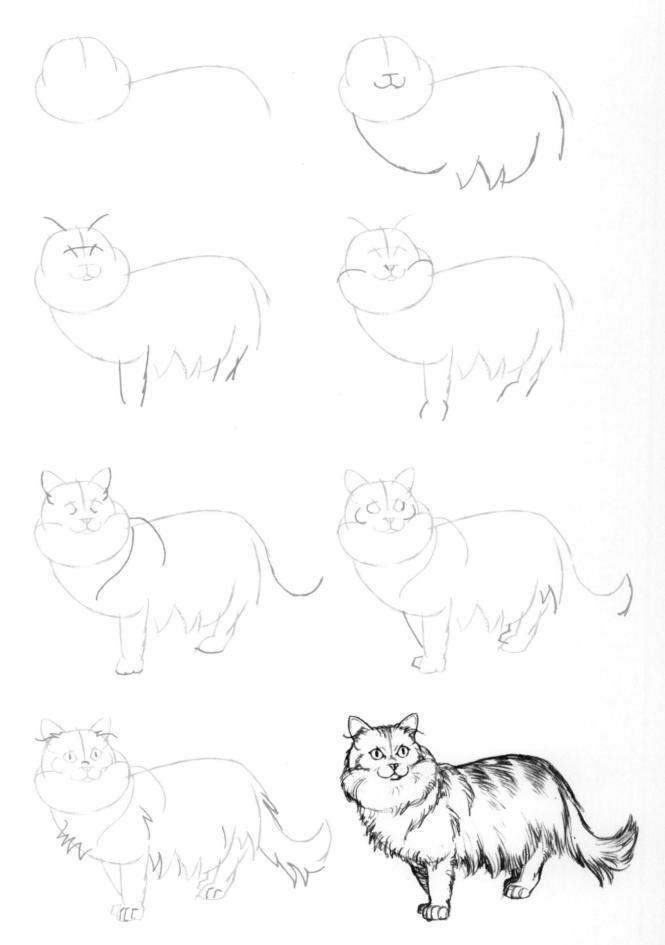

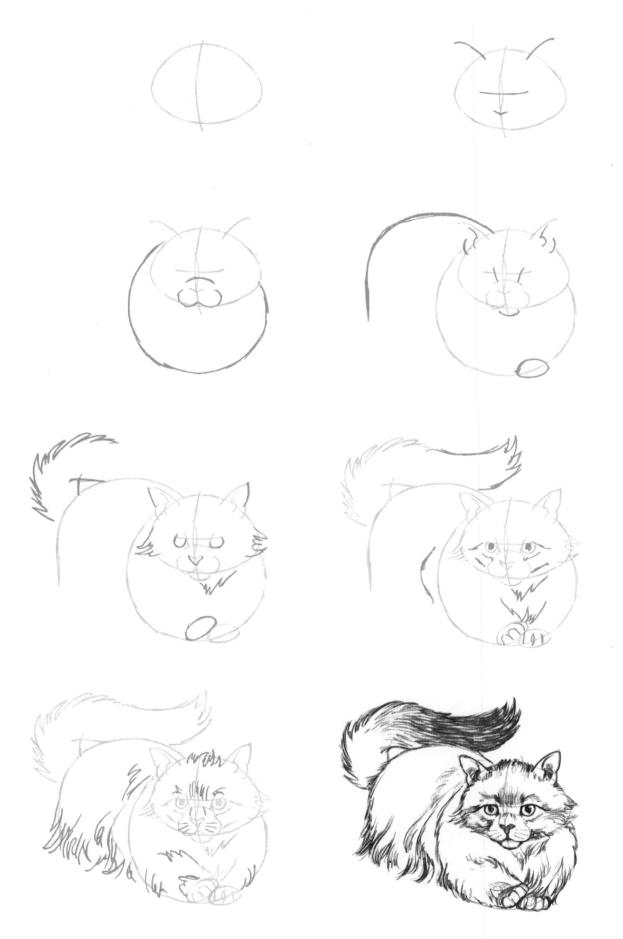

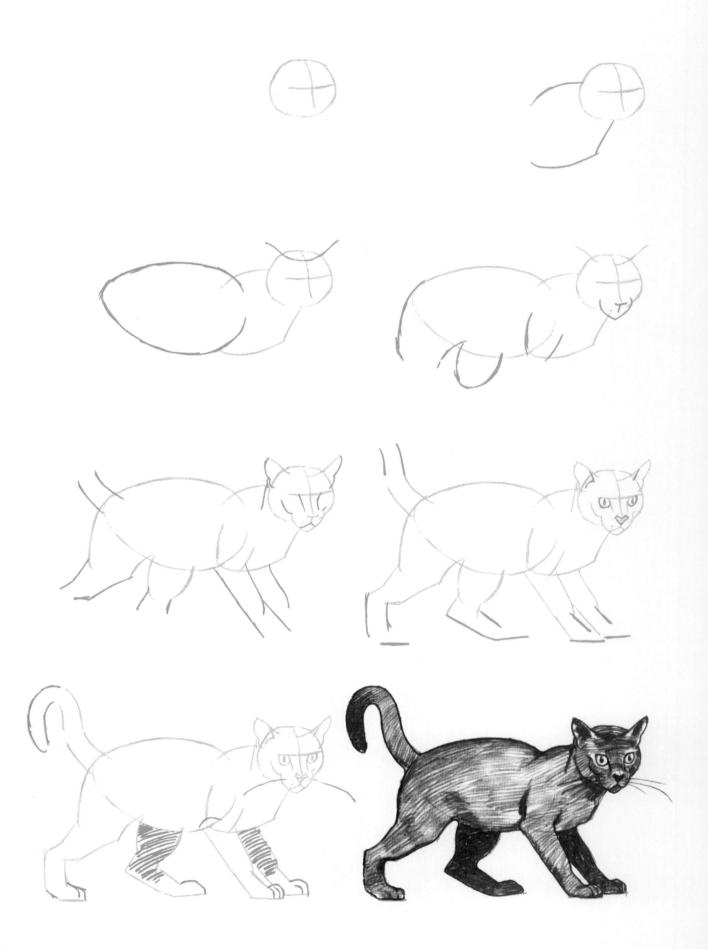

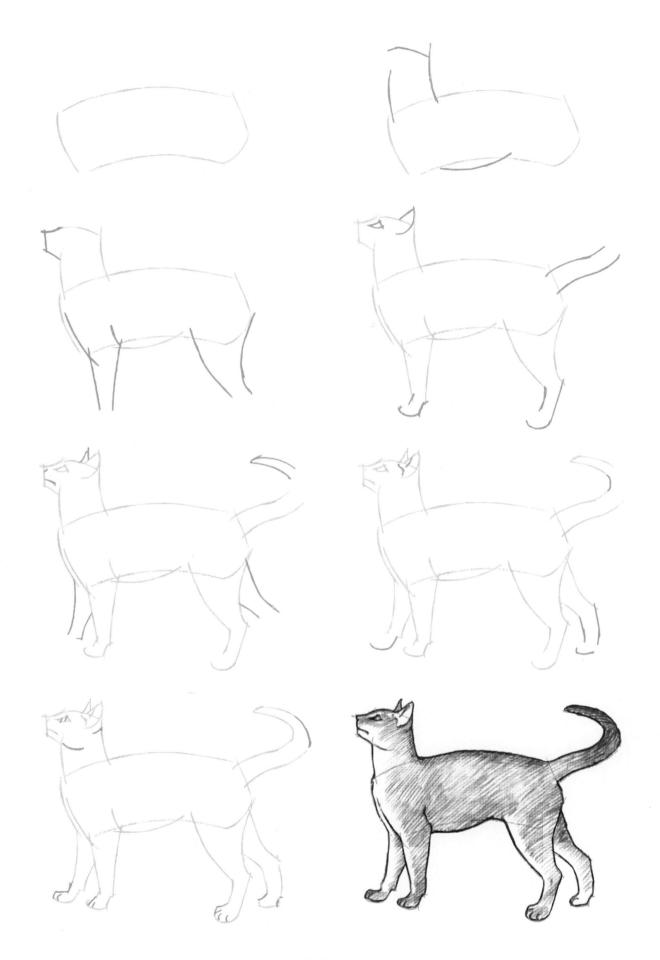

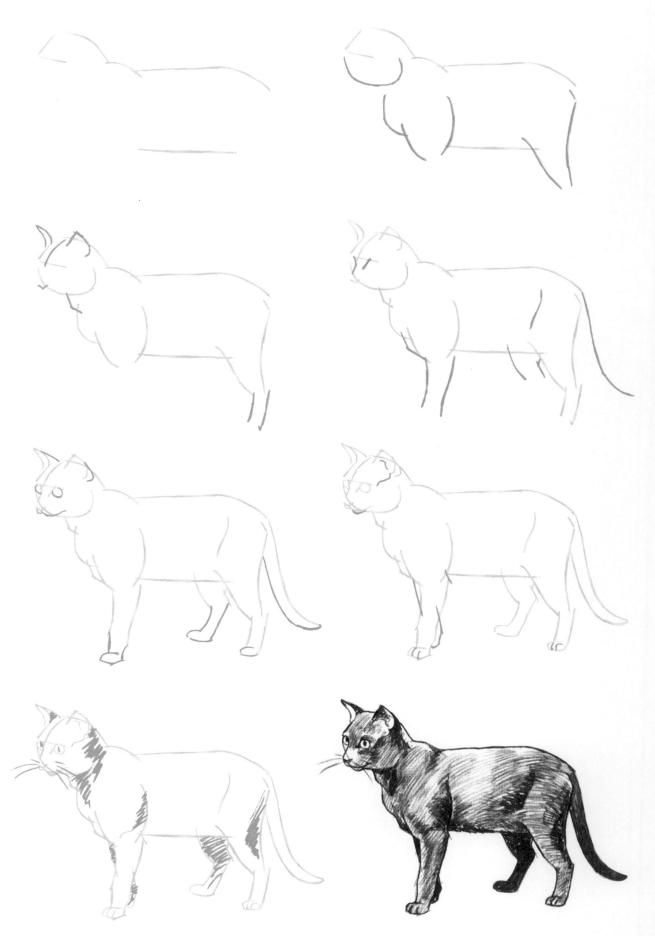

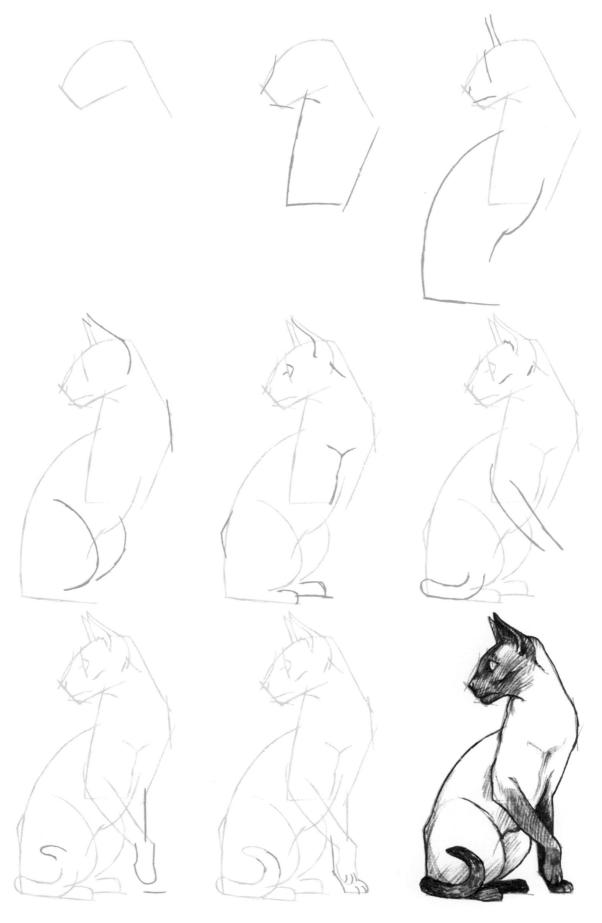

CATS

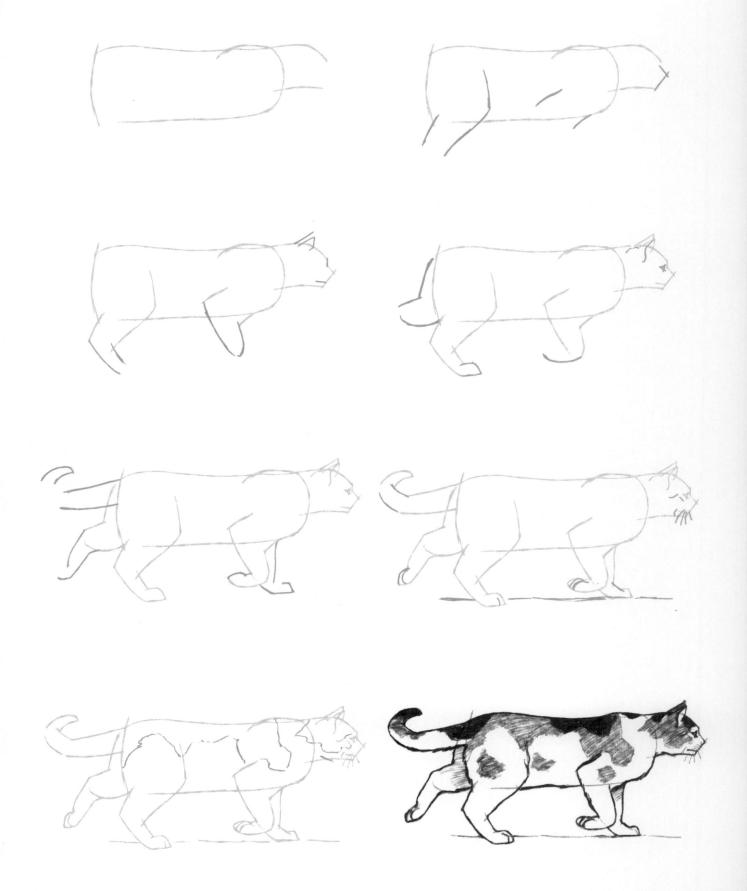

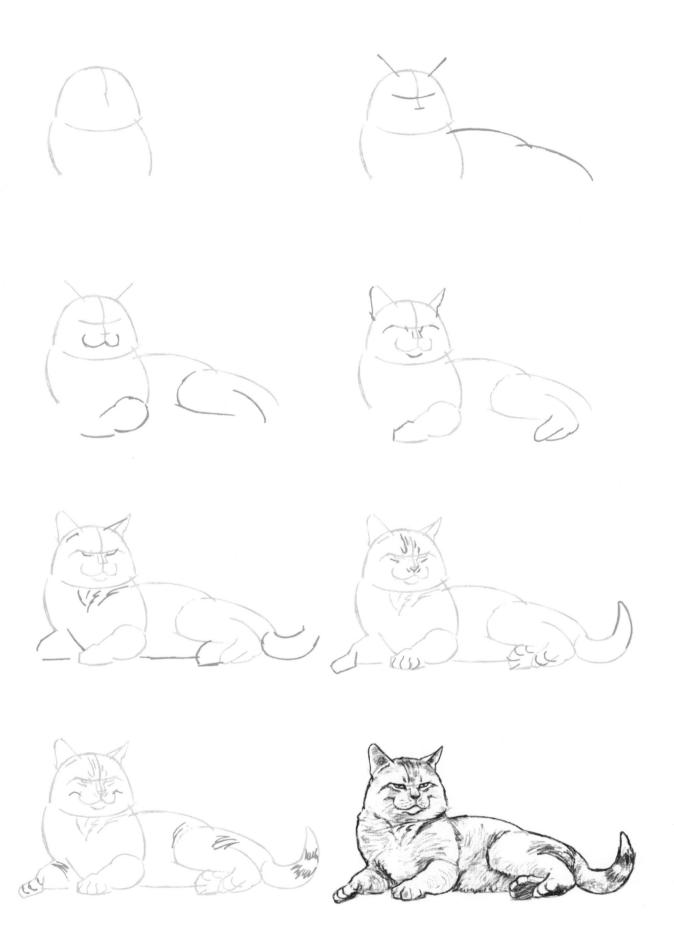

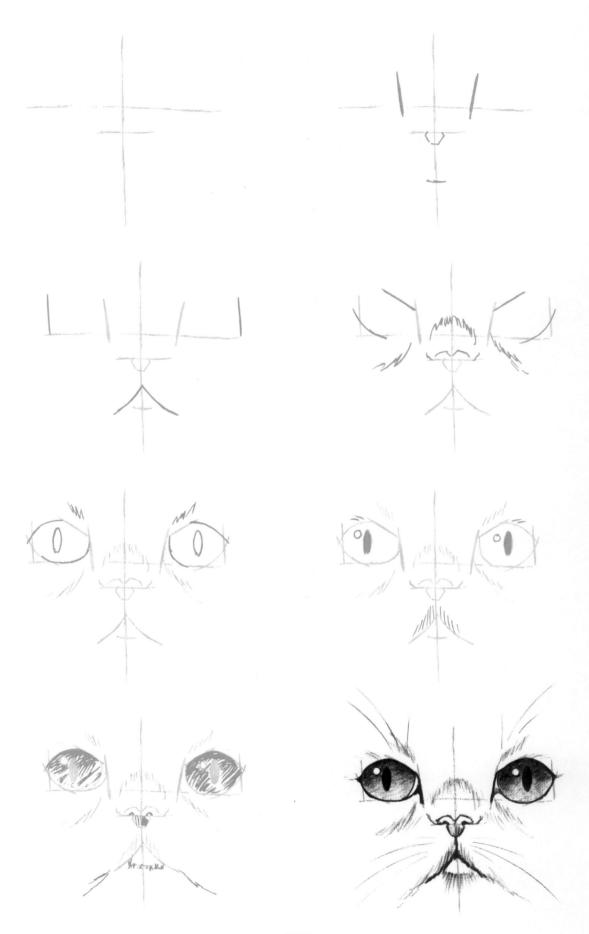

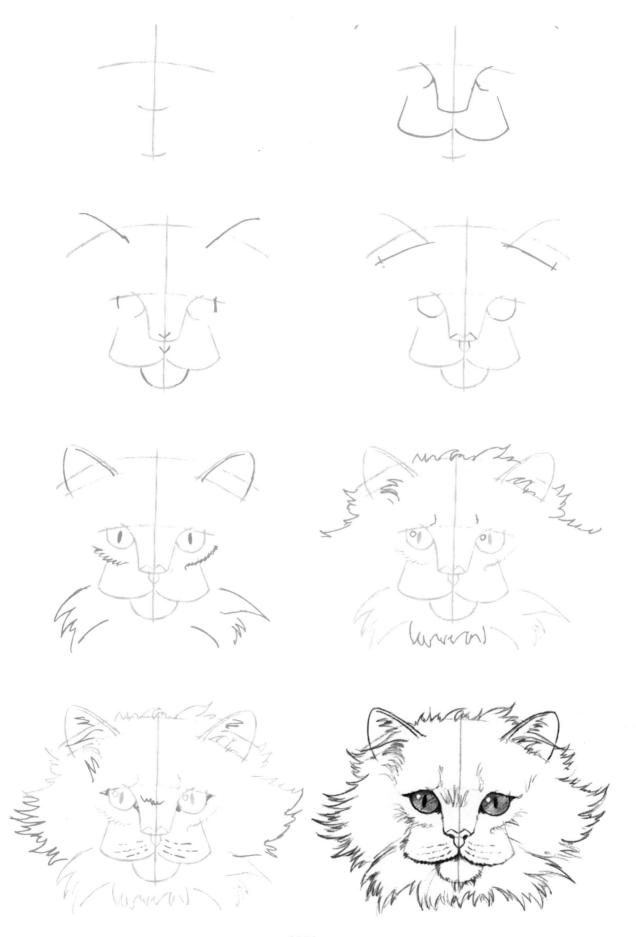

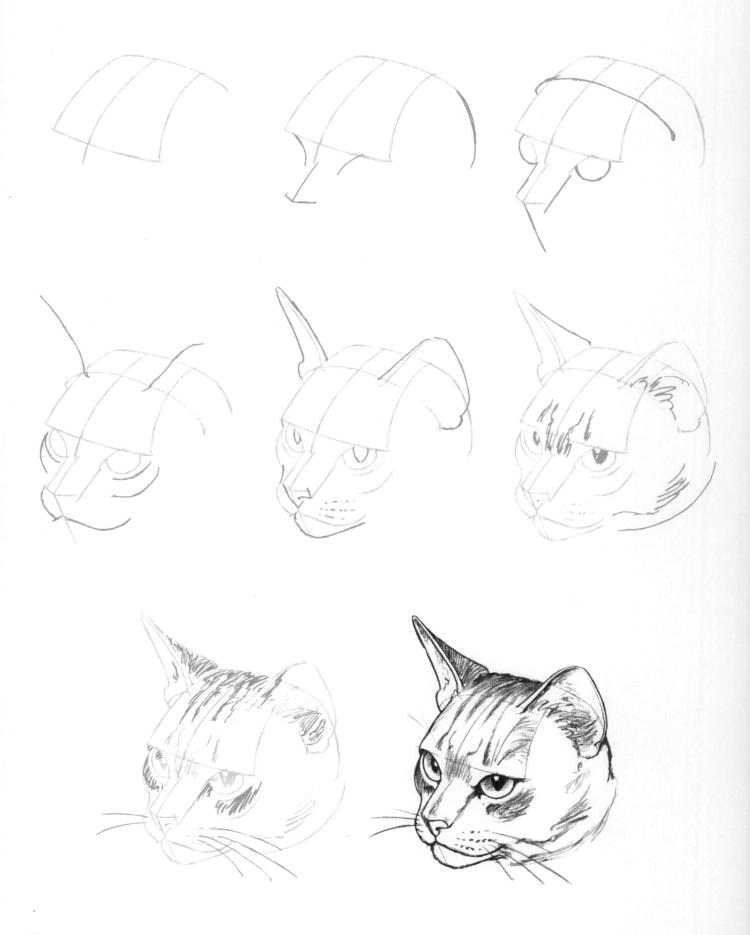

80

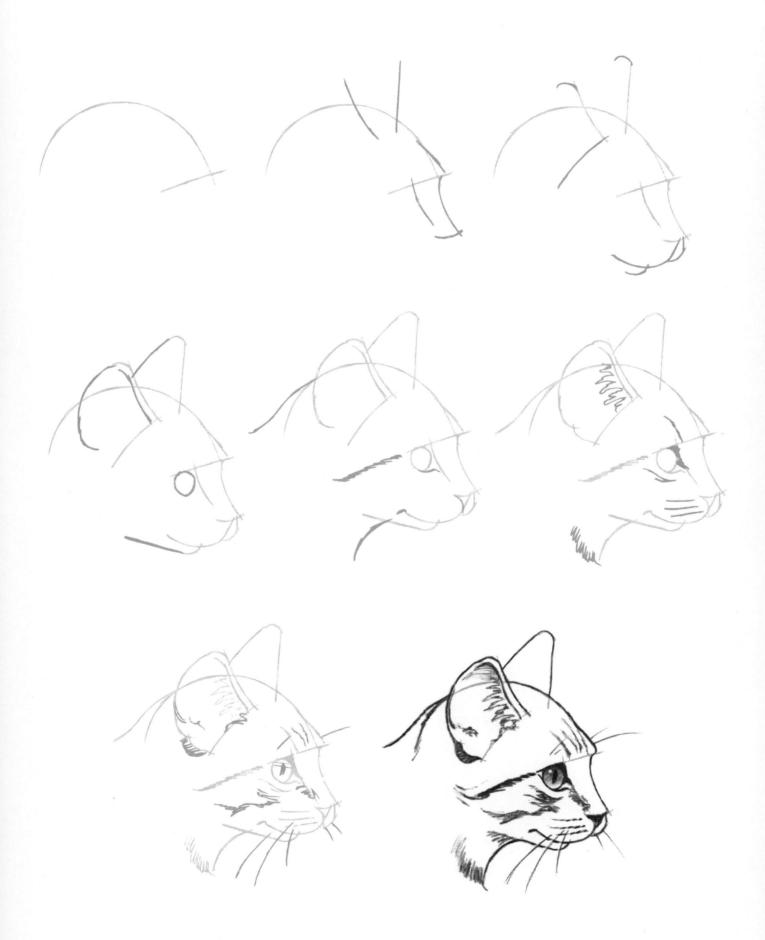

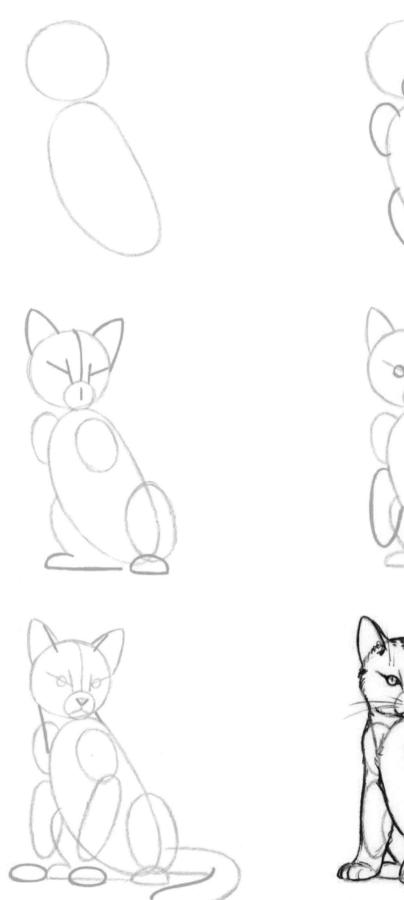

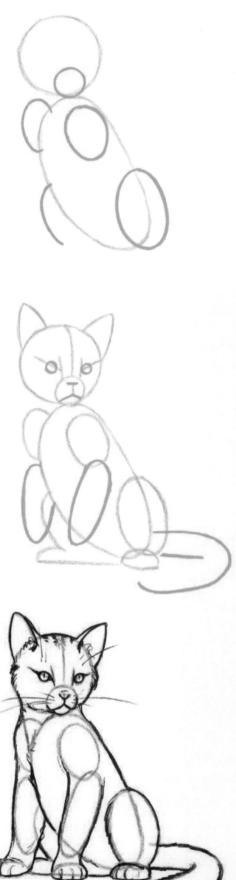

CATS

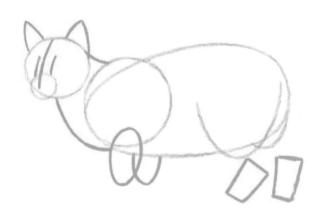

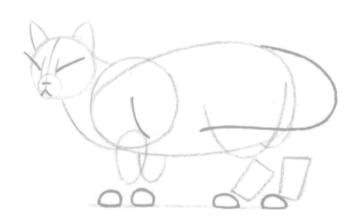

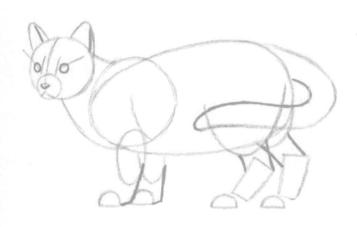

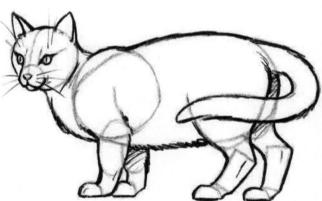

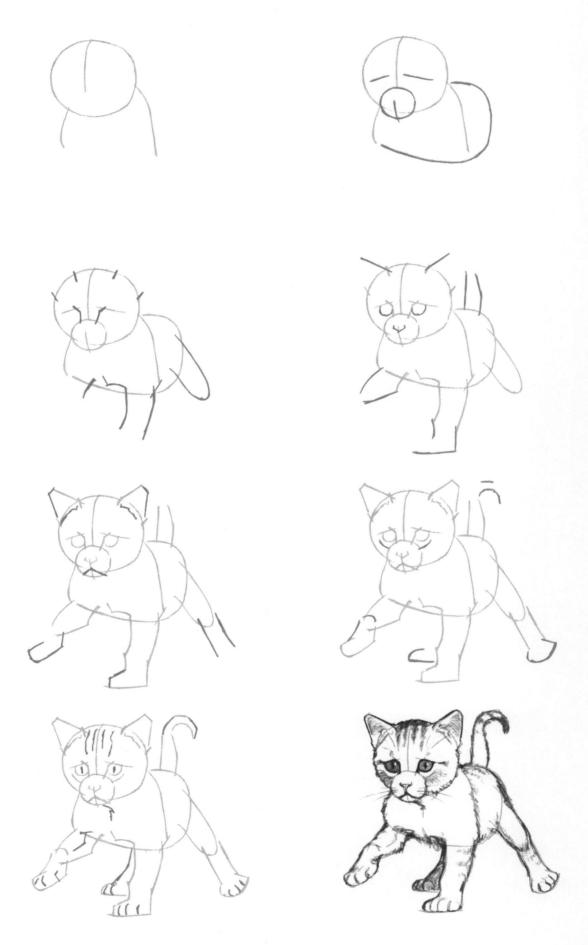

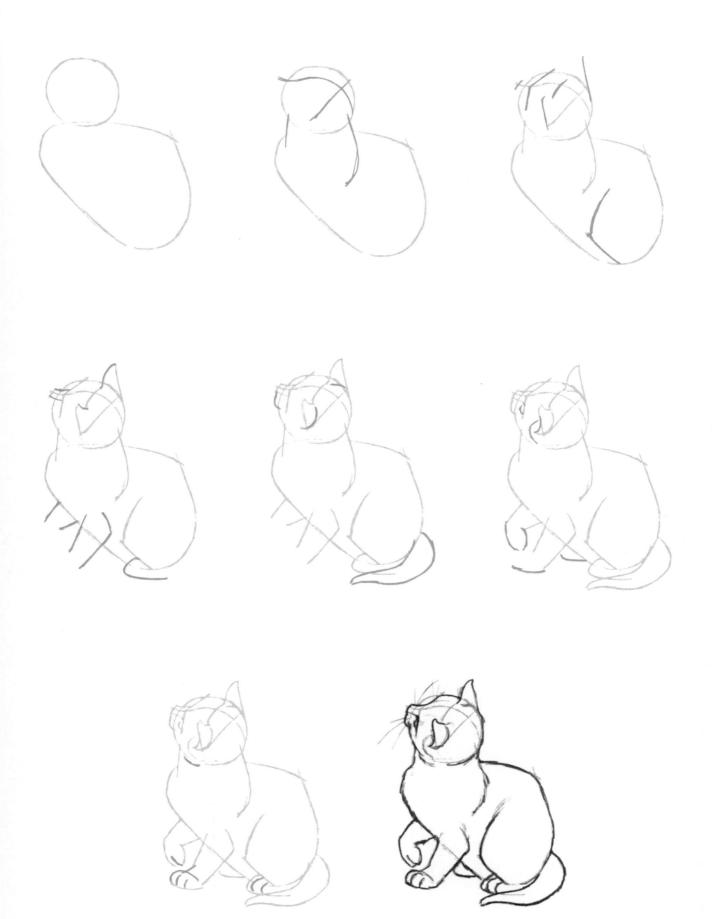

CATS

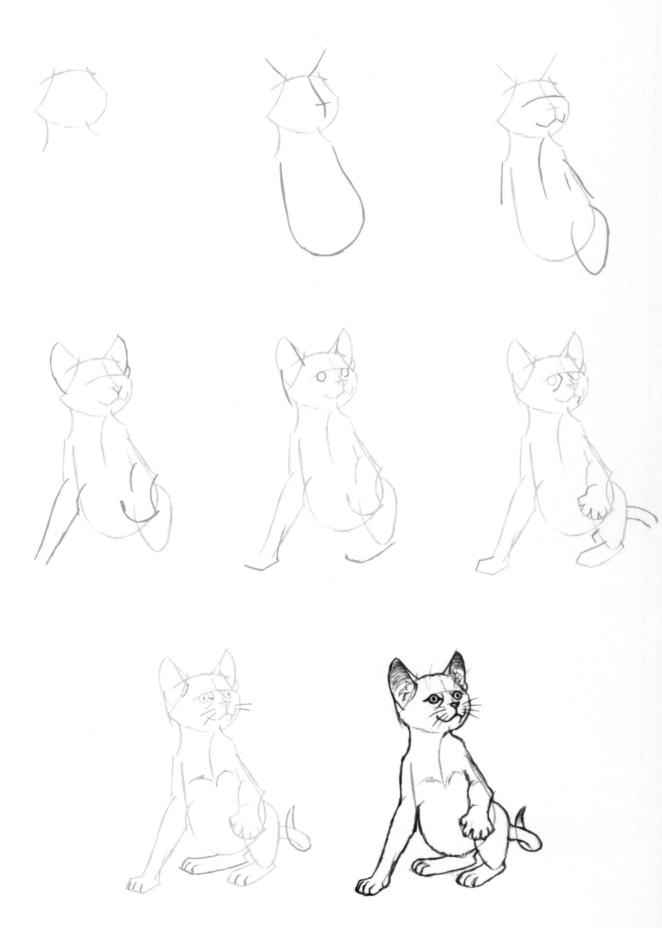

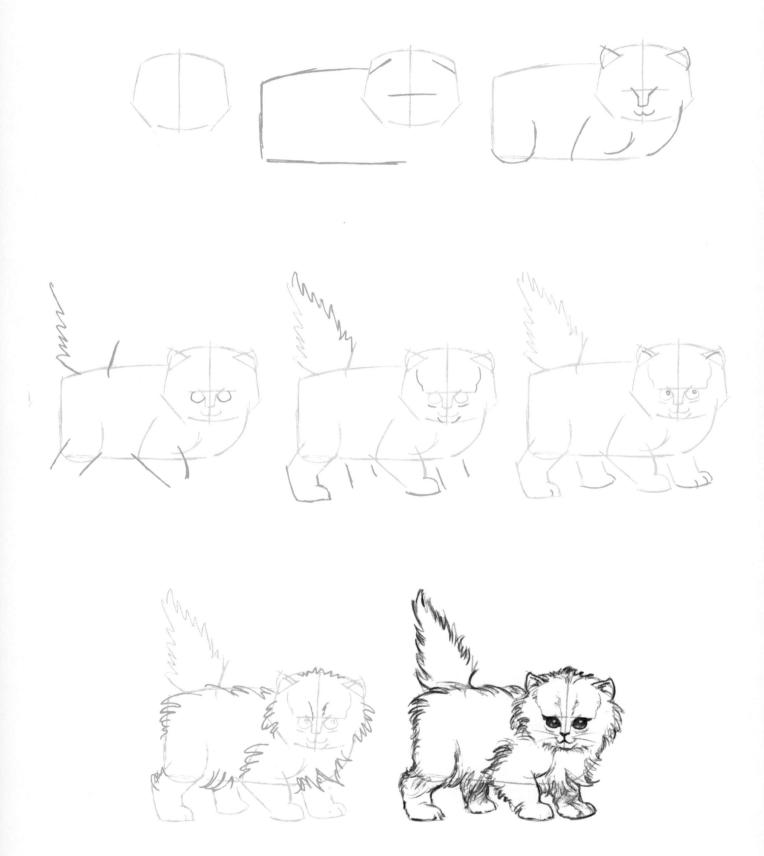

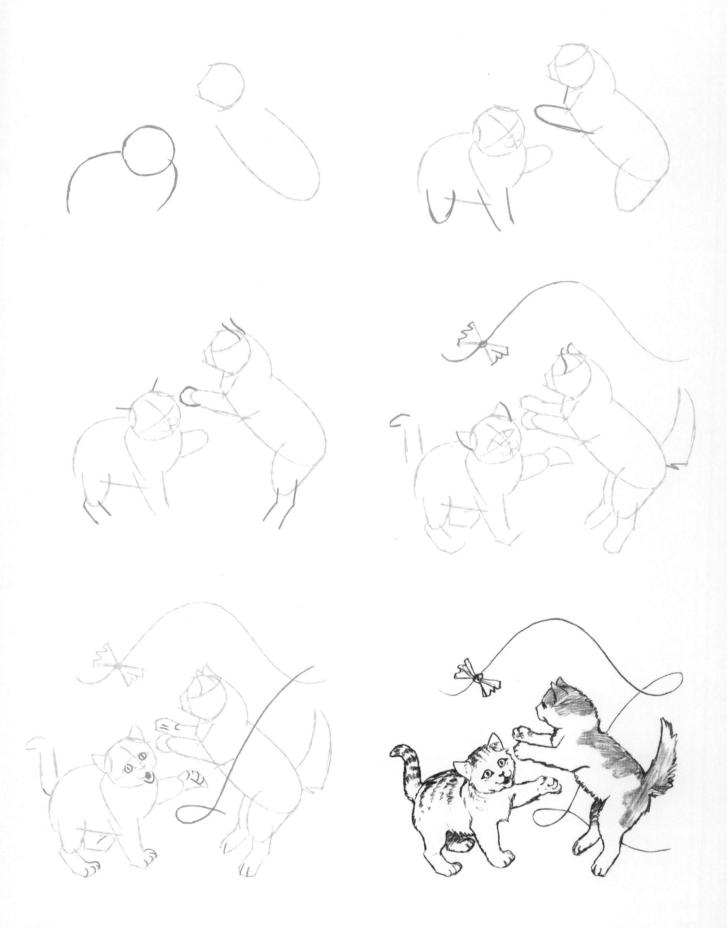

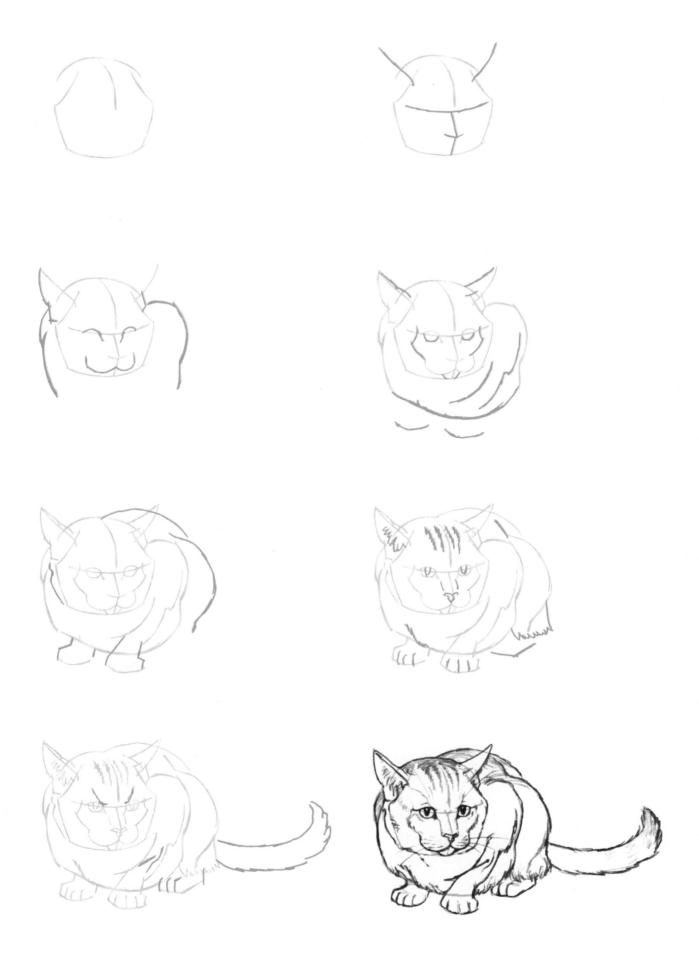

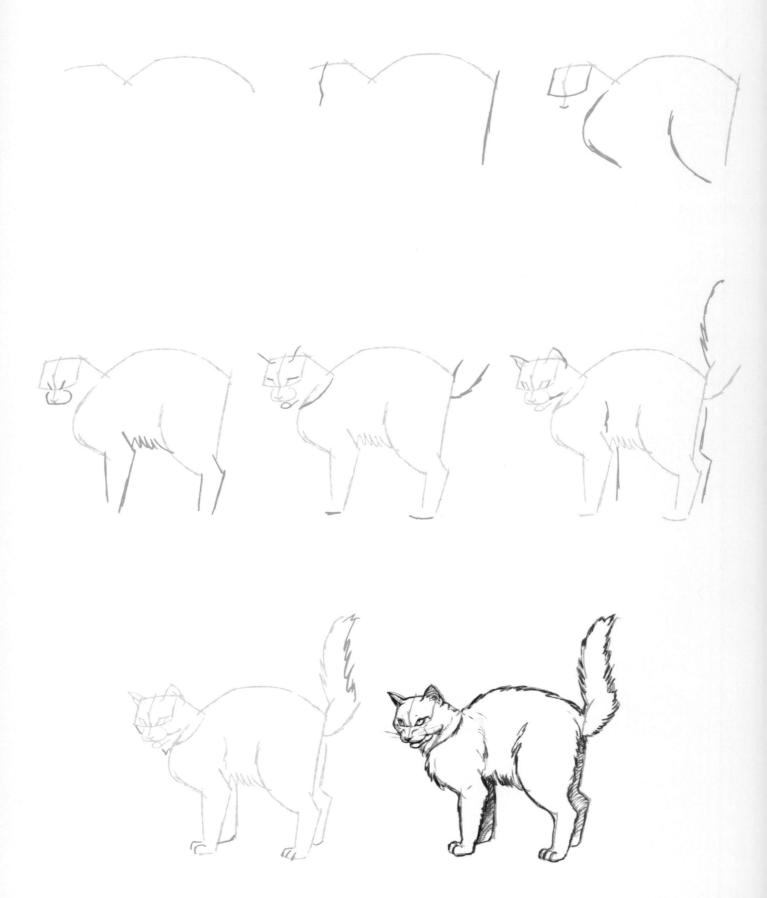

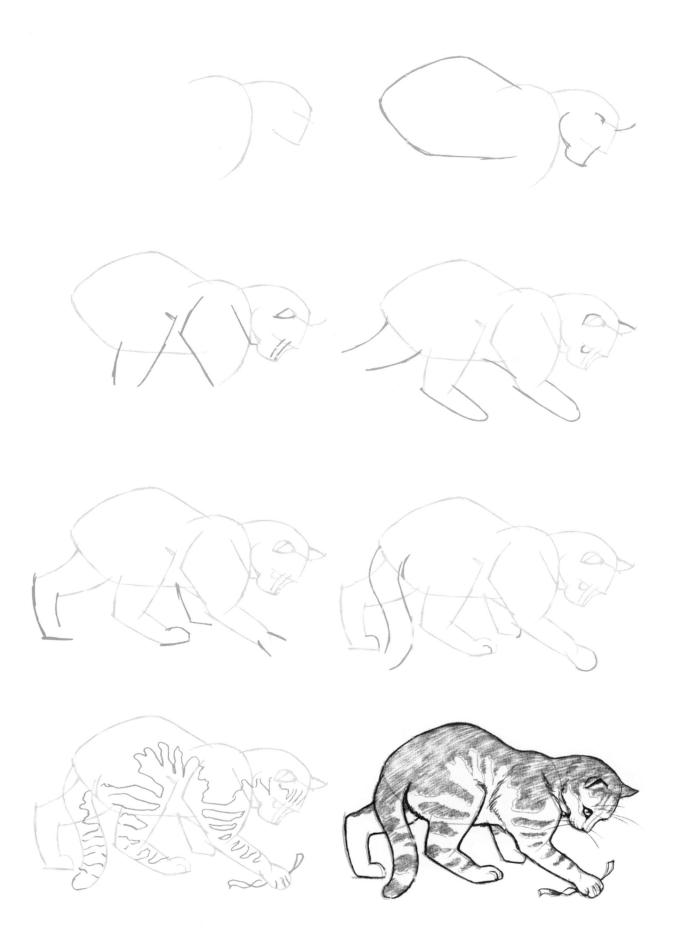

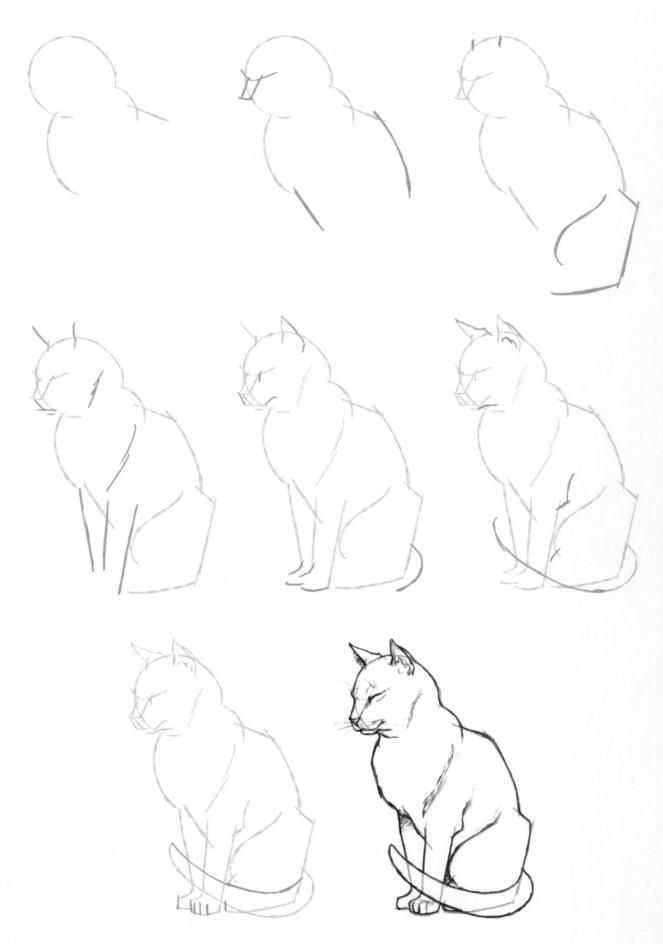

92

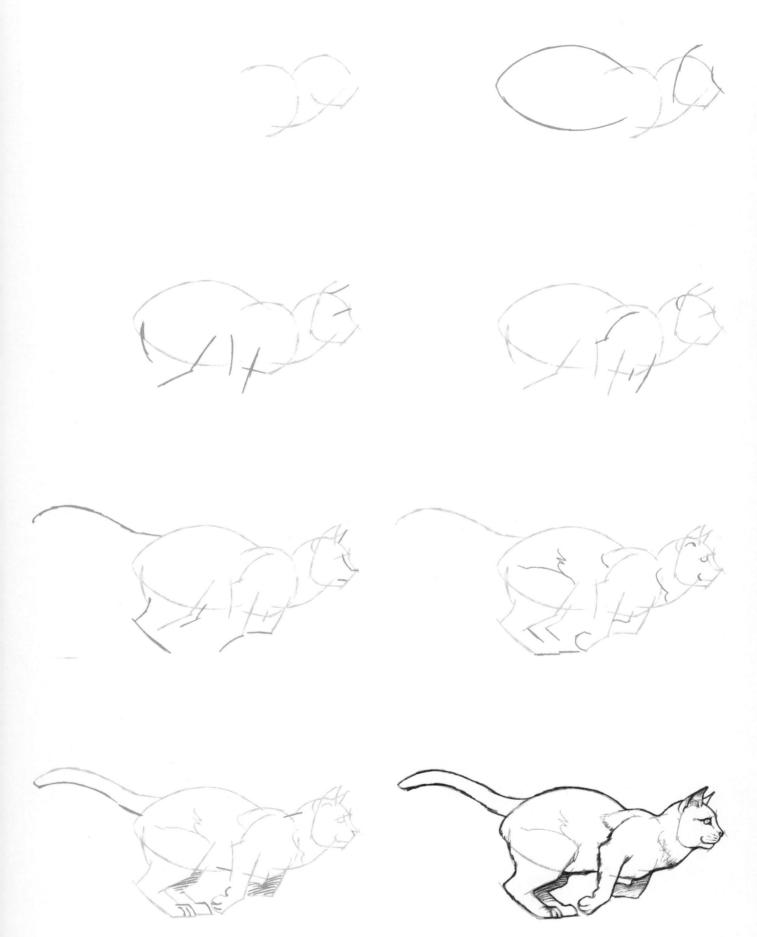

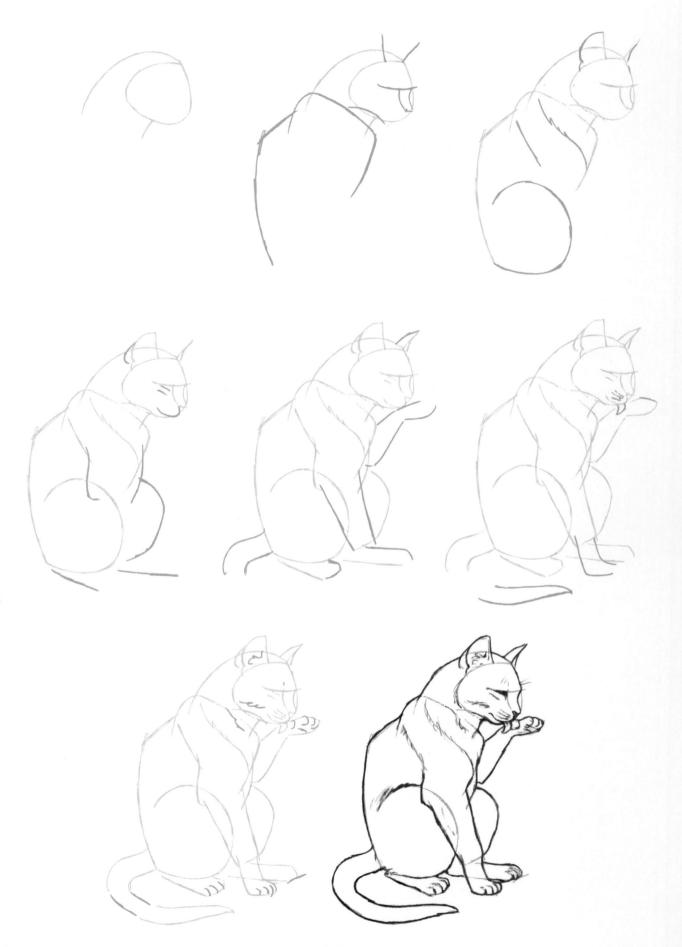

CATS

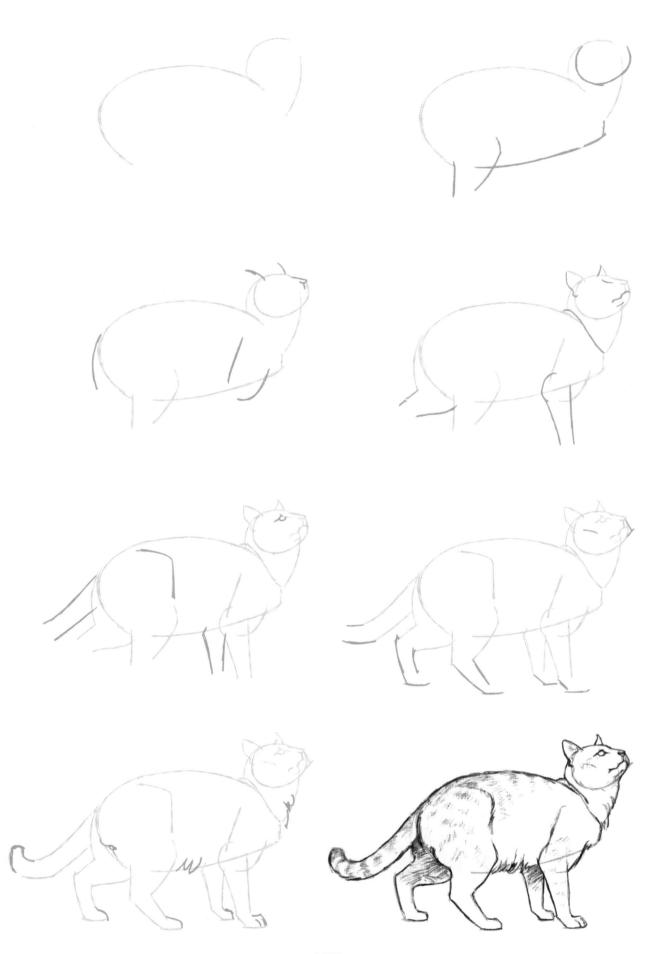

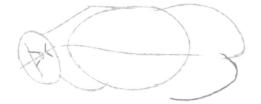

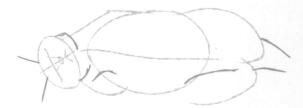

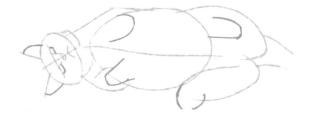

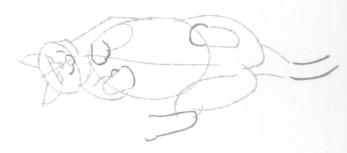

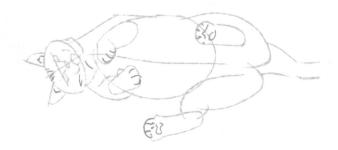

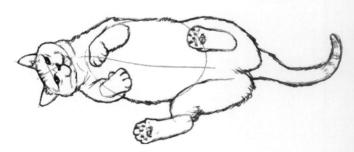

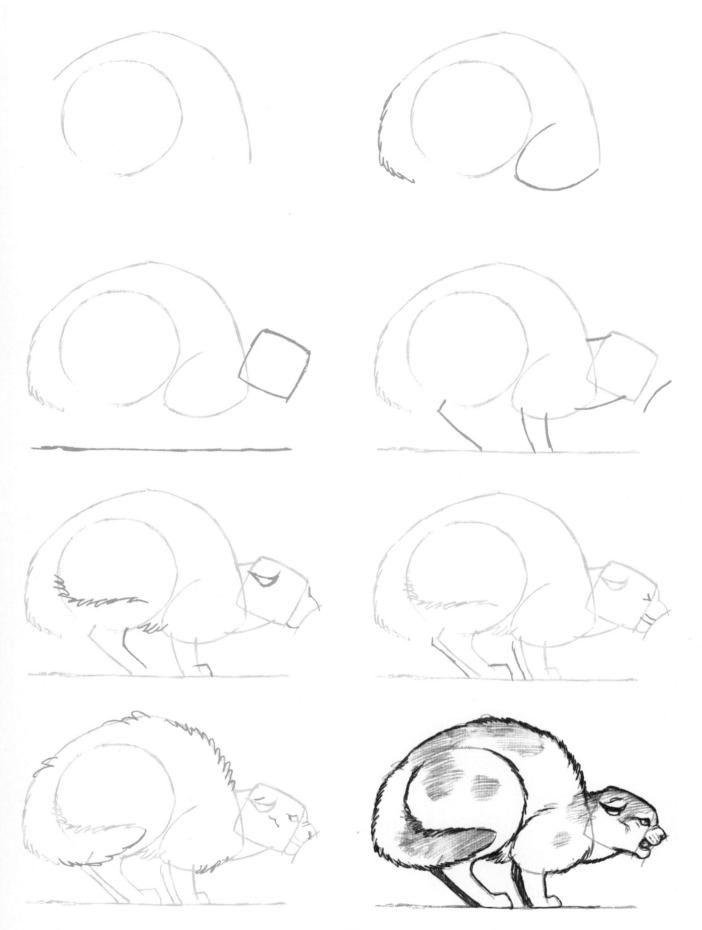

CATS

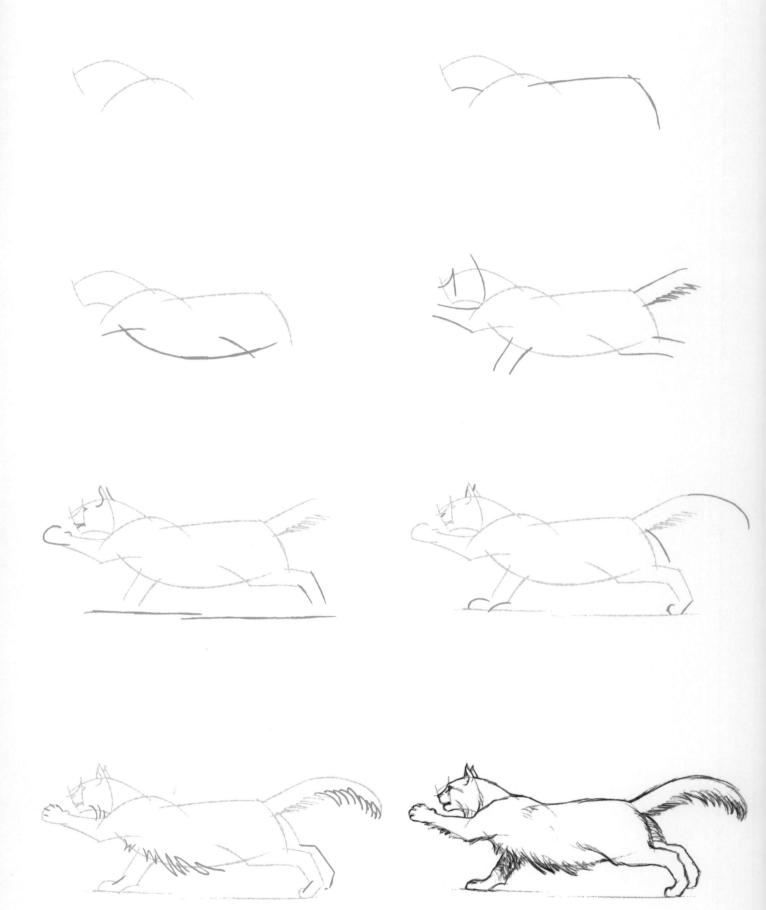

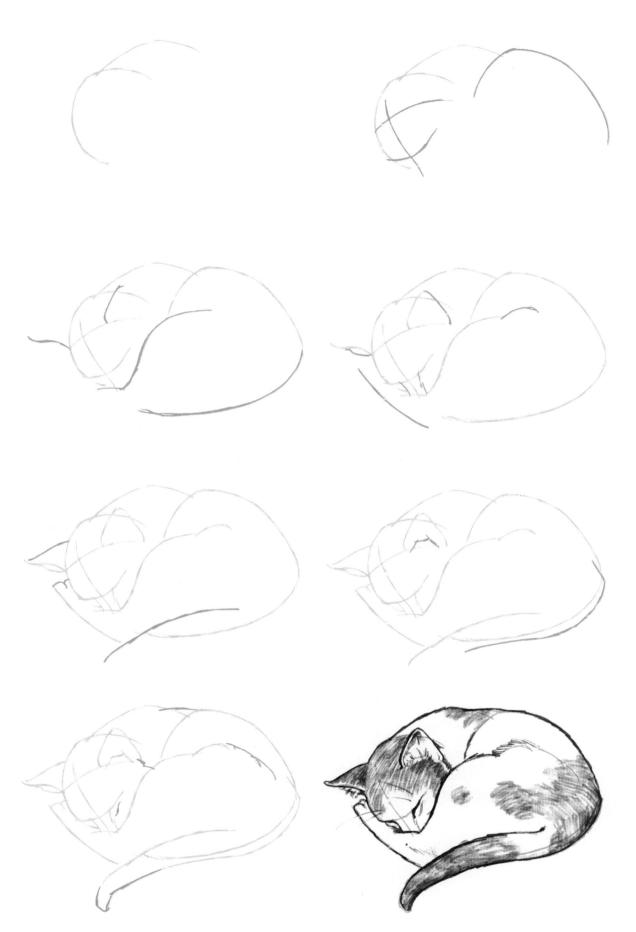

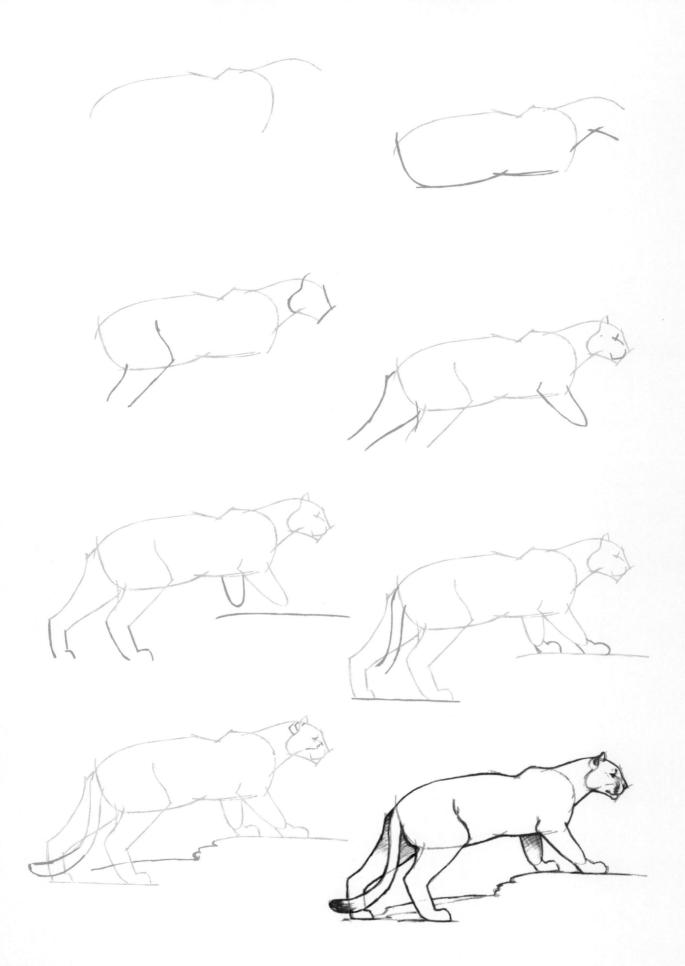

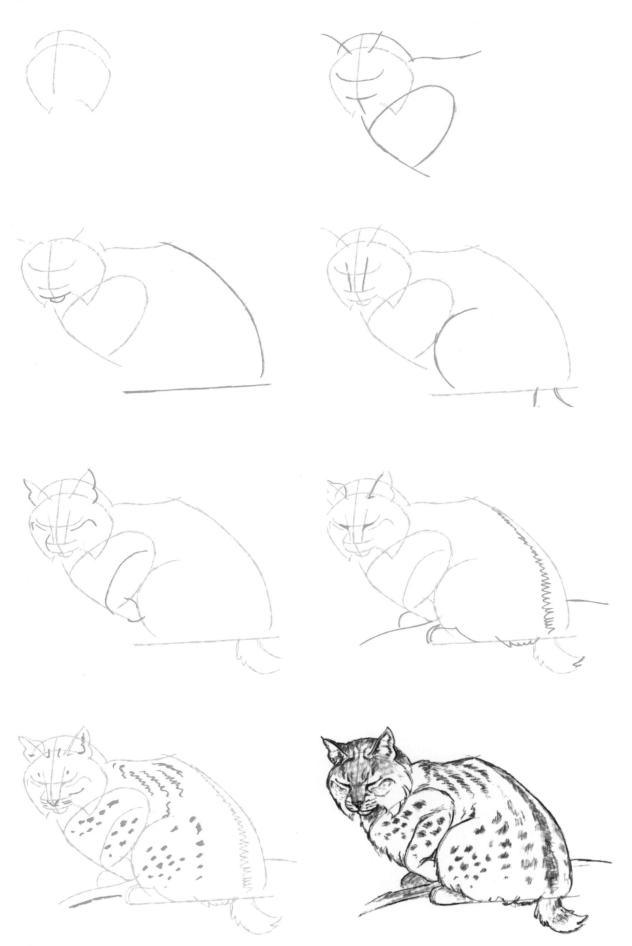

CATS

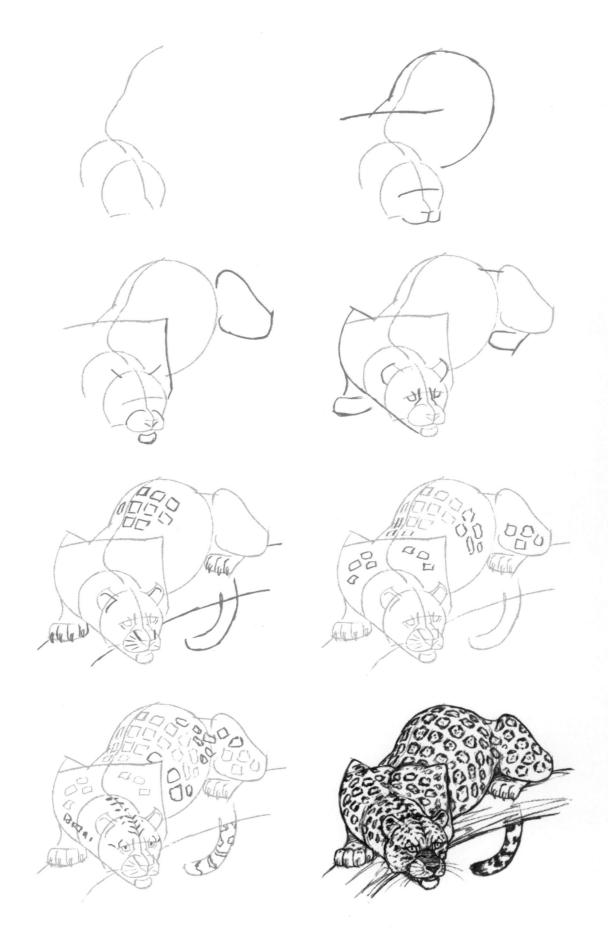

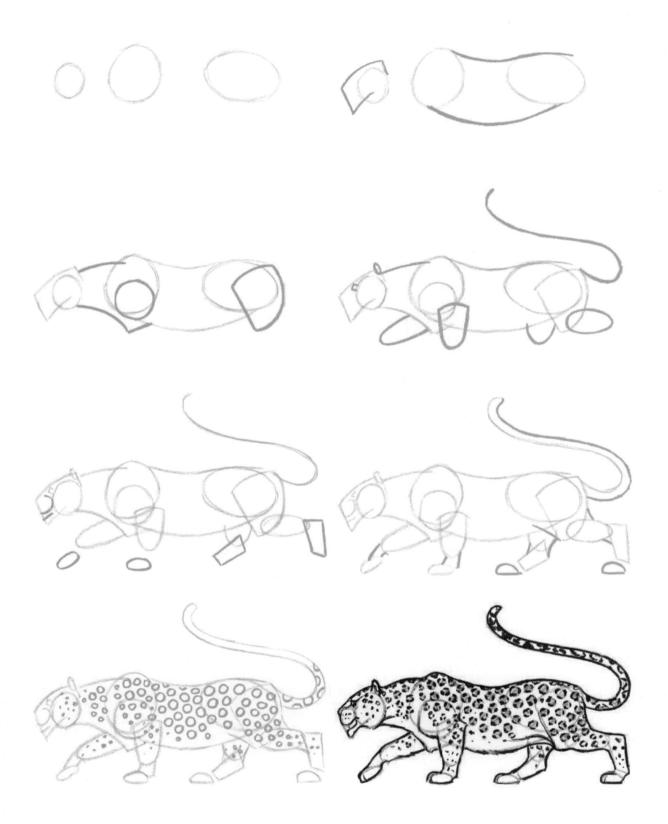

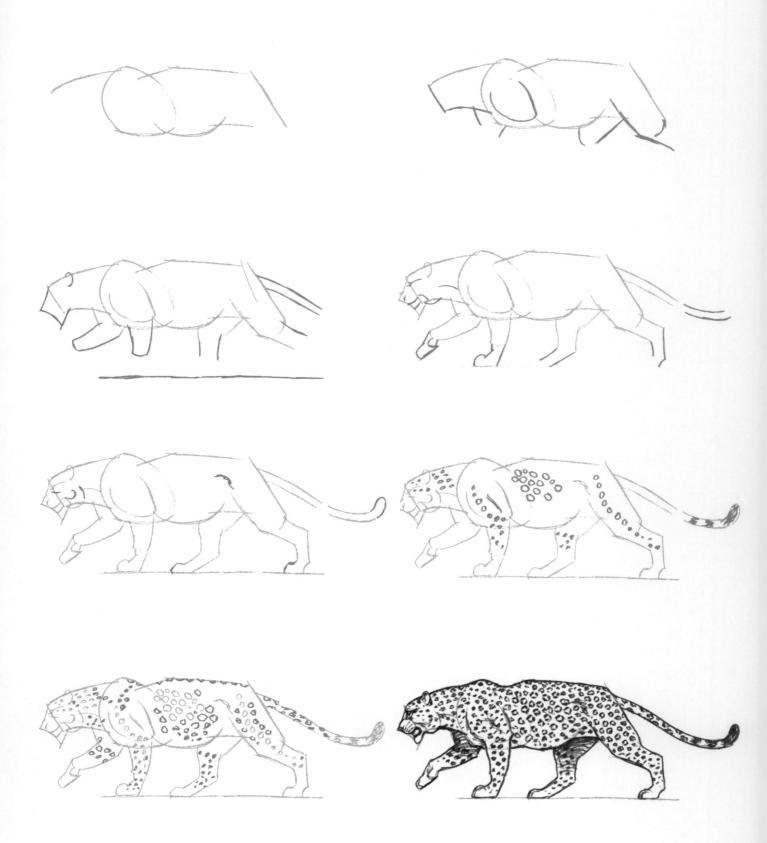

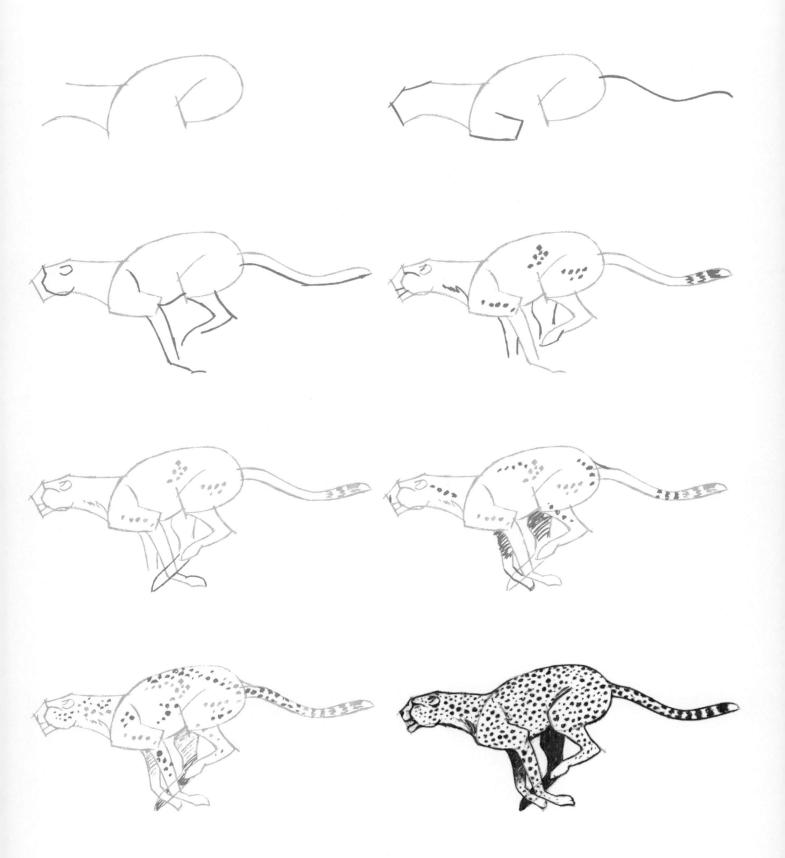

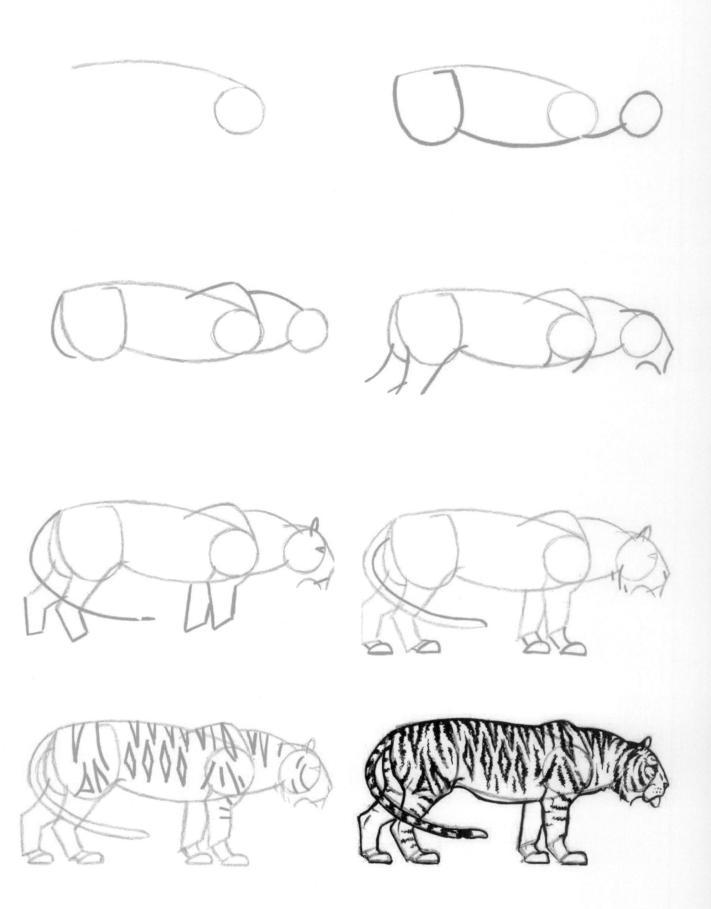

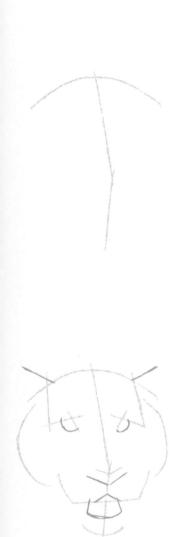

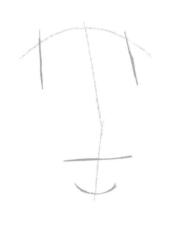

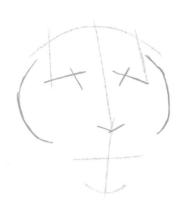

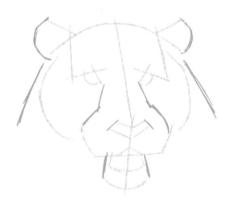

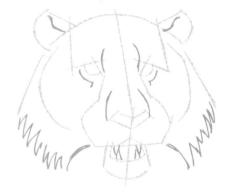

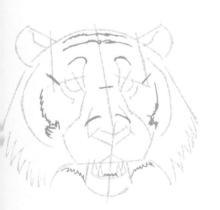

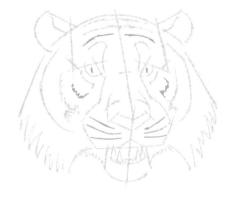

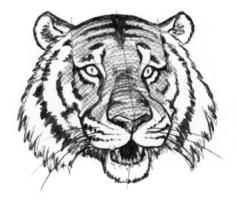

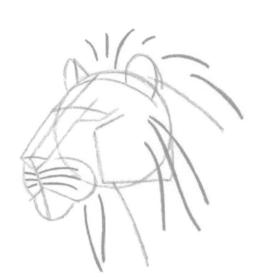

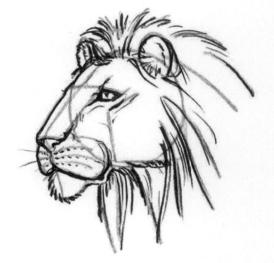

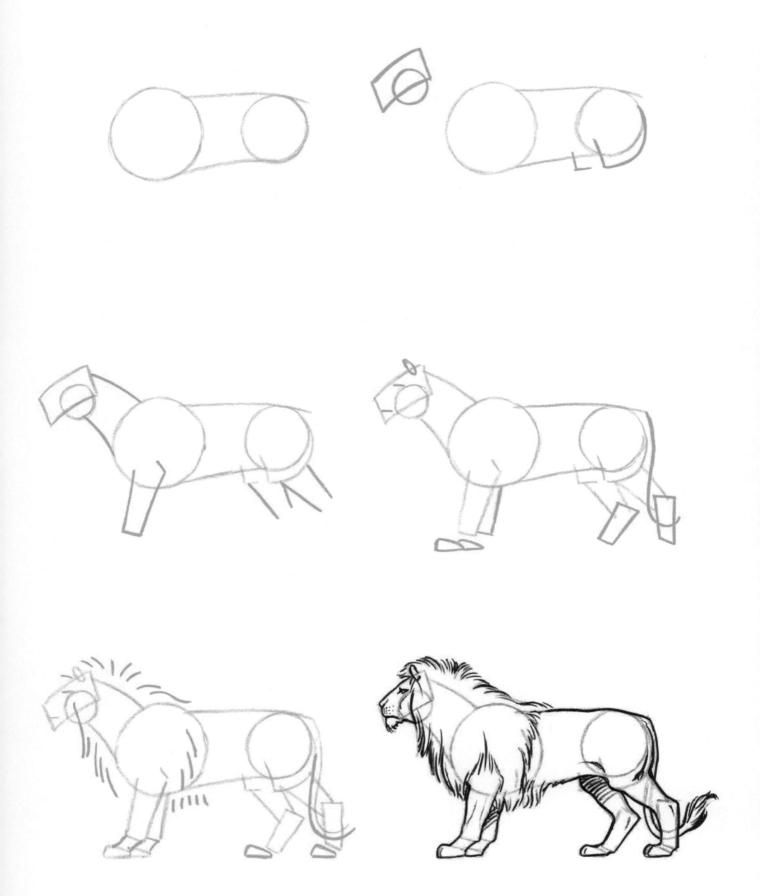

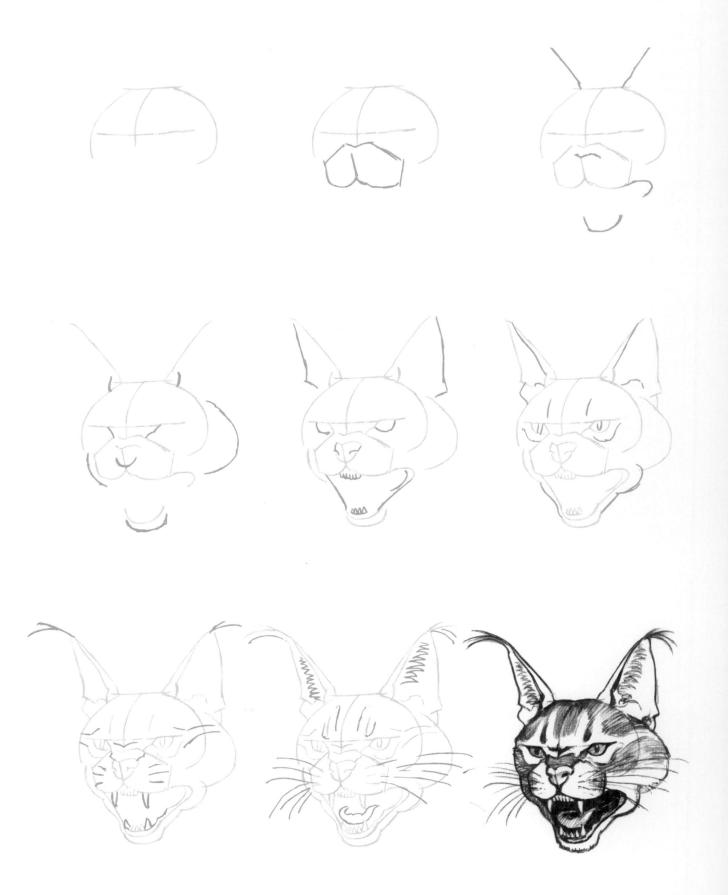

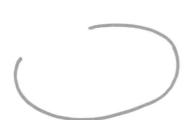

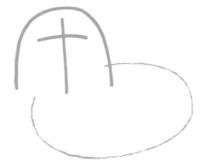

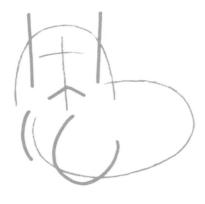

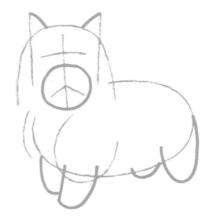

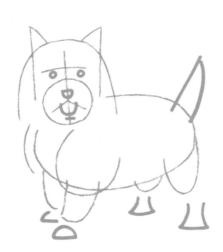

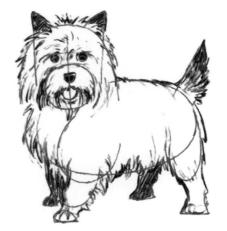

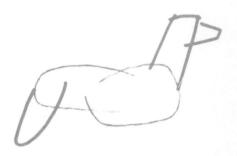

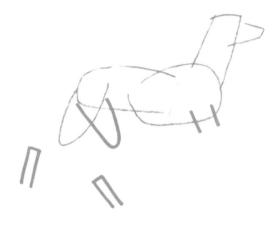

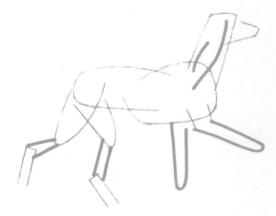

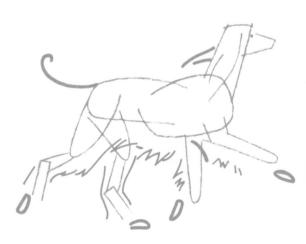

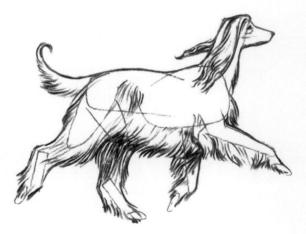

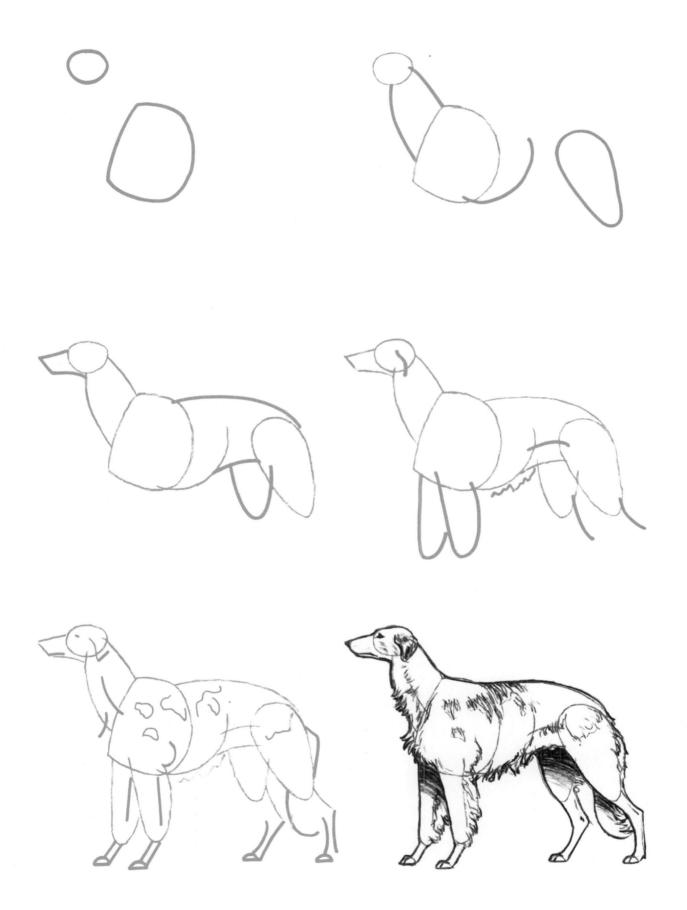

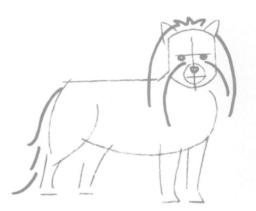

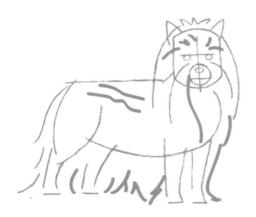

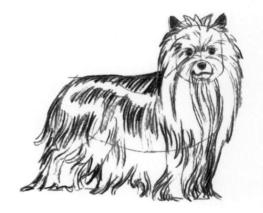

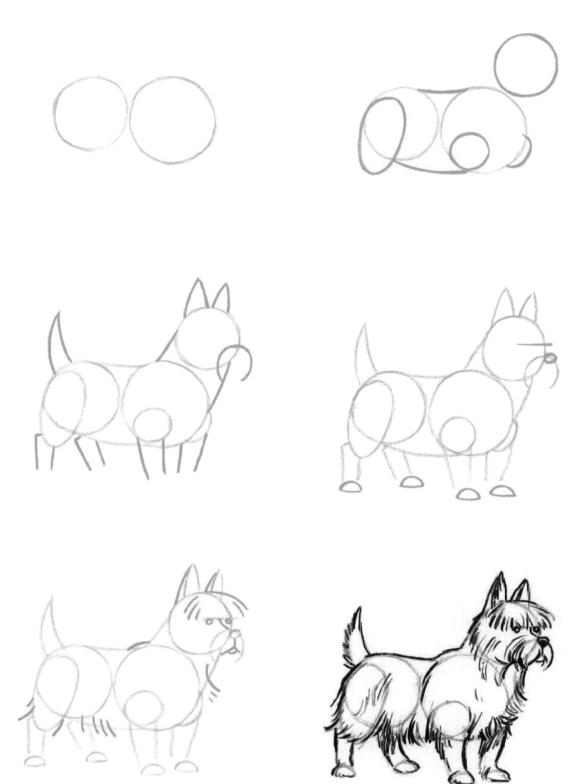

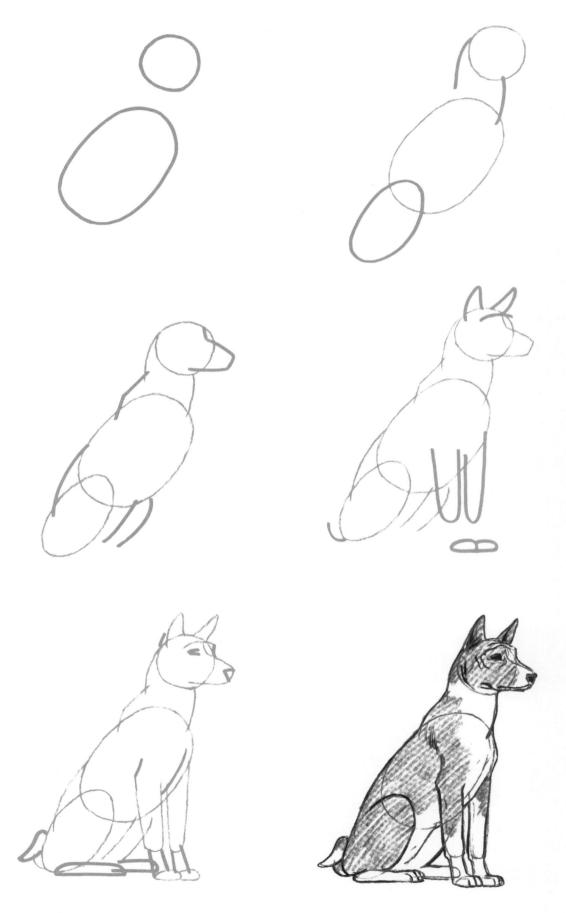

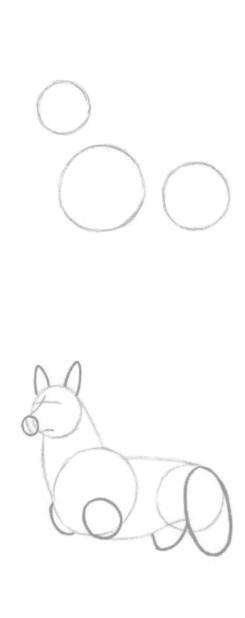

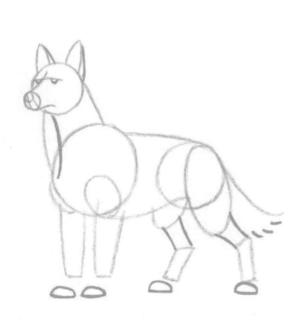

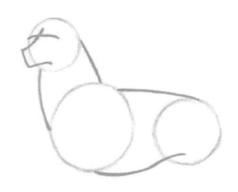

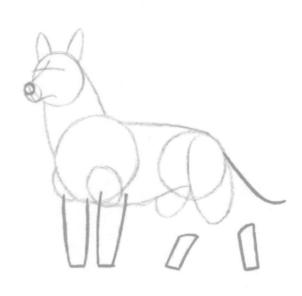

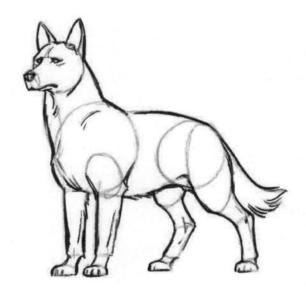

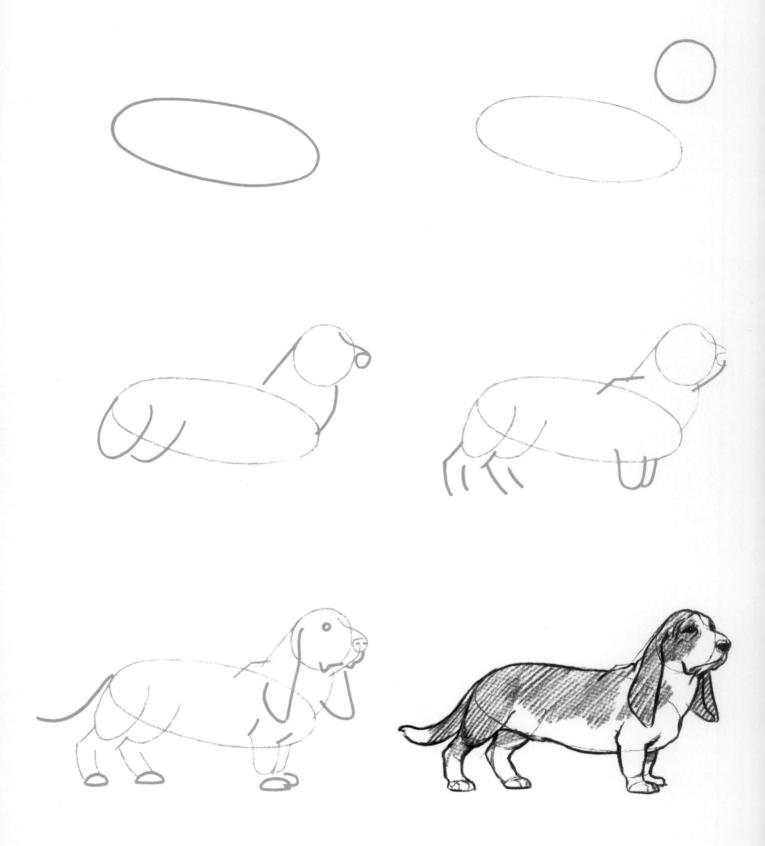

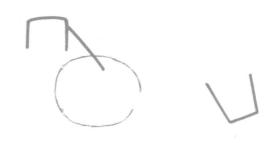

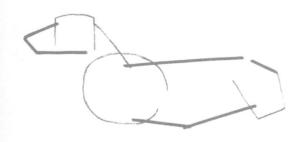

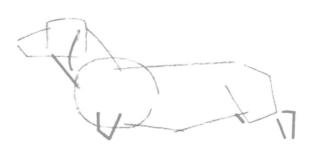

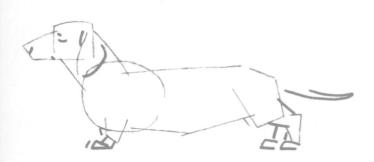

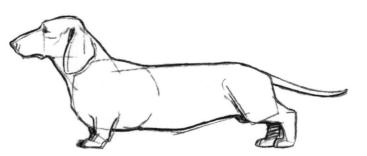

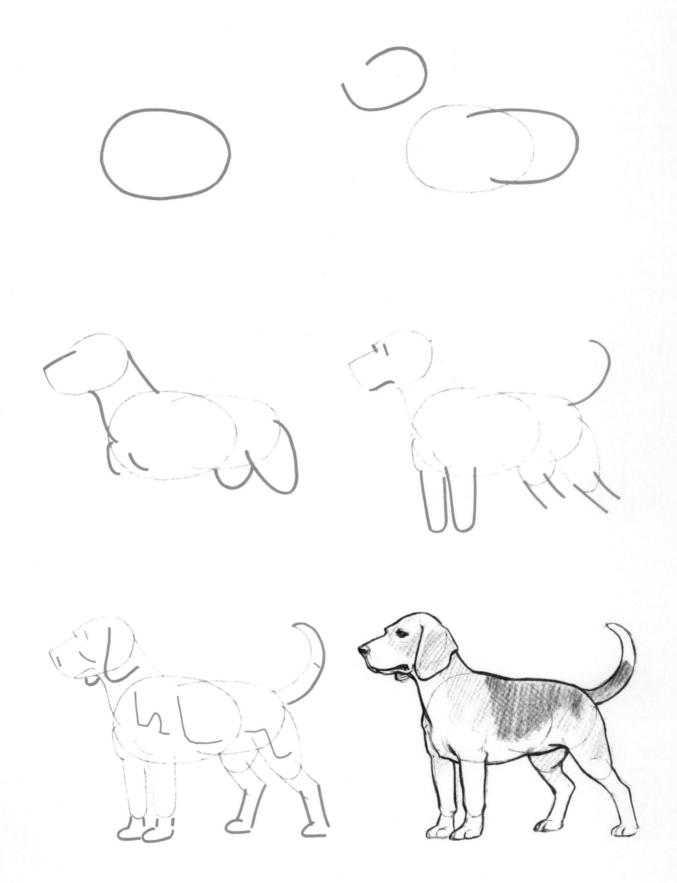

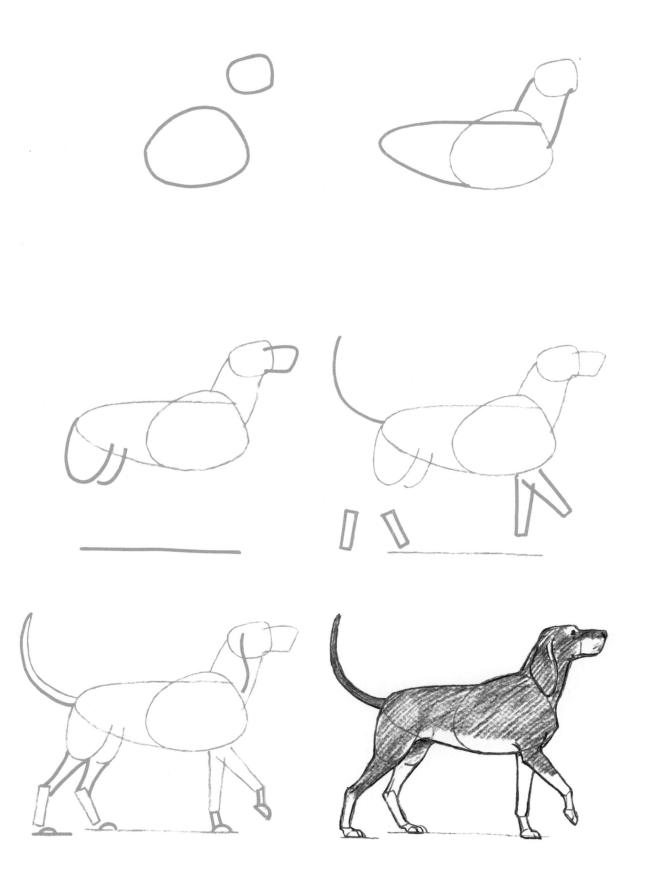

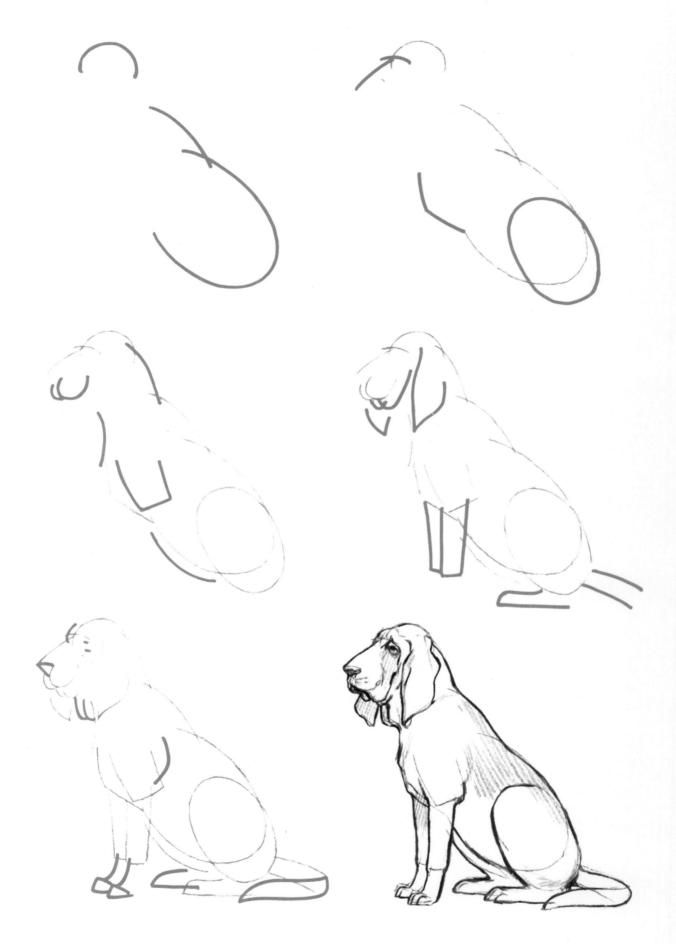

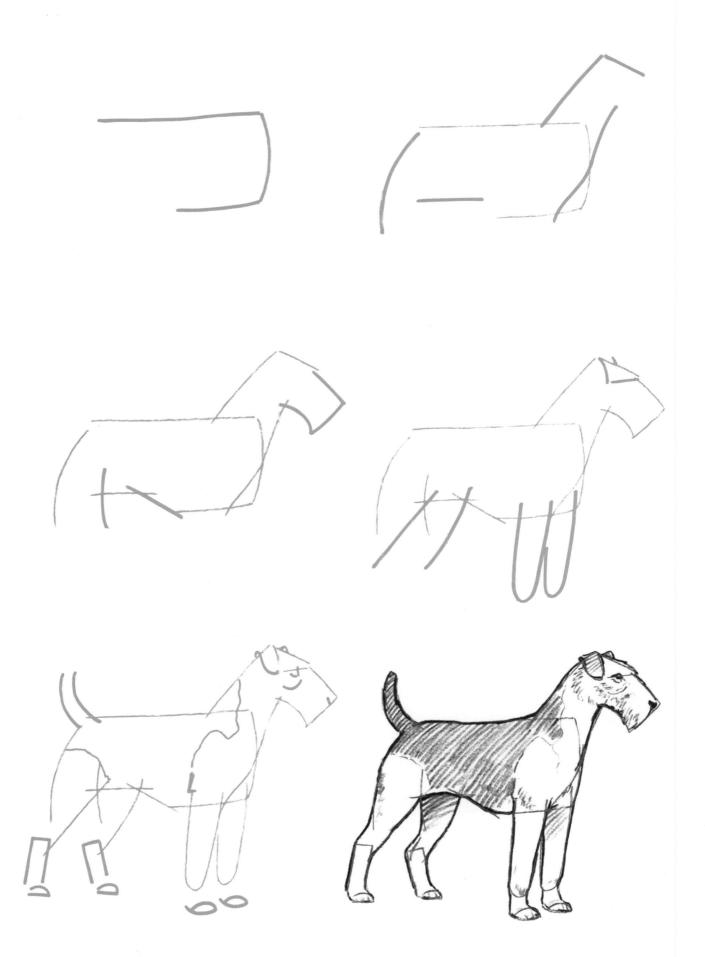

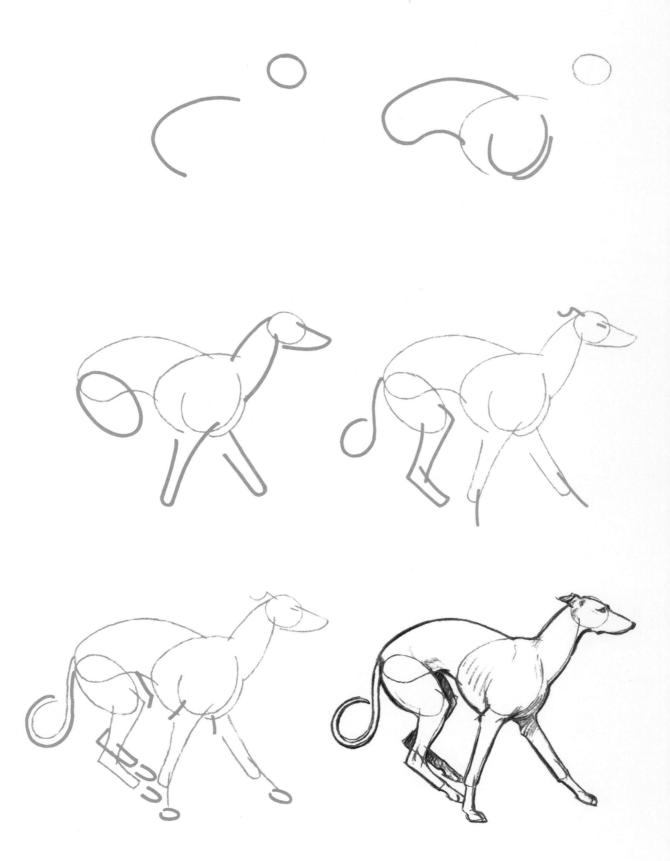

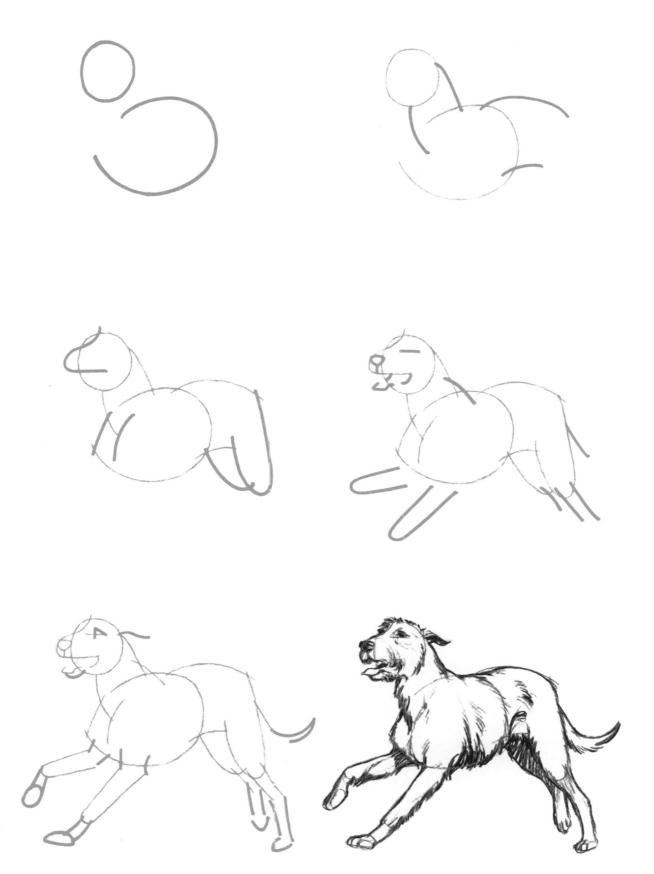

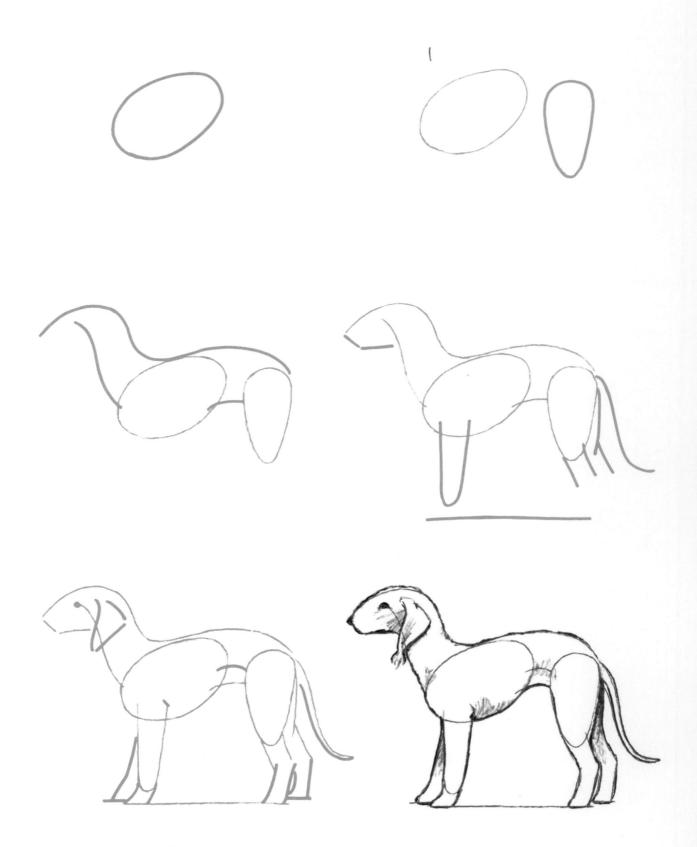

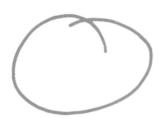

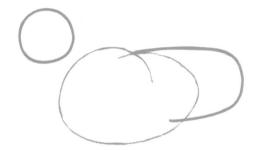

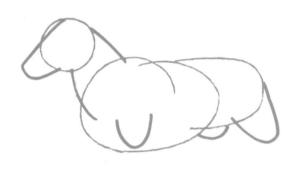

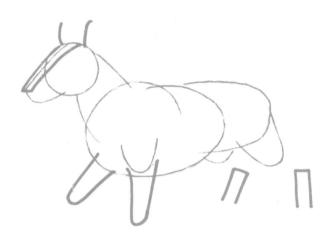

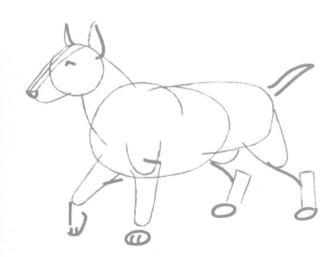

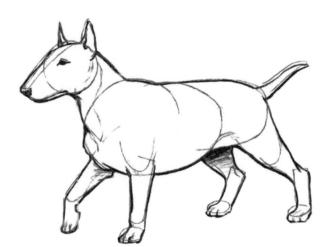

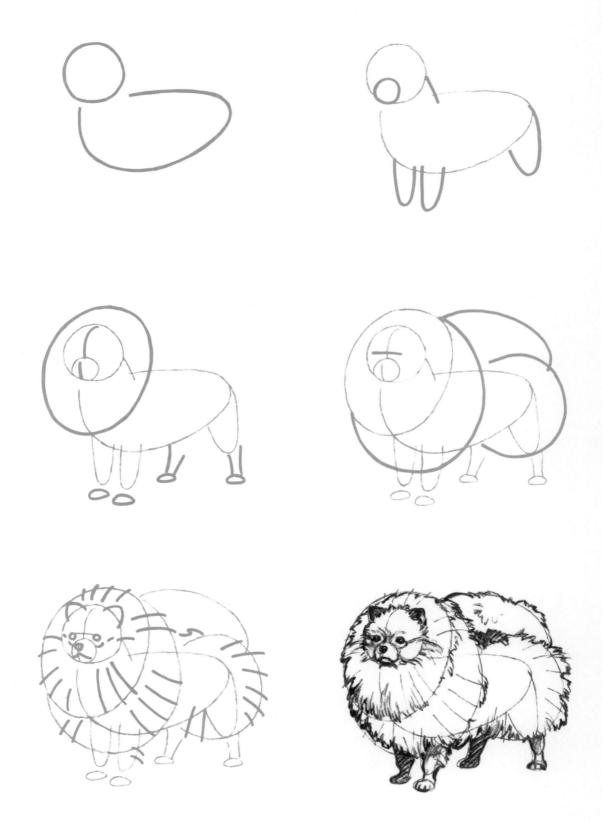

128

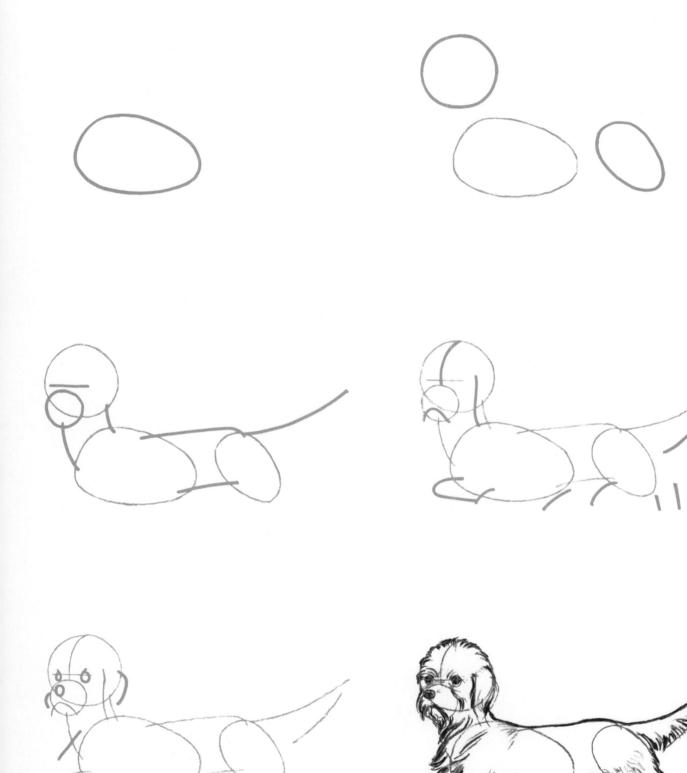

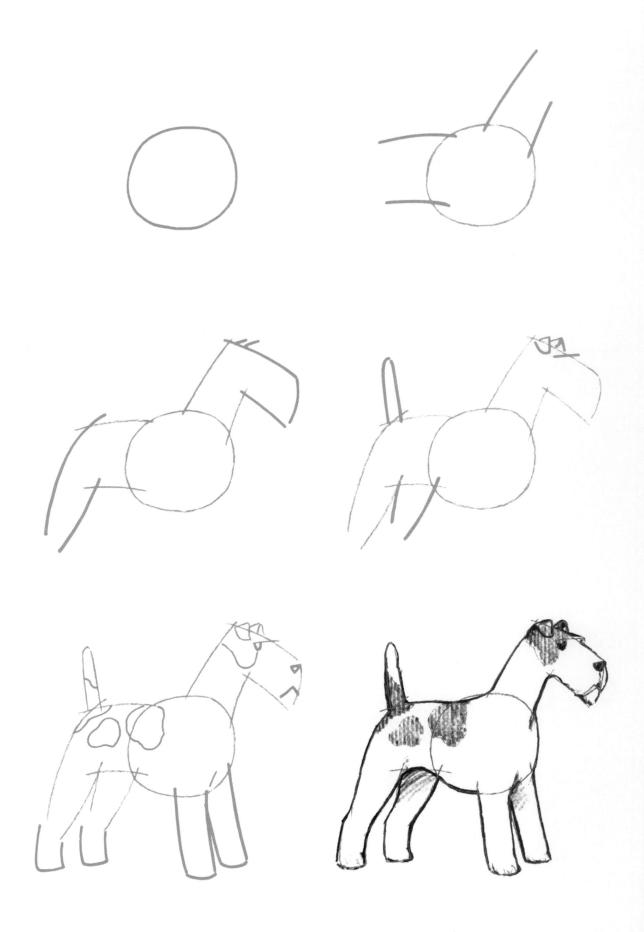

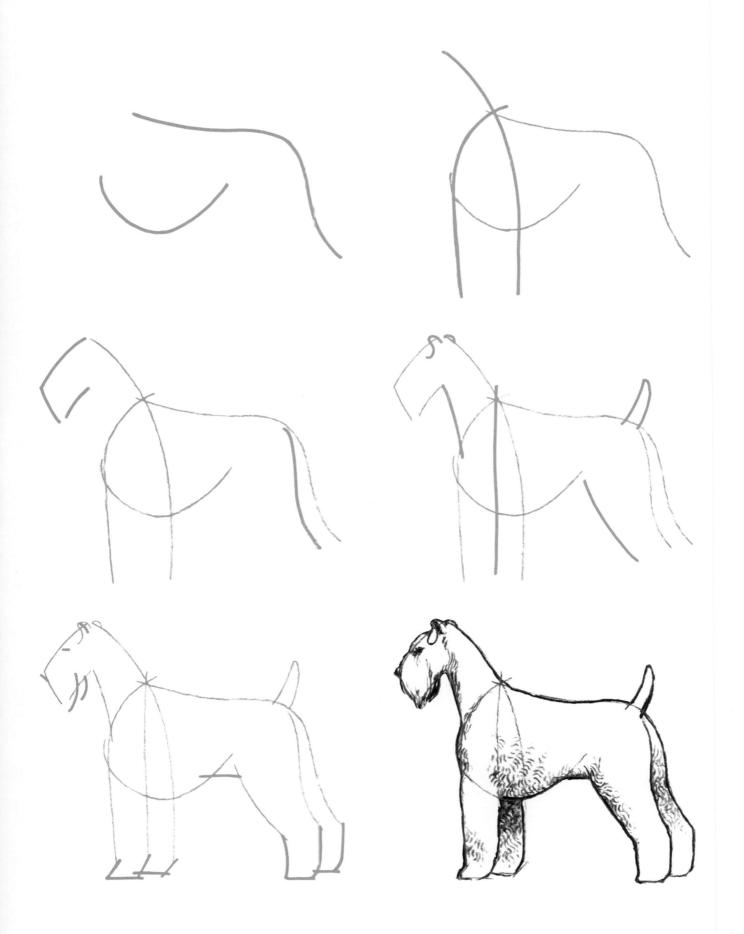

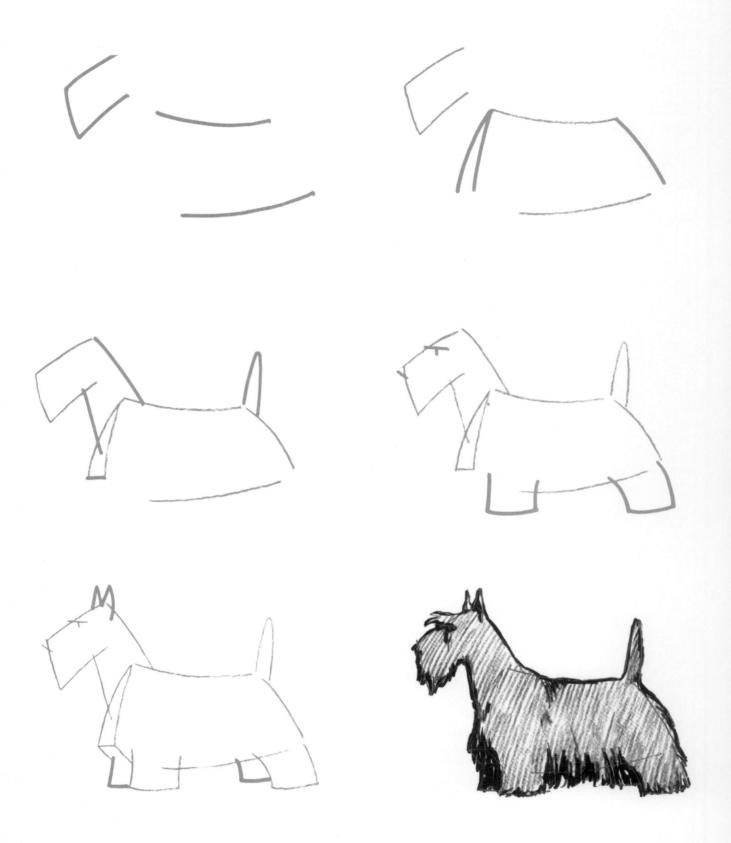

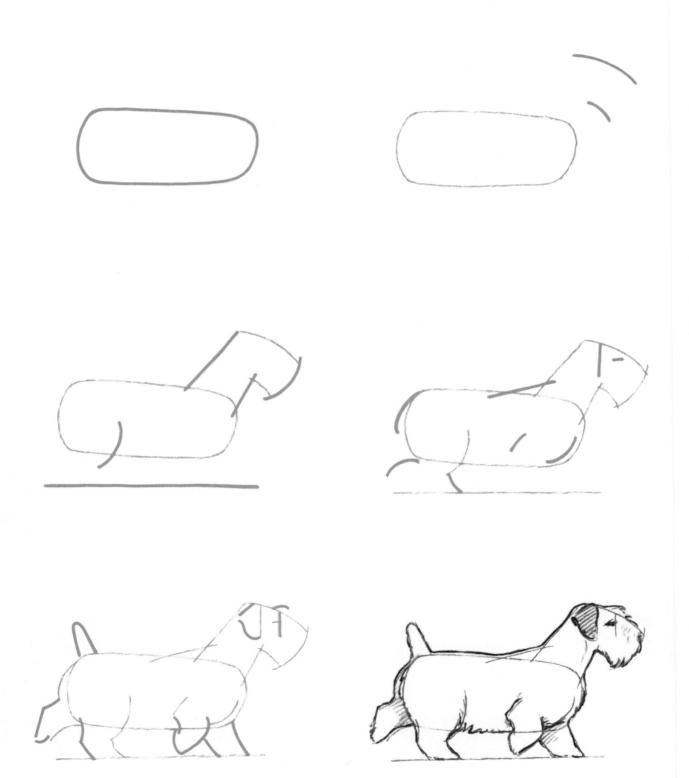

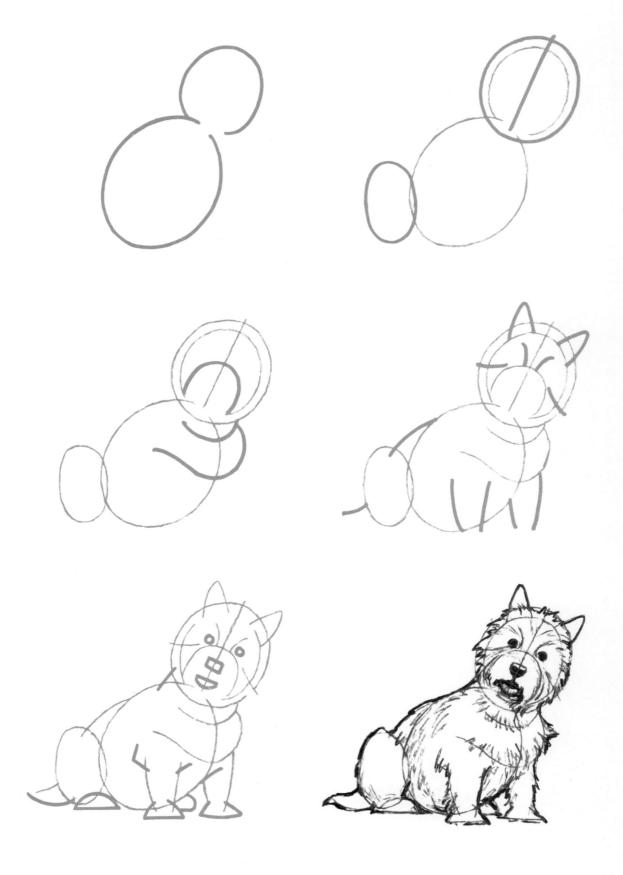

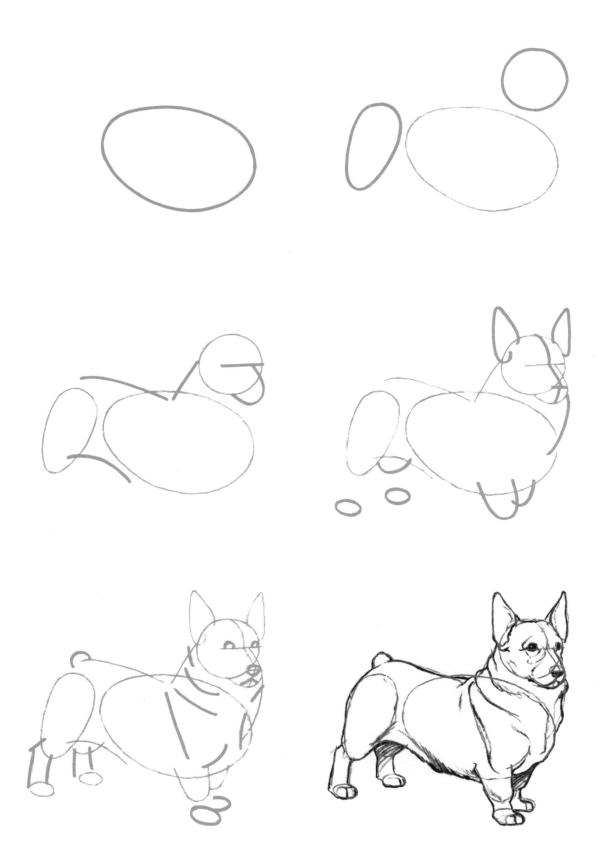

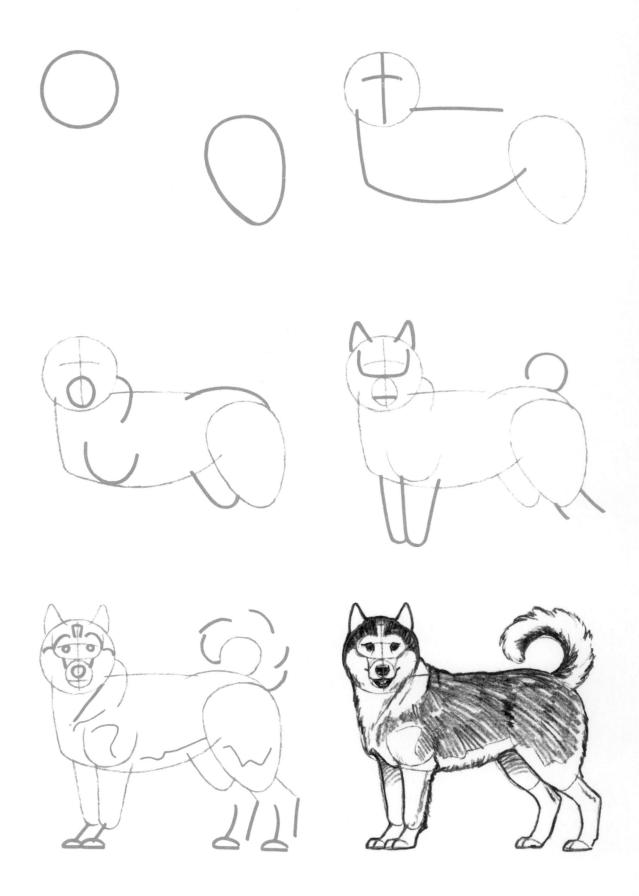

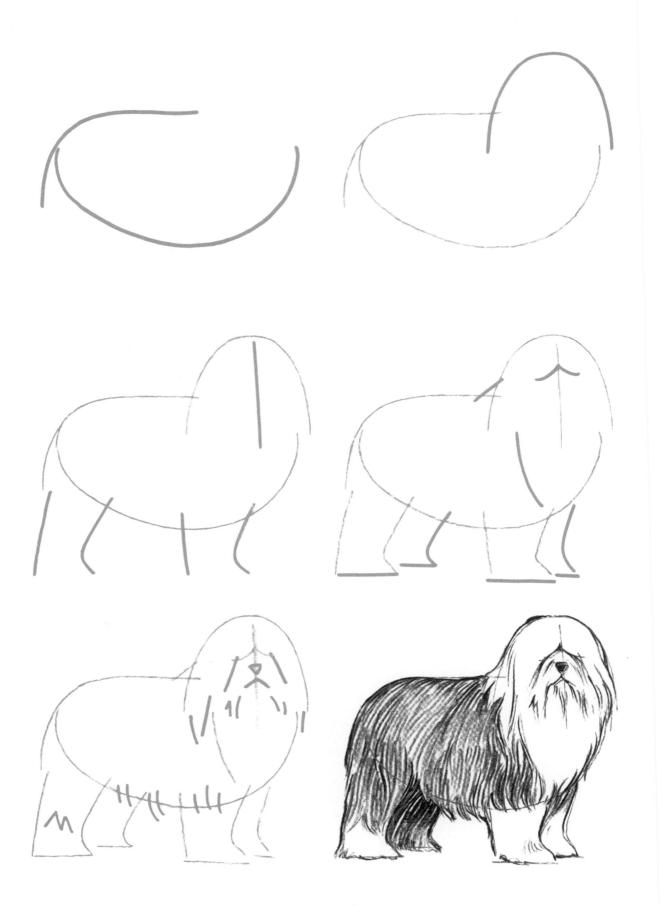

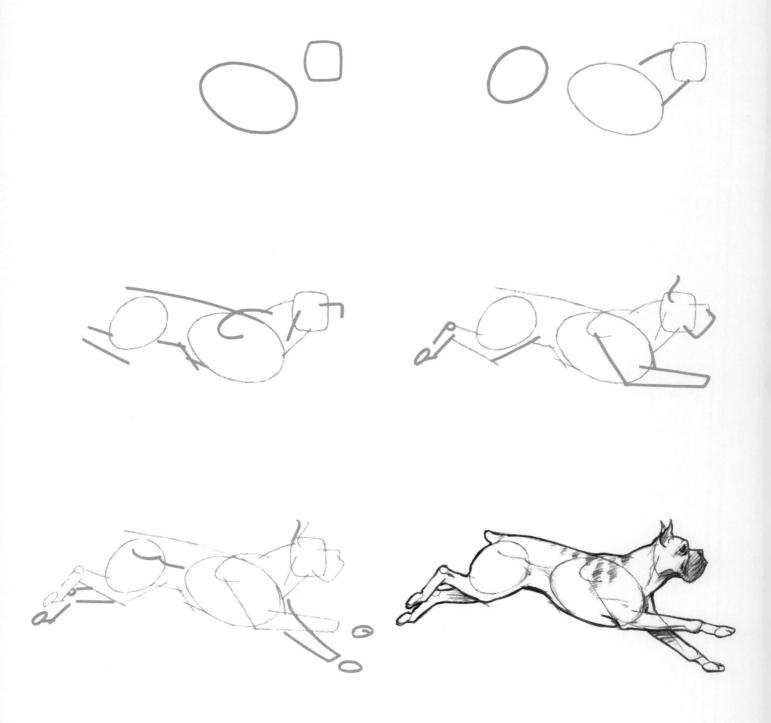

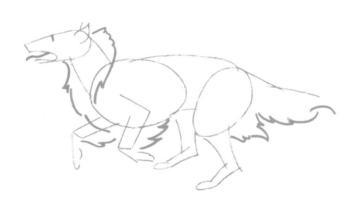

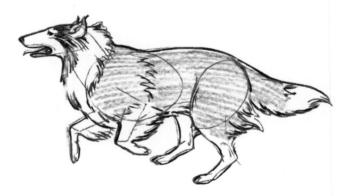

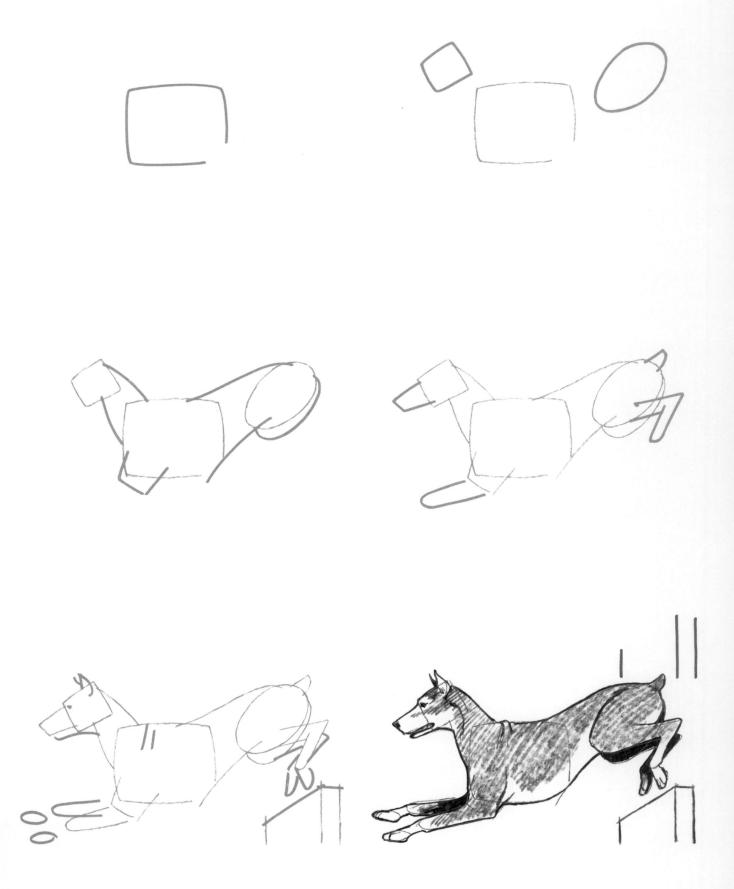

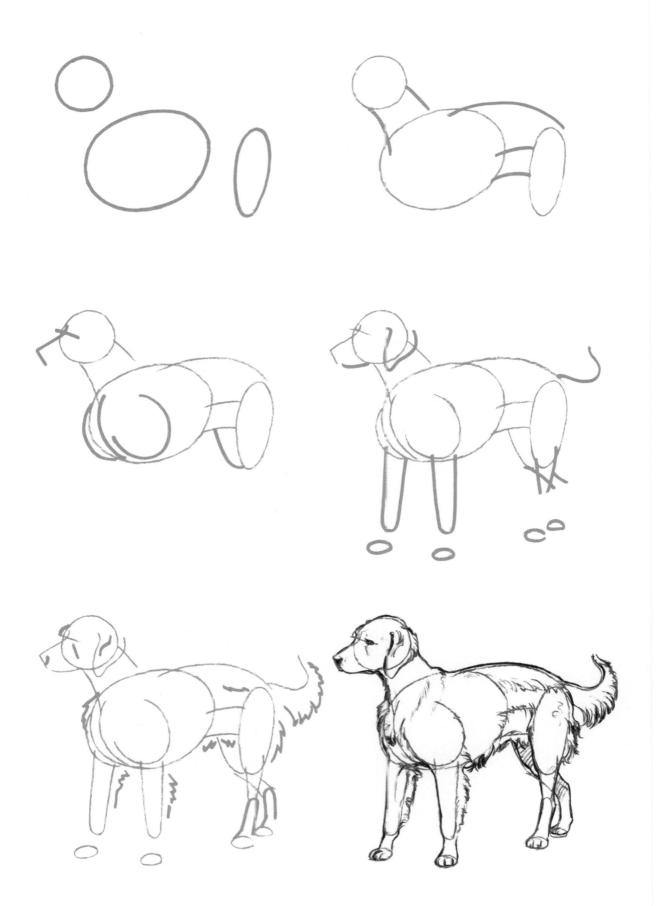

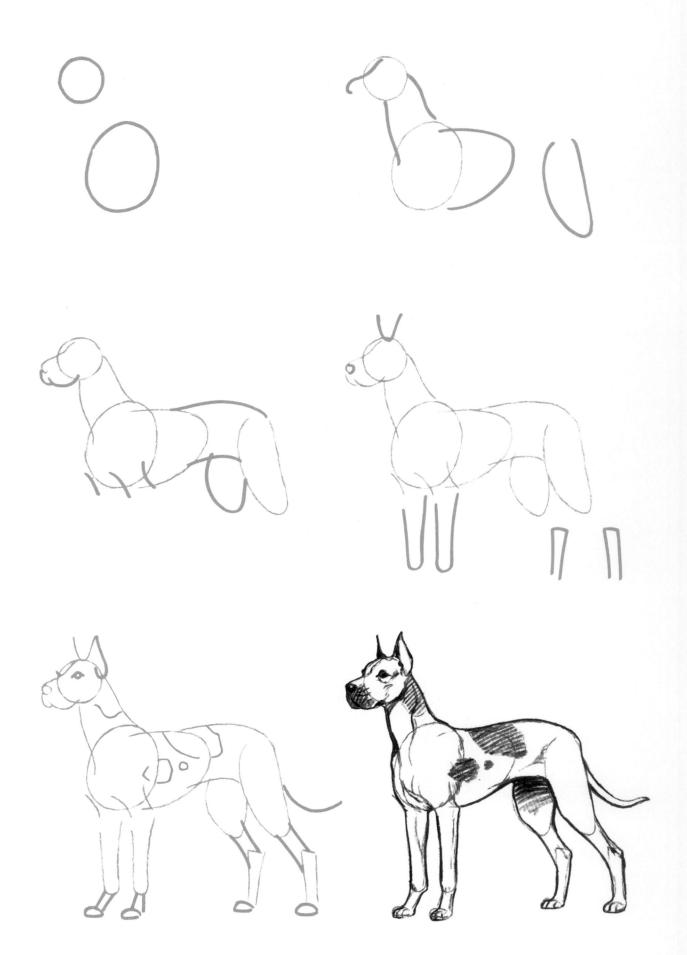

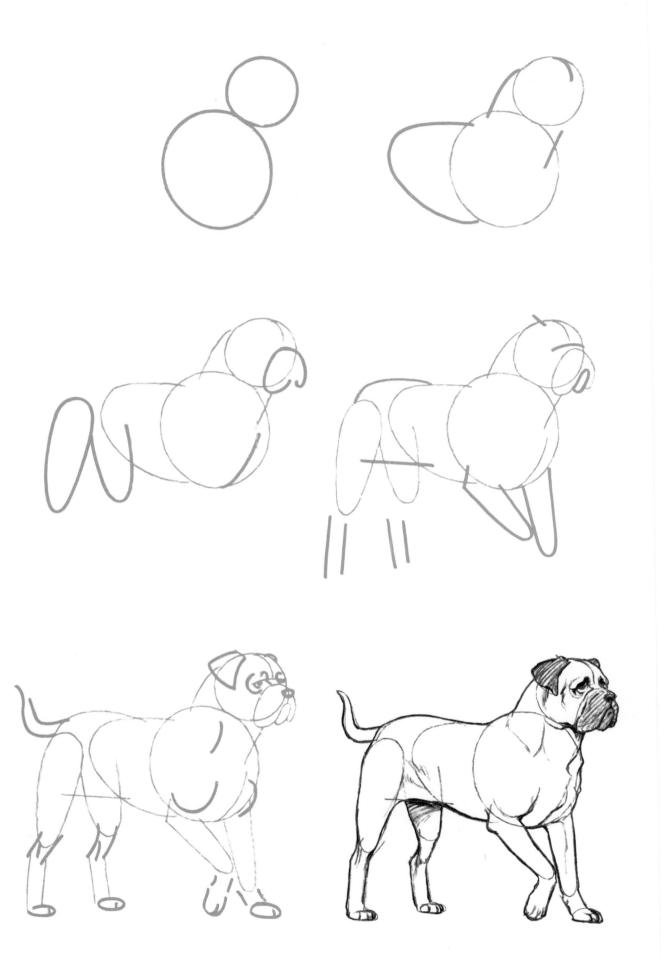

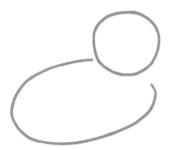

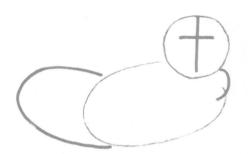

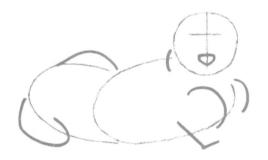

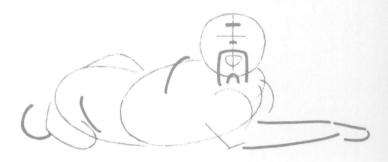

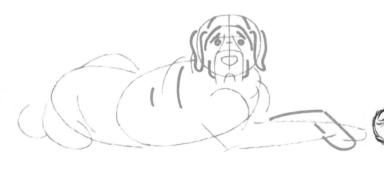

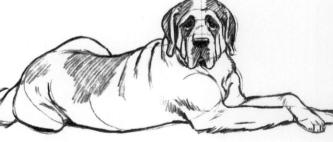

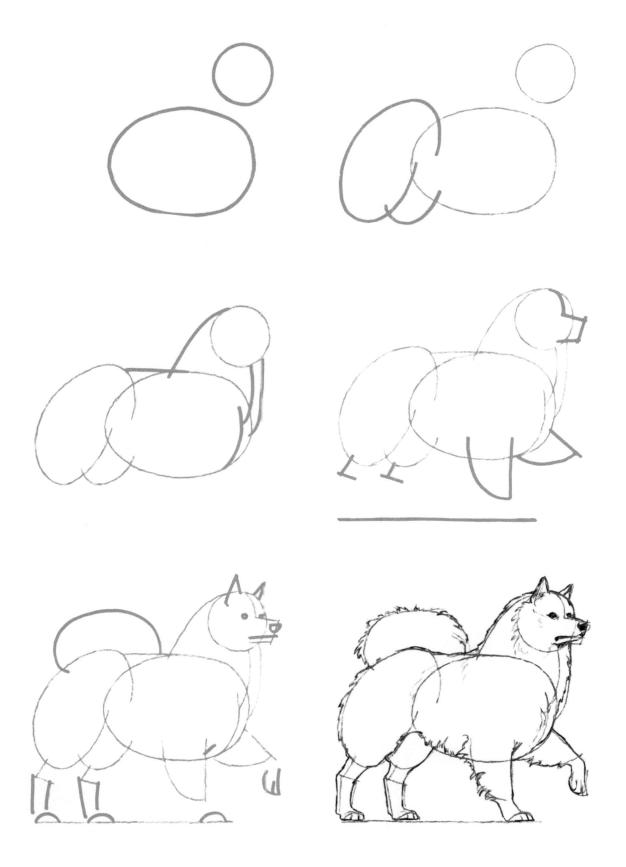

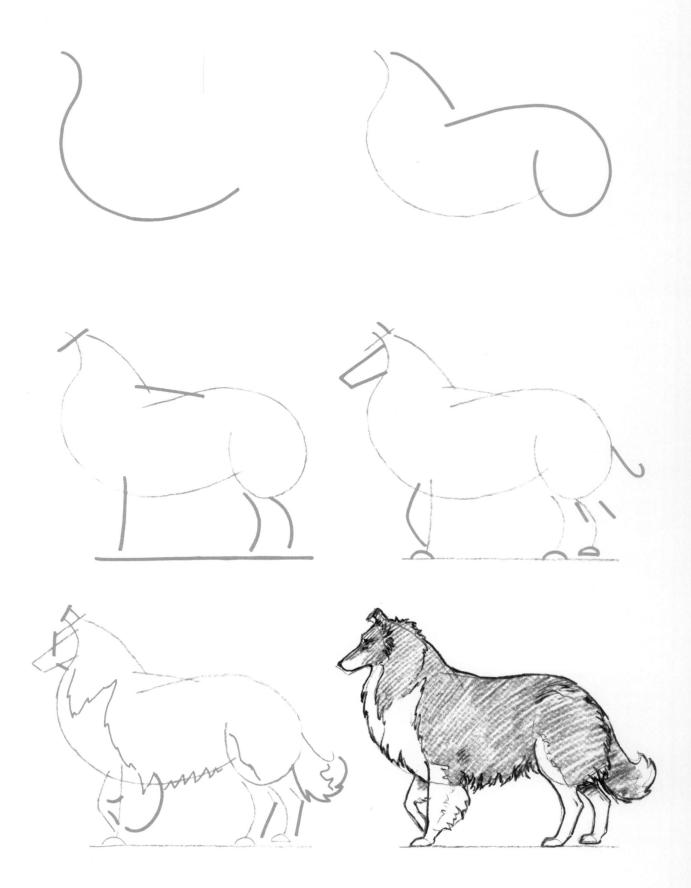

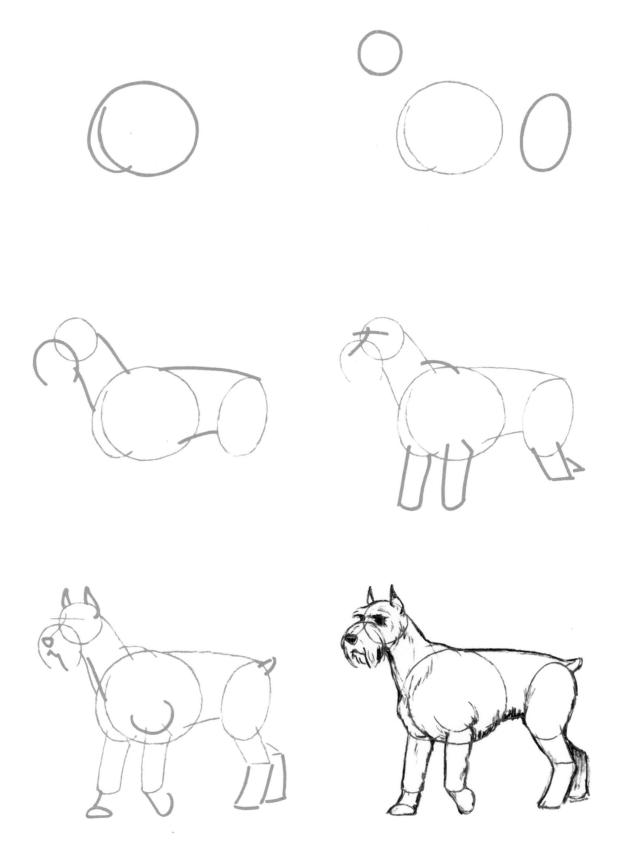

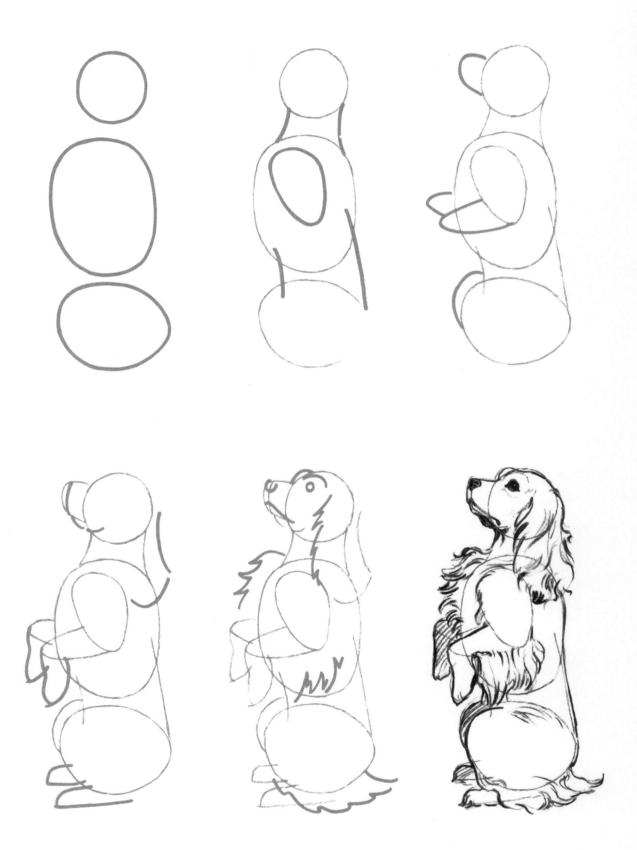

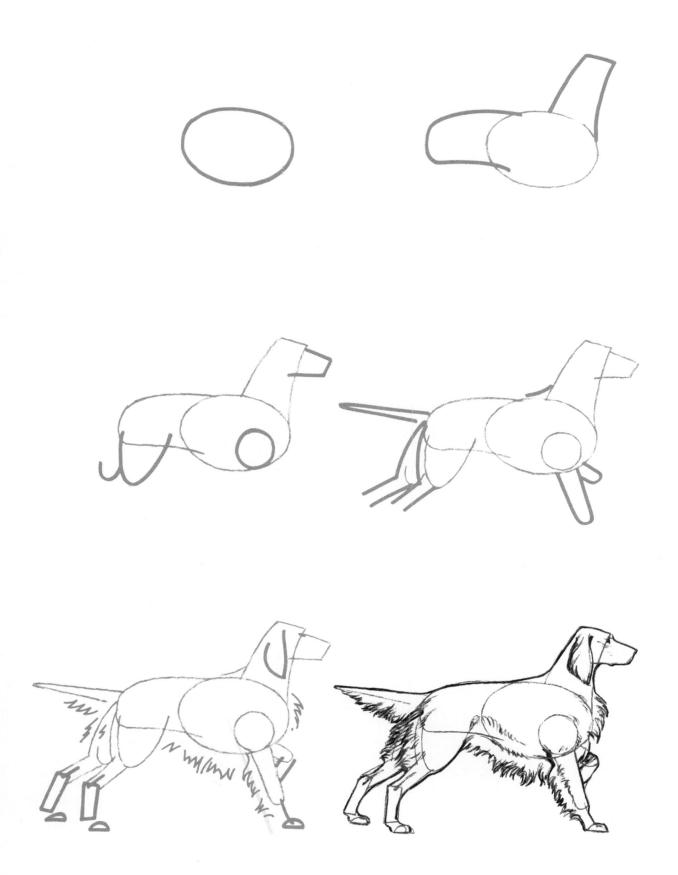

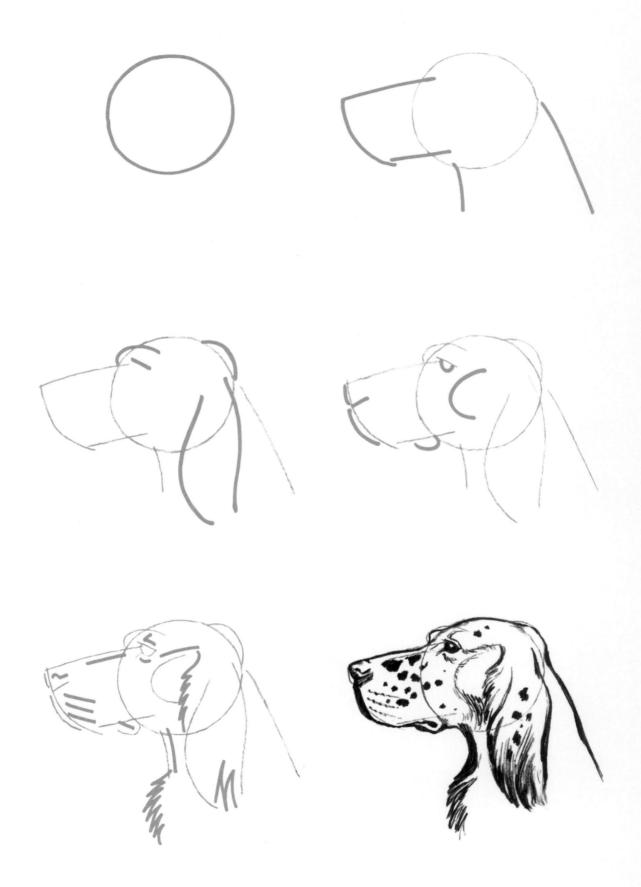

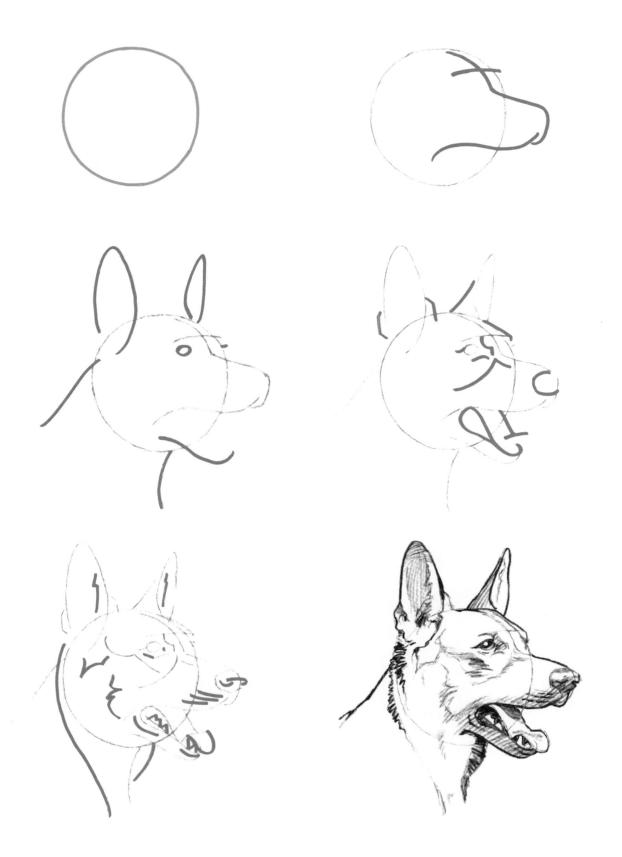

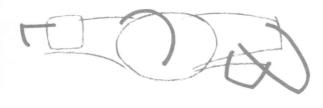

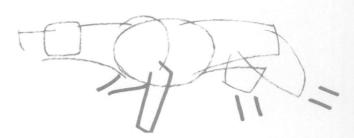

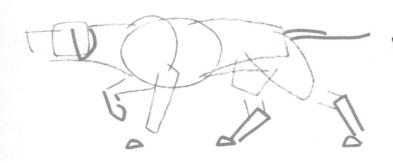

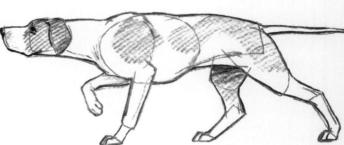

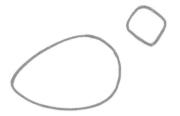

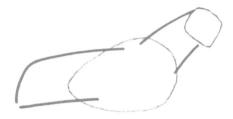

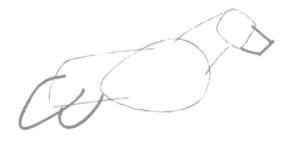

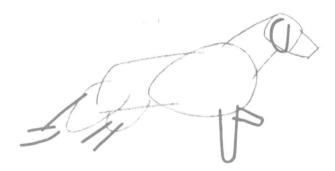

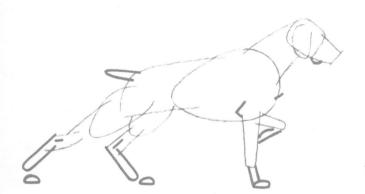

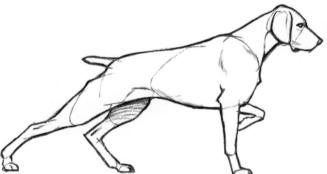

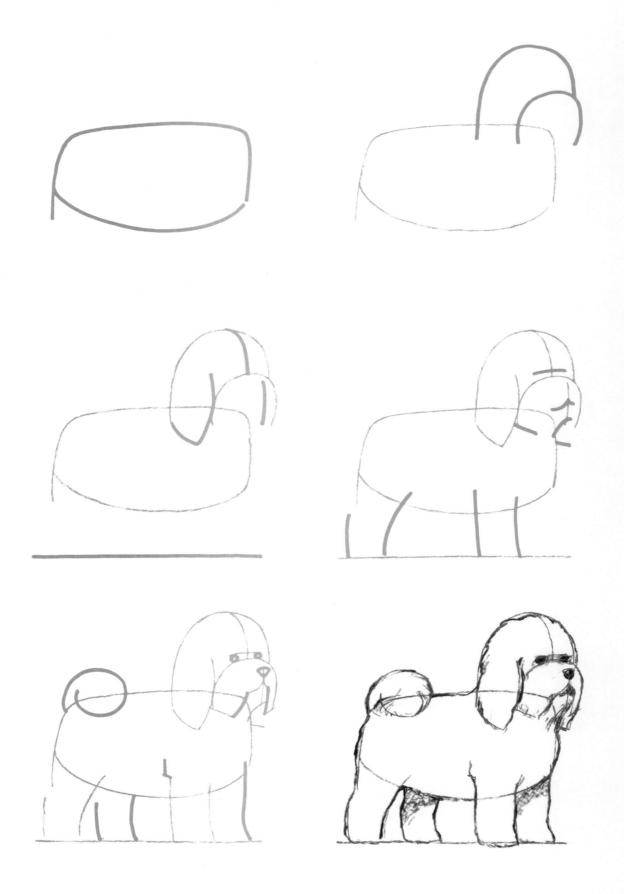

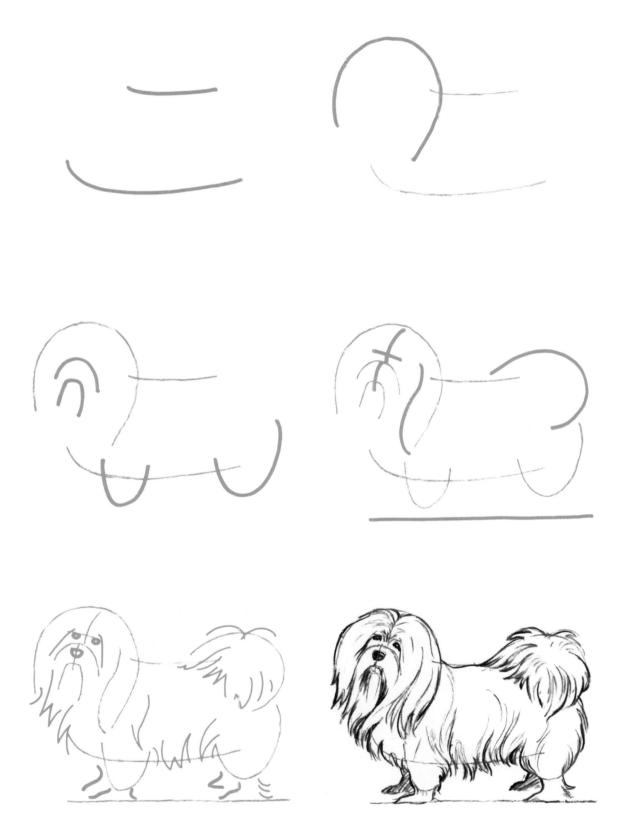

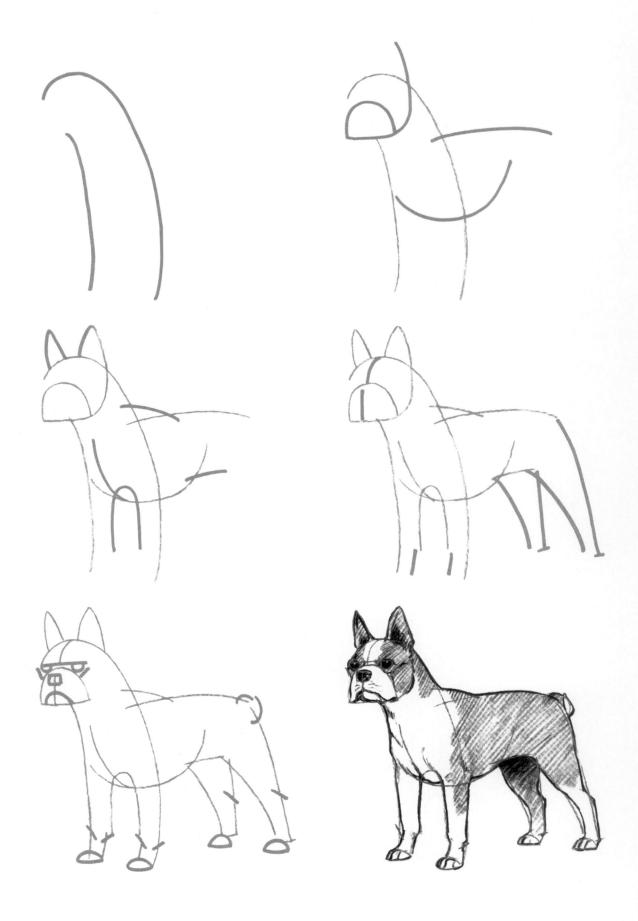

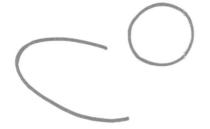

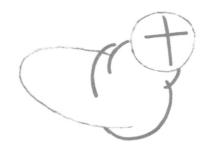

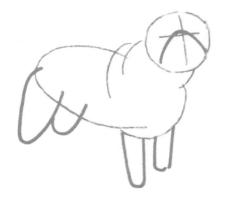

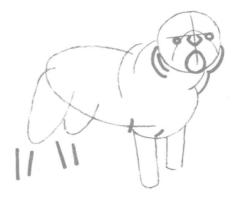

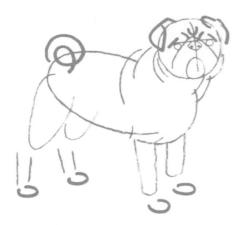

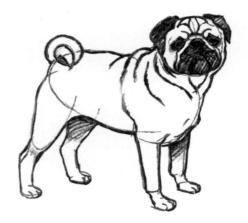

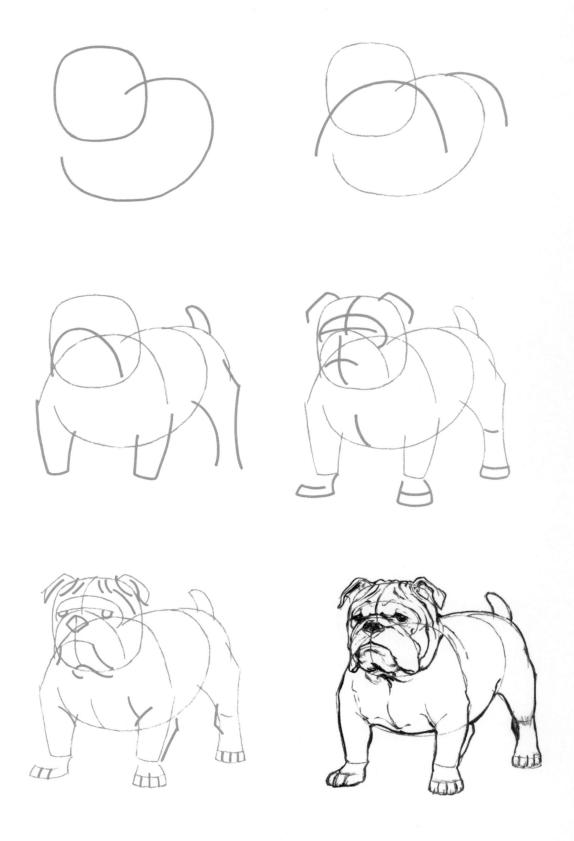

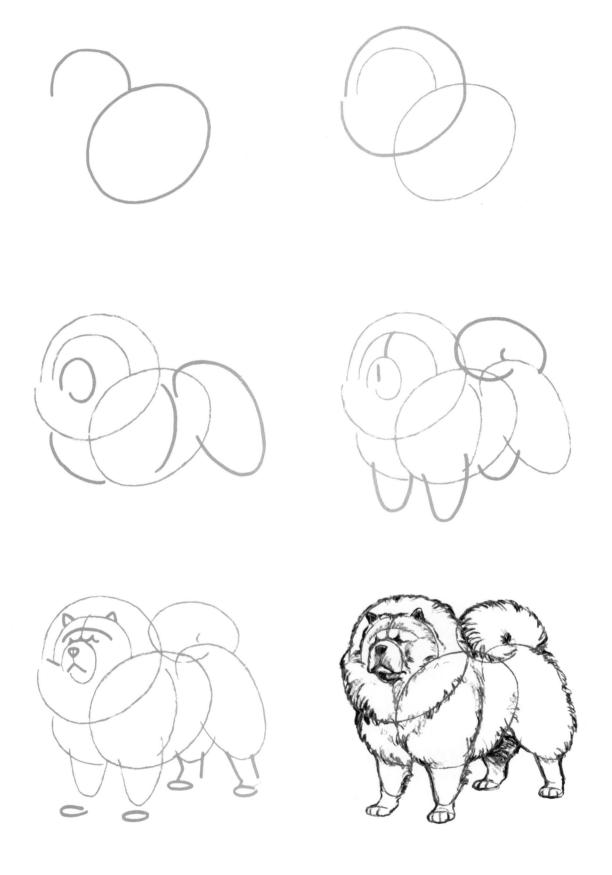

DOGS

159

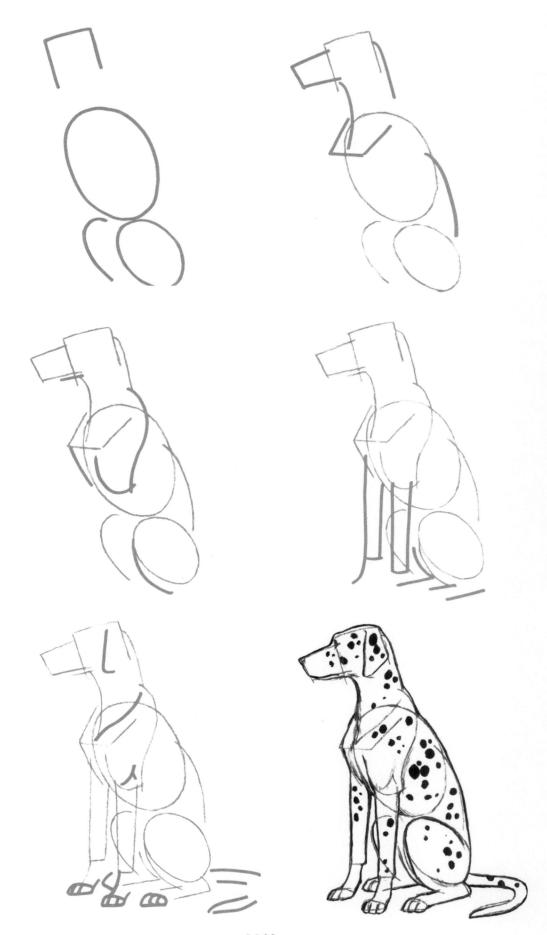

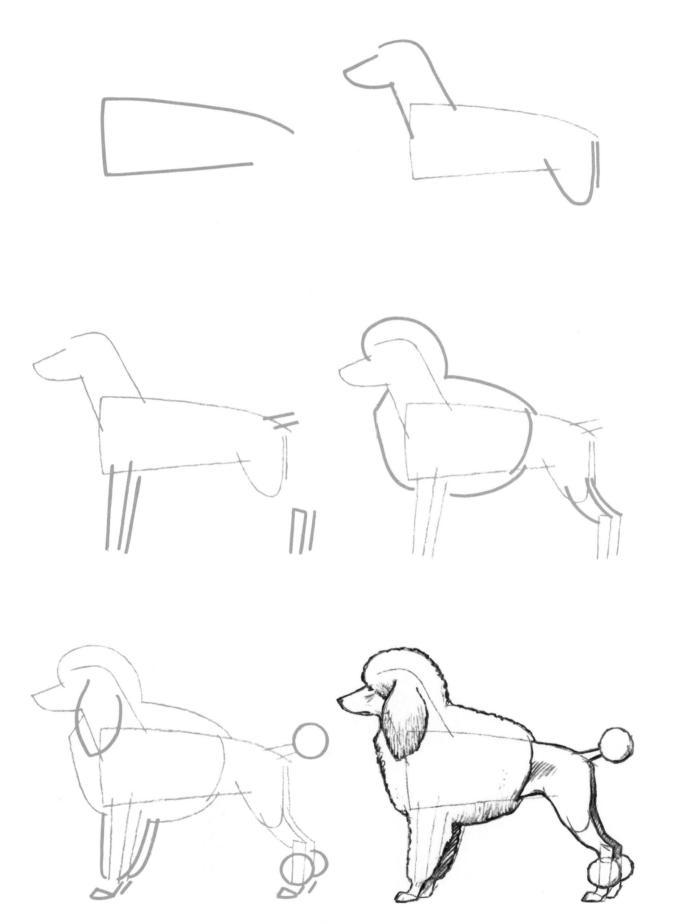

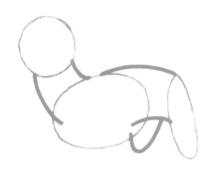

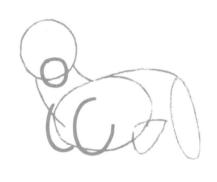

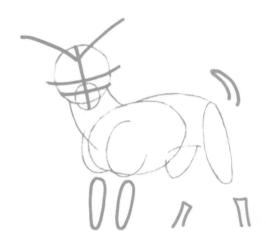

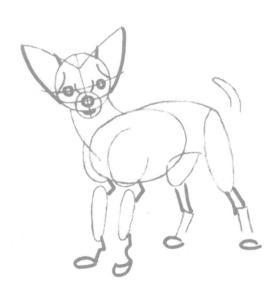

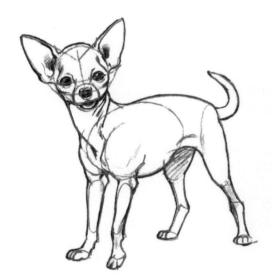

Birds

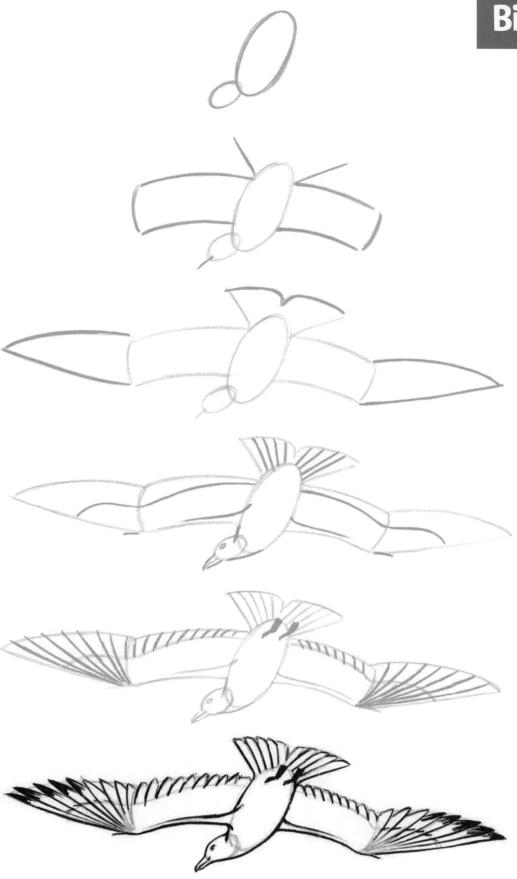

BIRDS

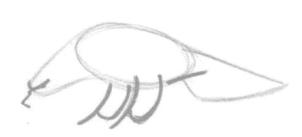

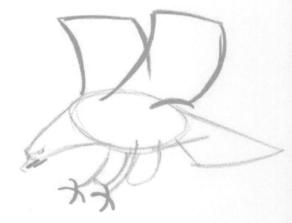

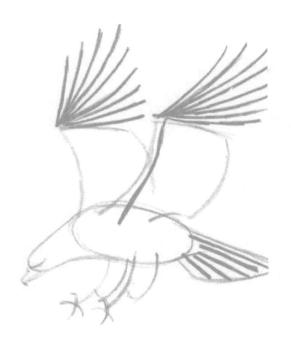

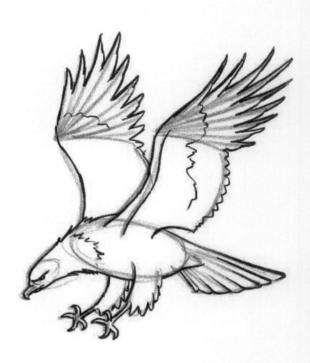

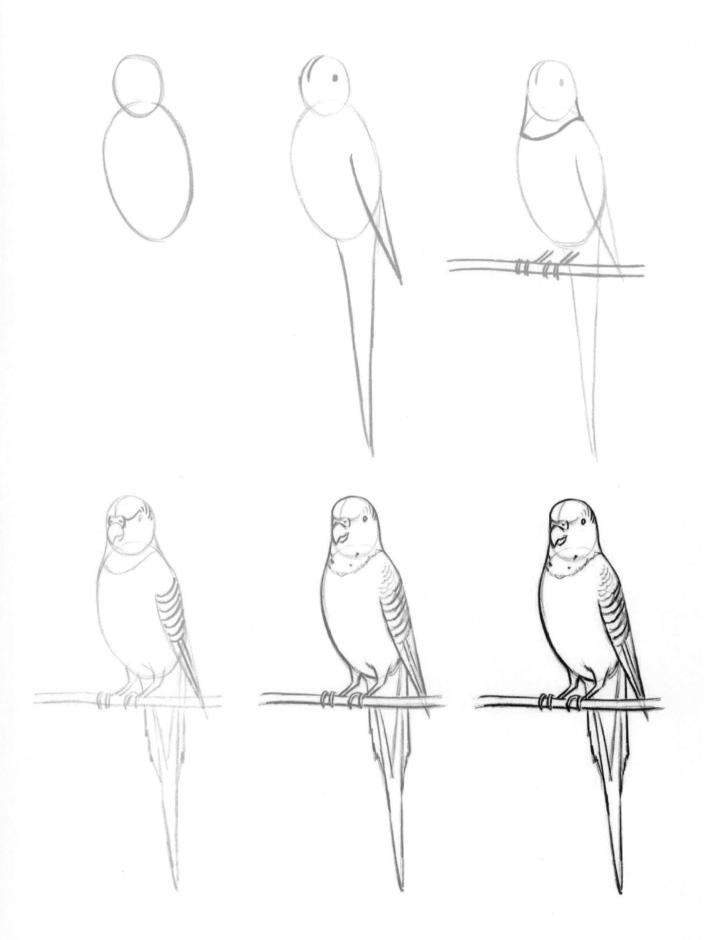

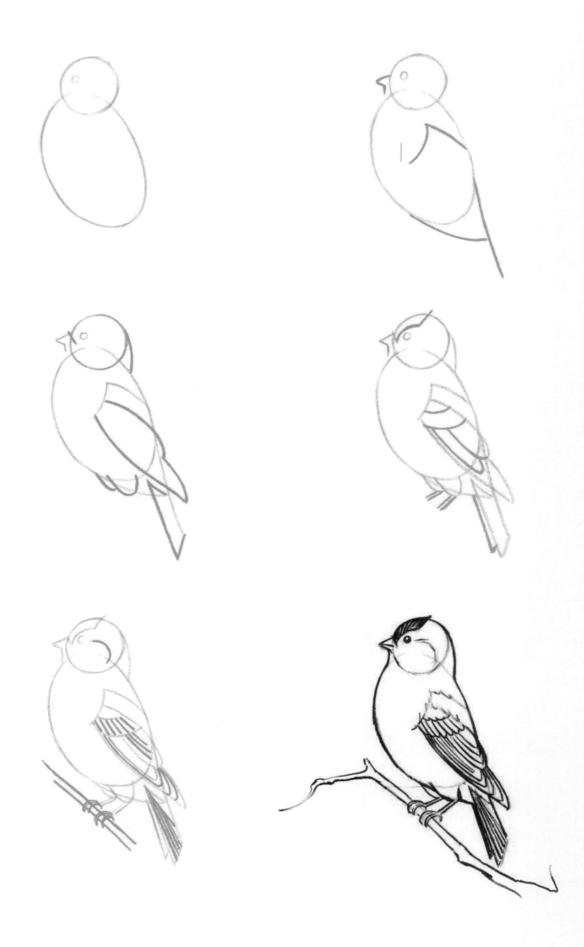

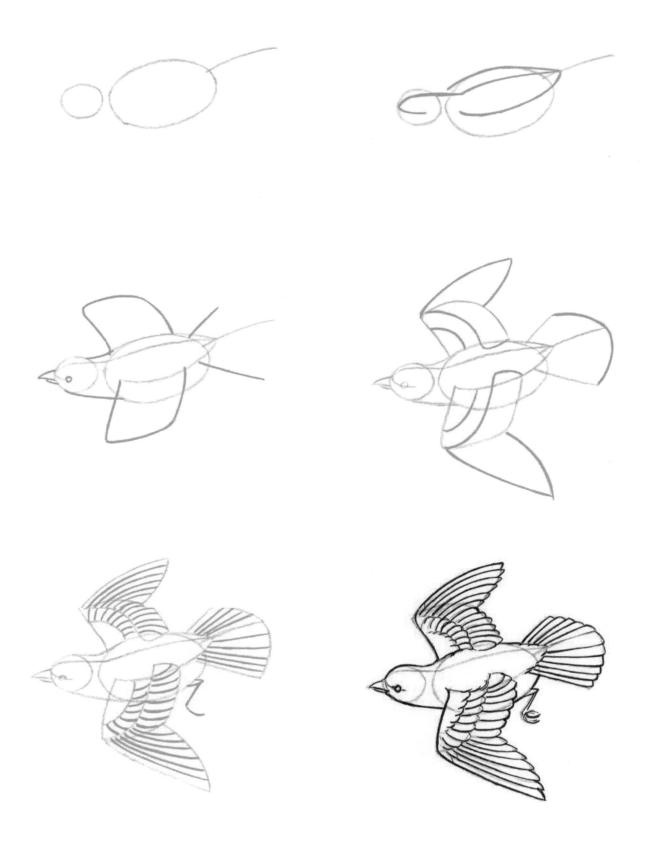

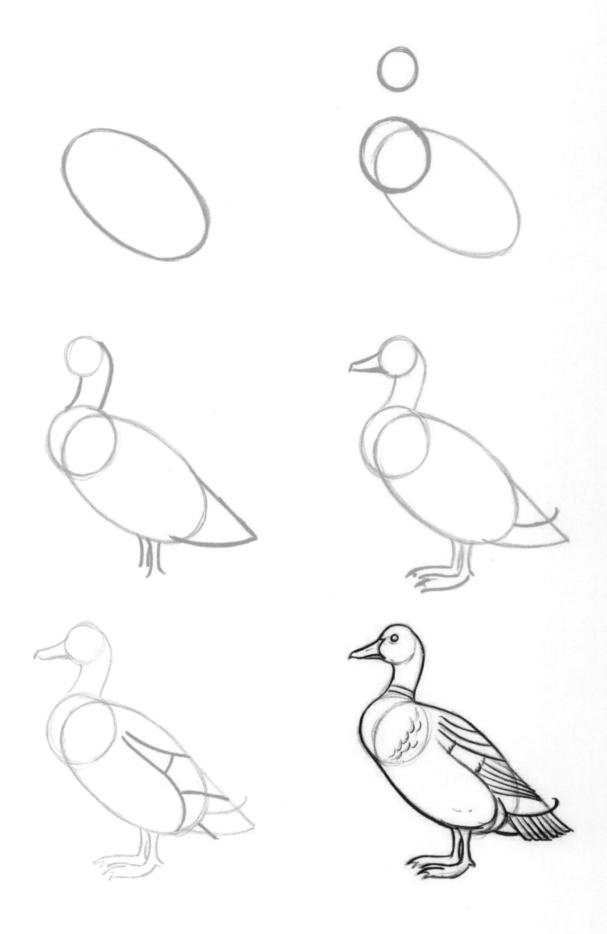

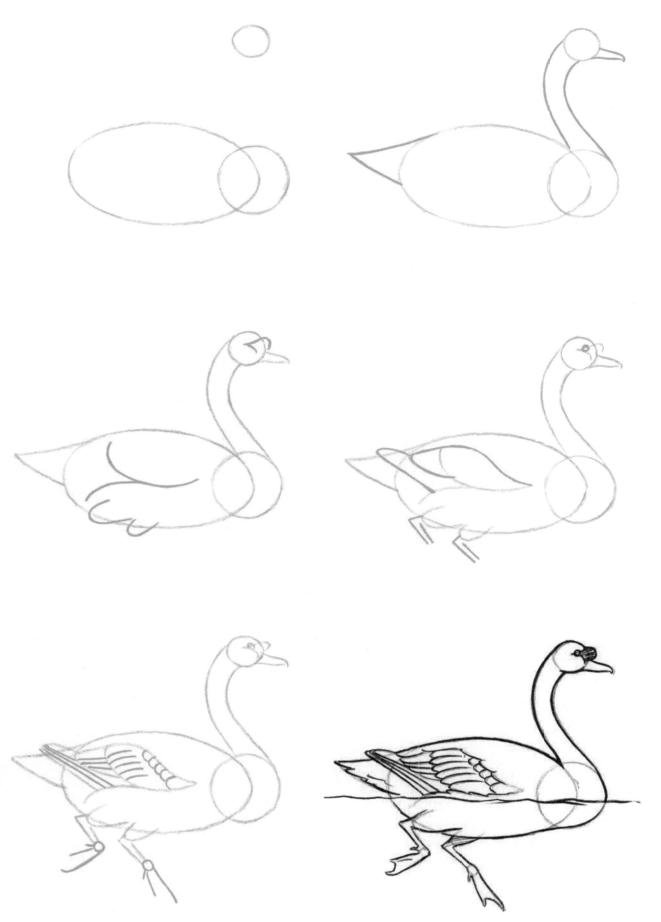

BIRDS

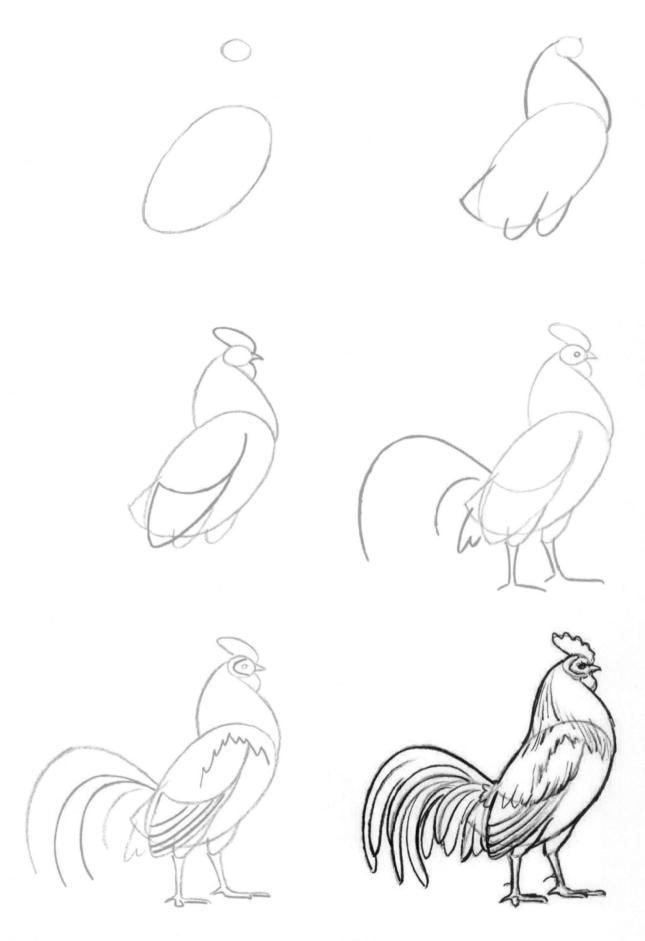

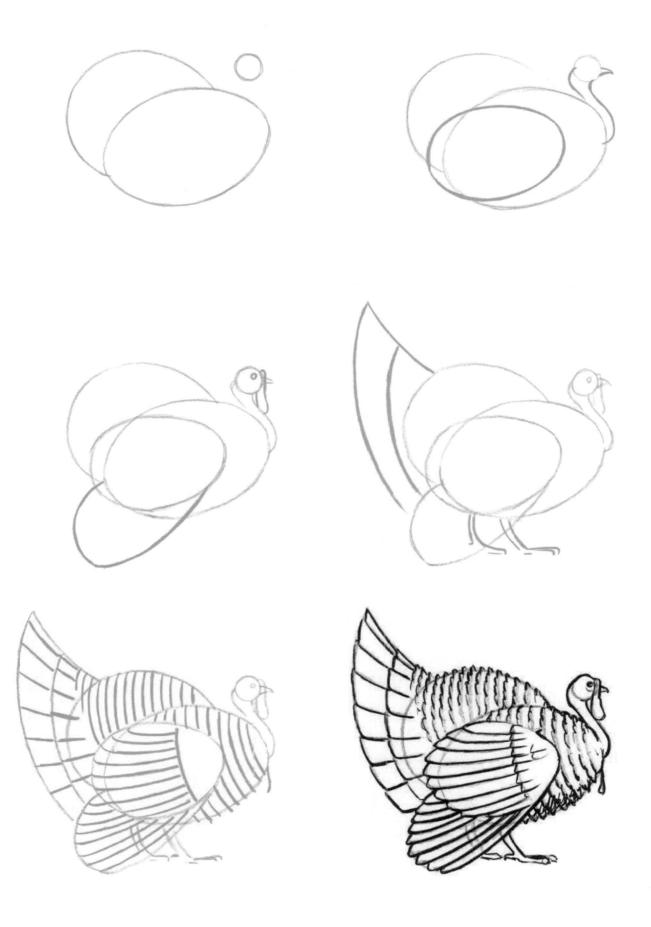

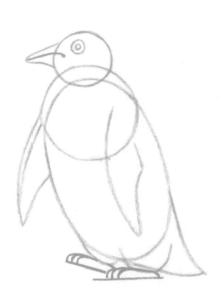

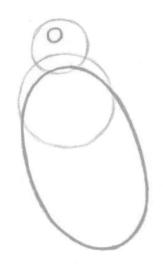

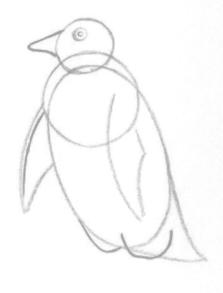

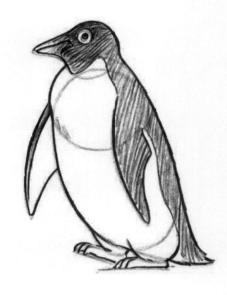

Reptiles & Amphibians

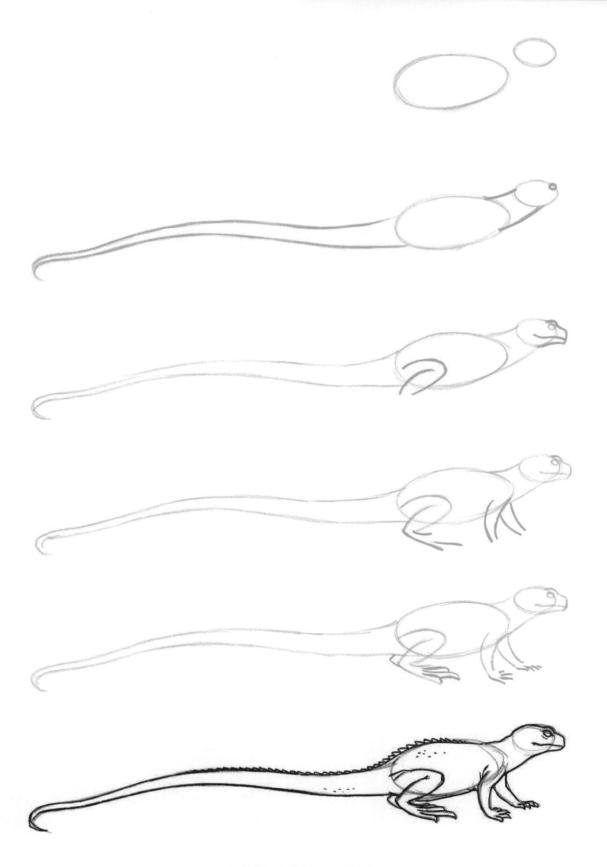

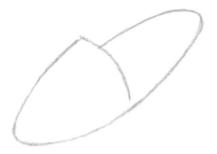

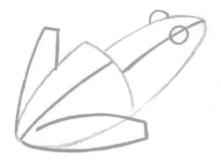

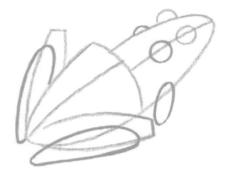

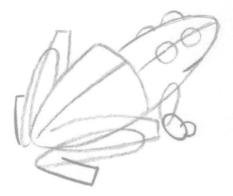

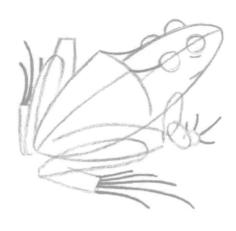

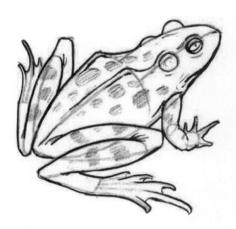

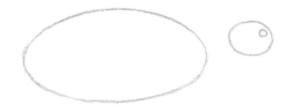

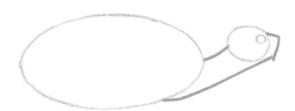

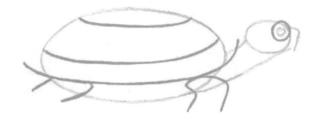

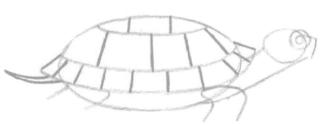

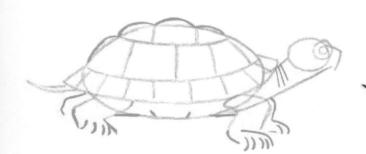

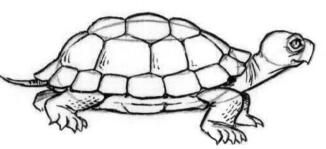

Fish & Other Marine Life

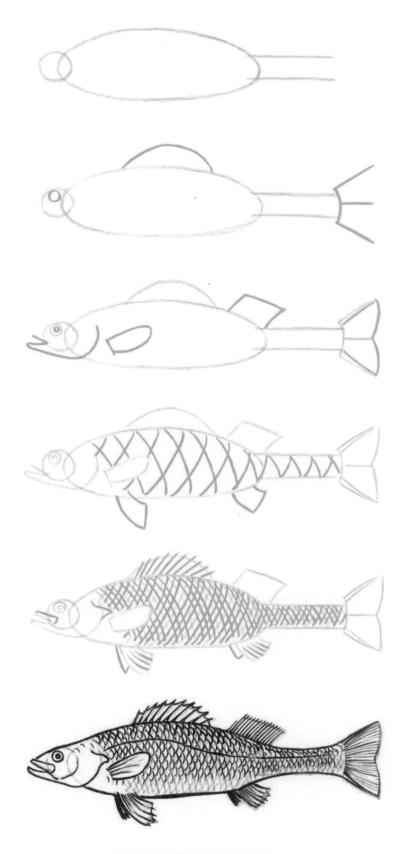

FISH & OTHER MARINE LIFE

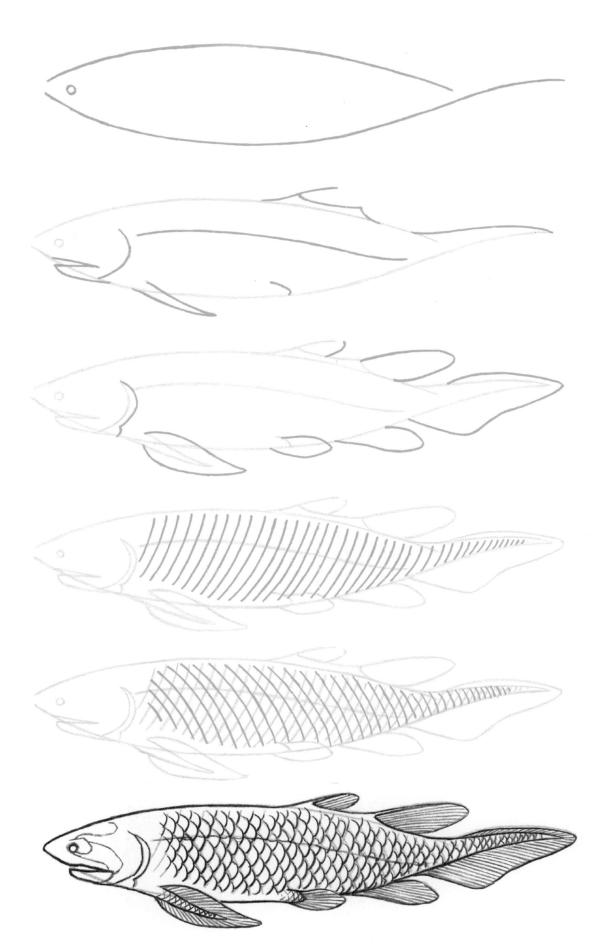

FISH & OTHER MARINE LIFE

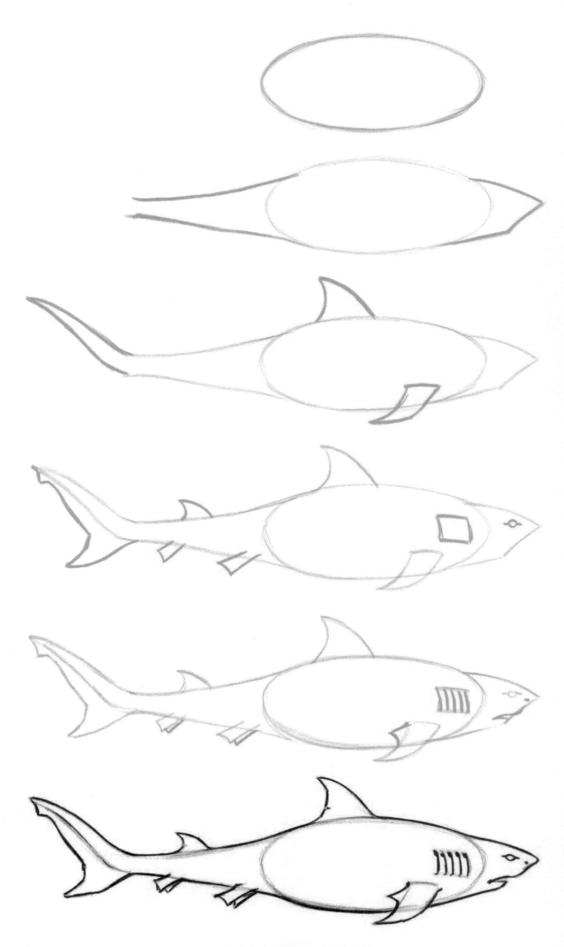

FISH & OTHER MARINE LIFE

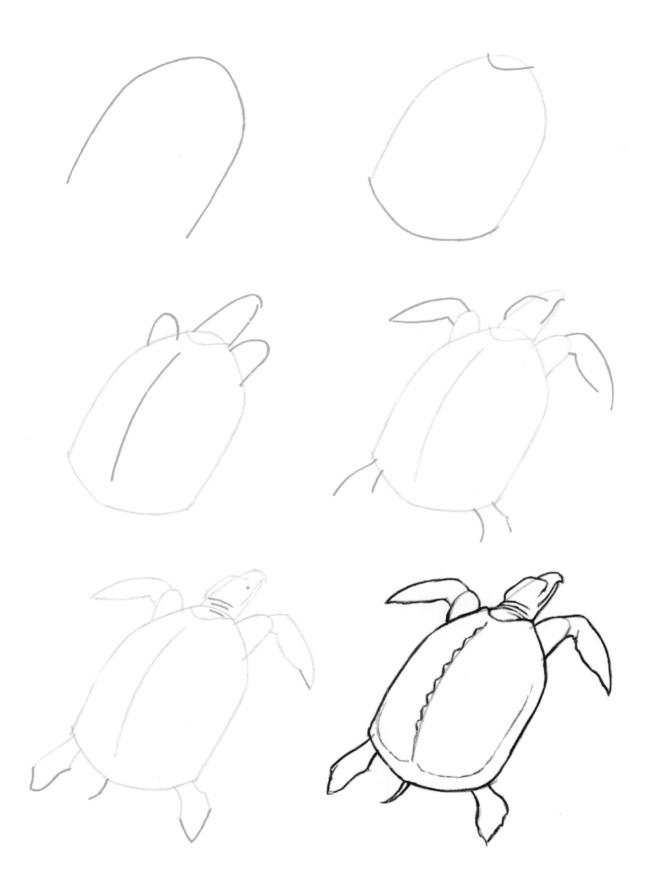

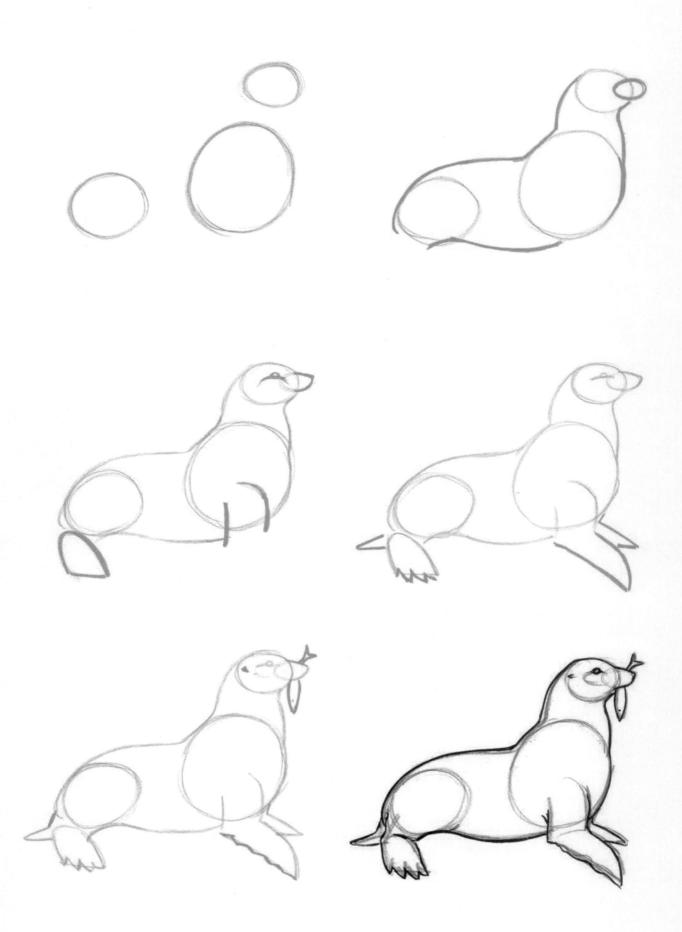

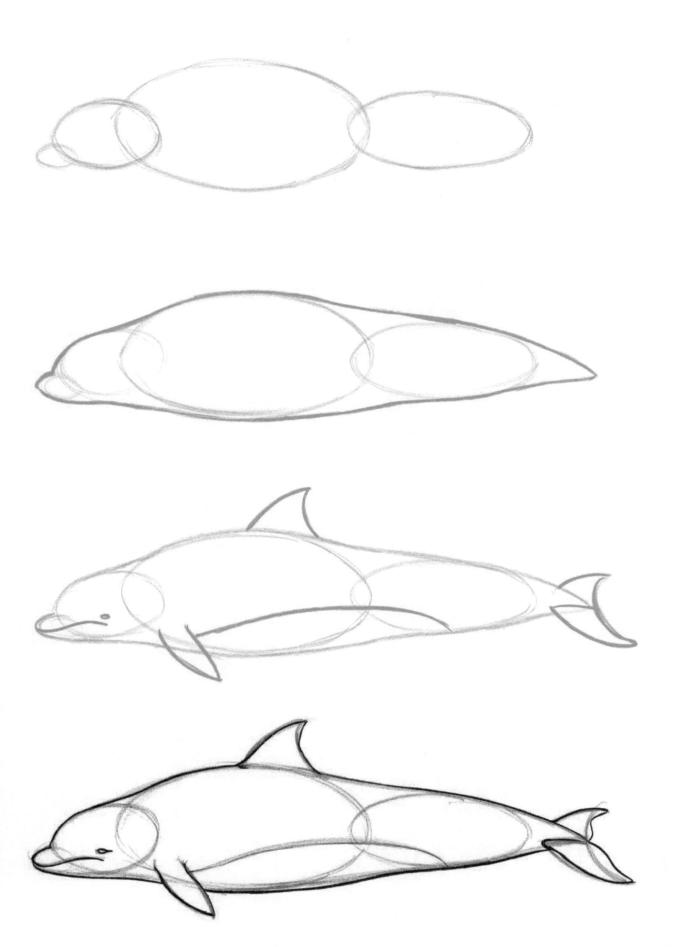

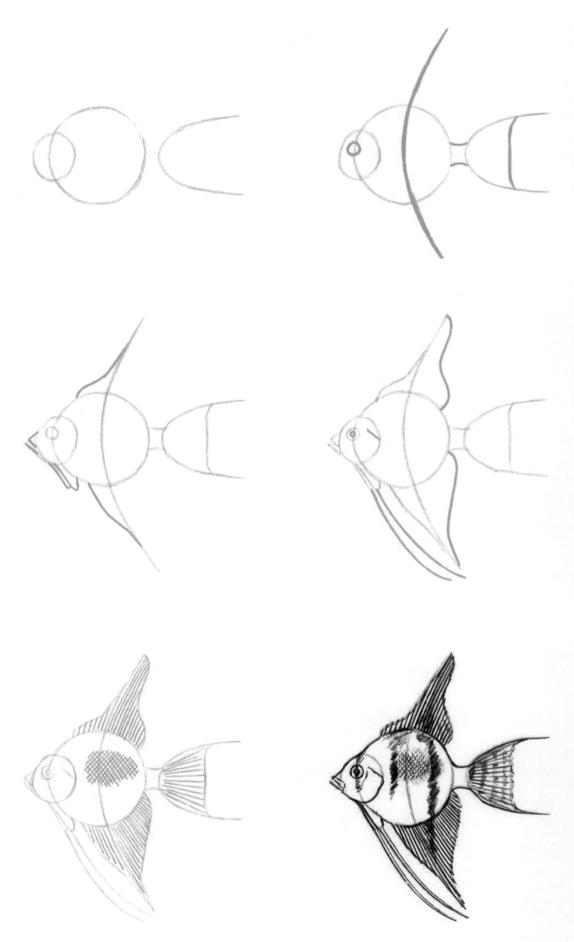

FISH & OTHER MARINE LIFE

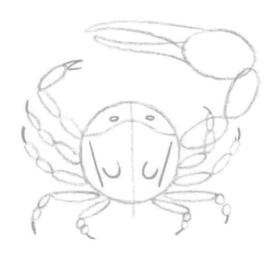

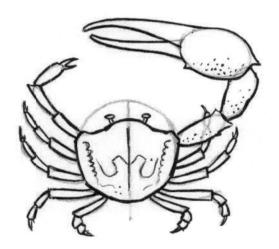

Insects, Bugs, Spiders & Crawling Critters

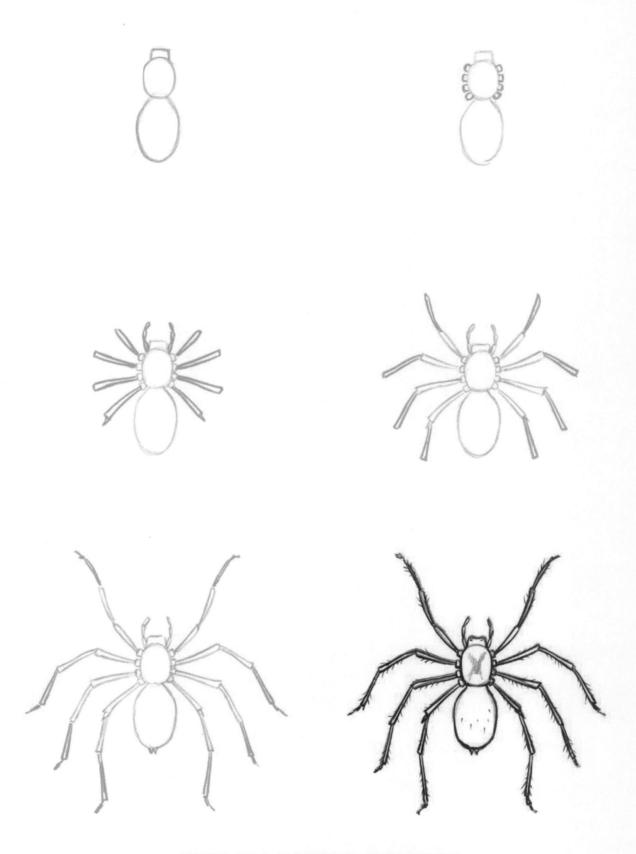

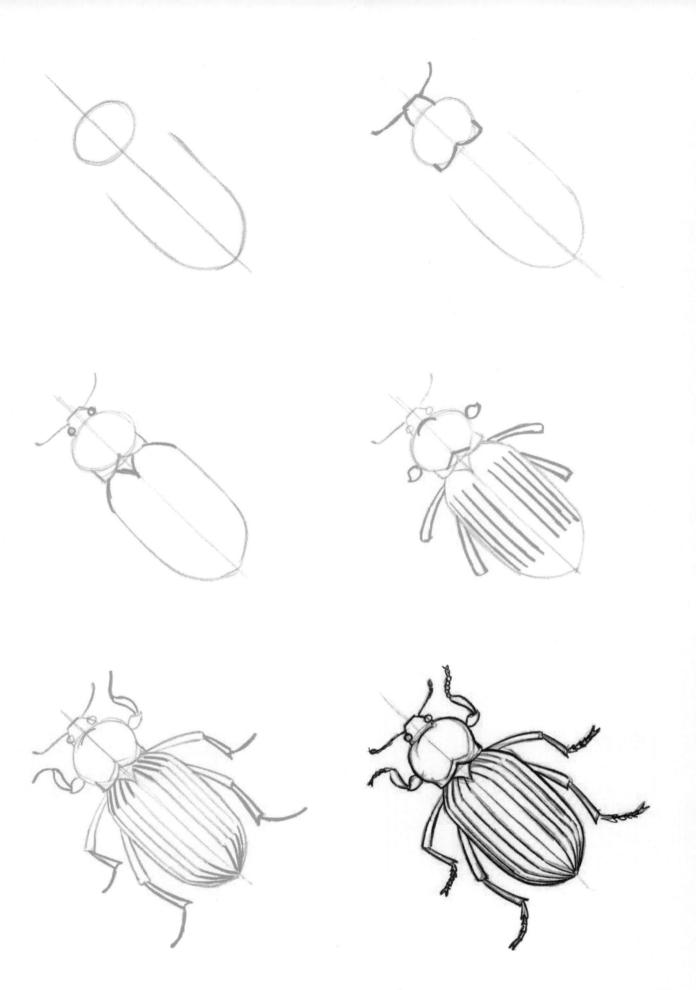

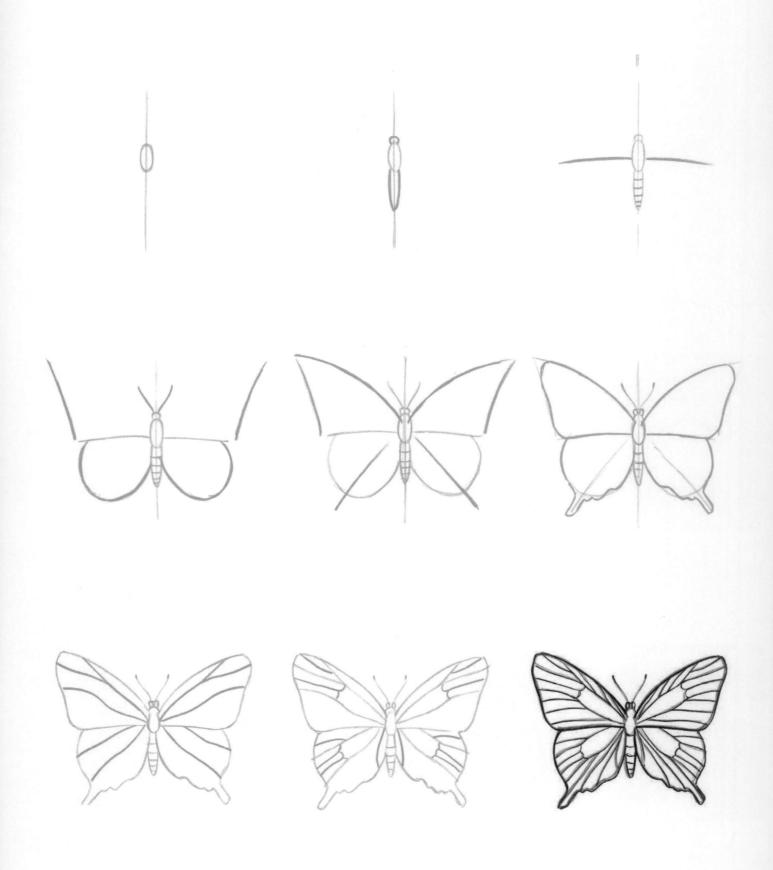

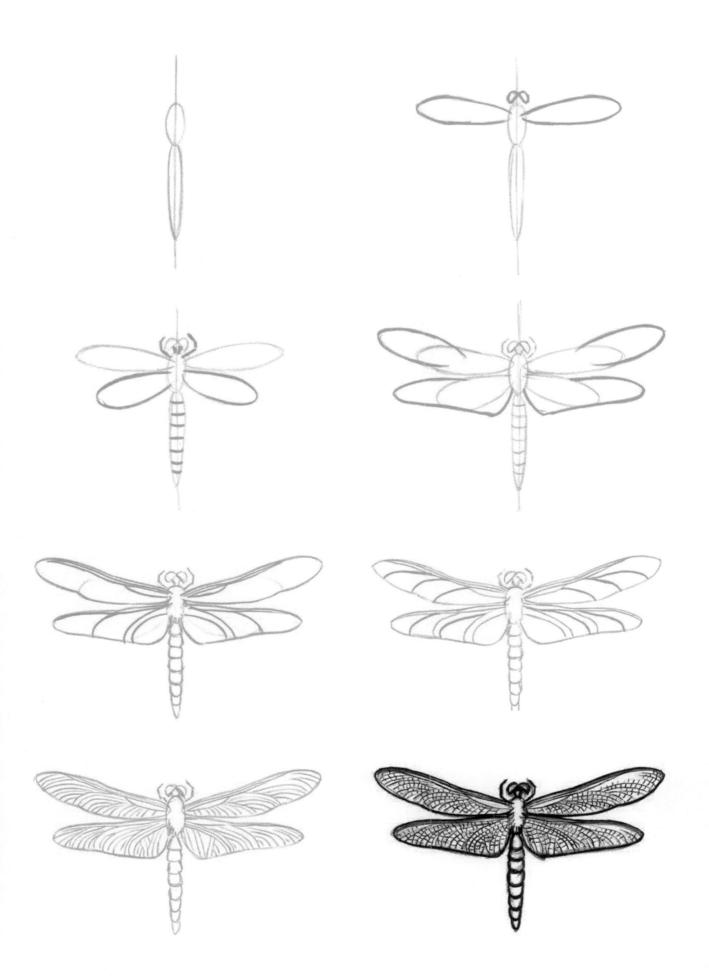

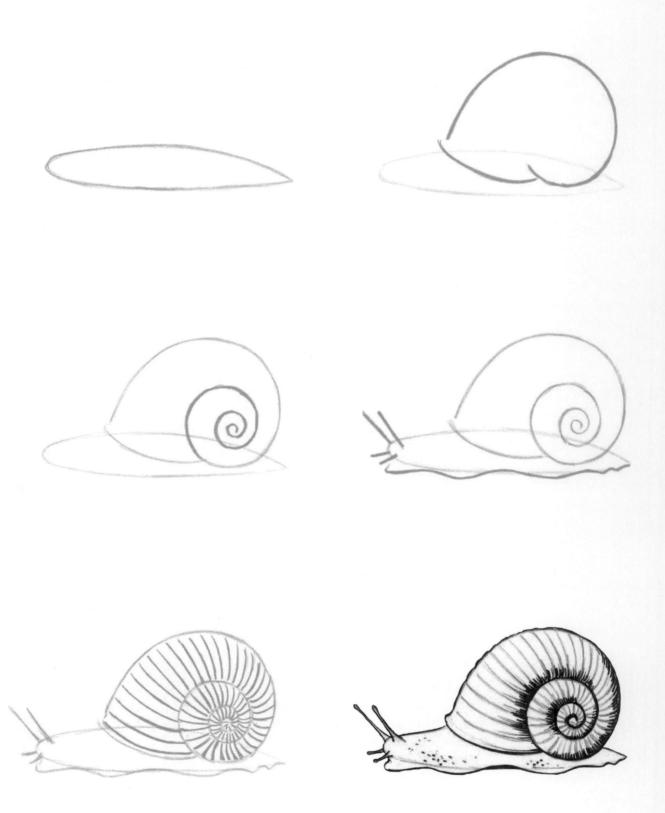

Mammals

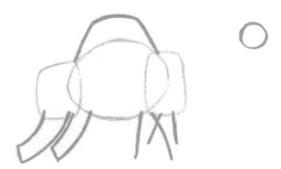

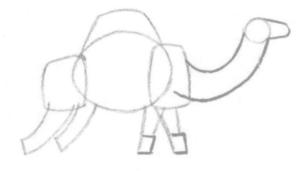

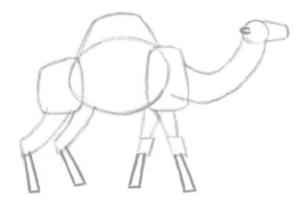

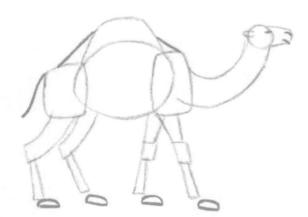

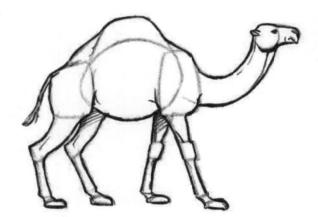

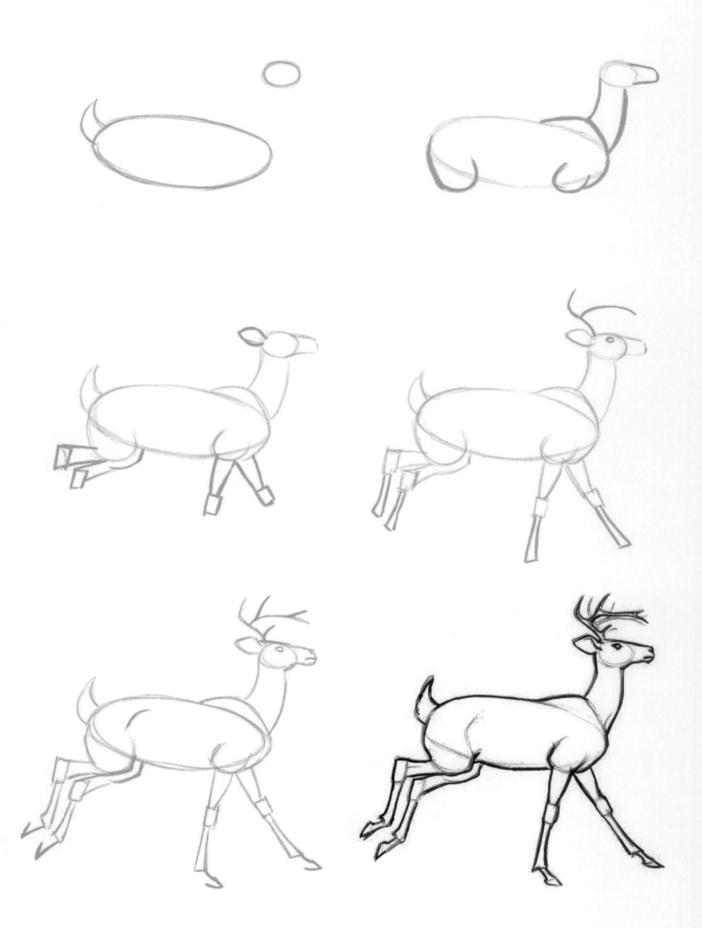

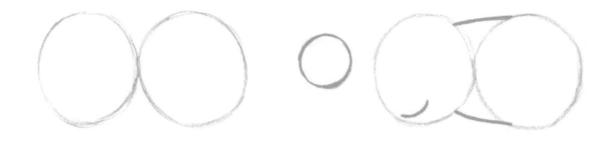

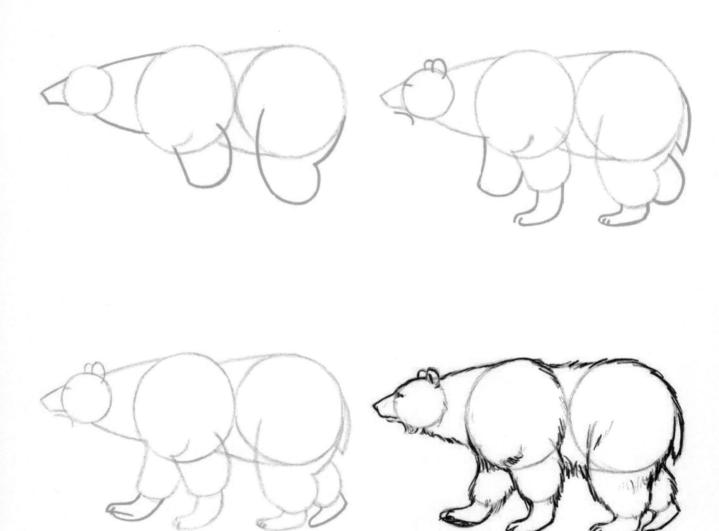

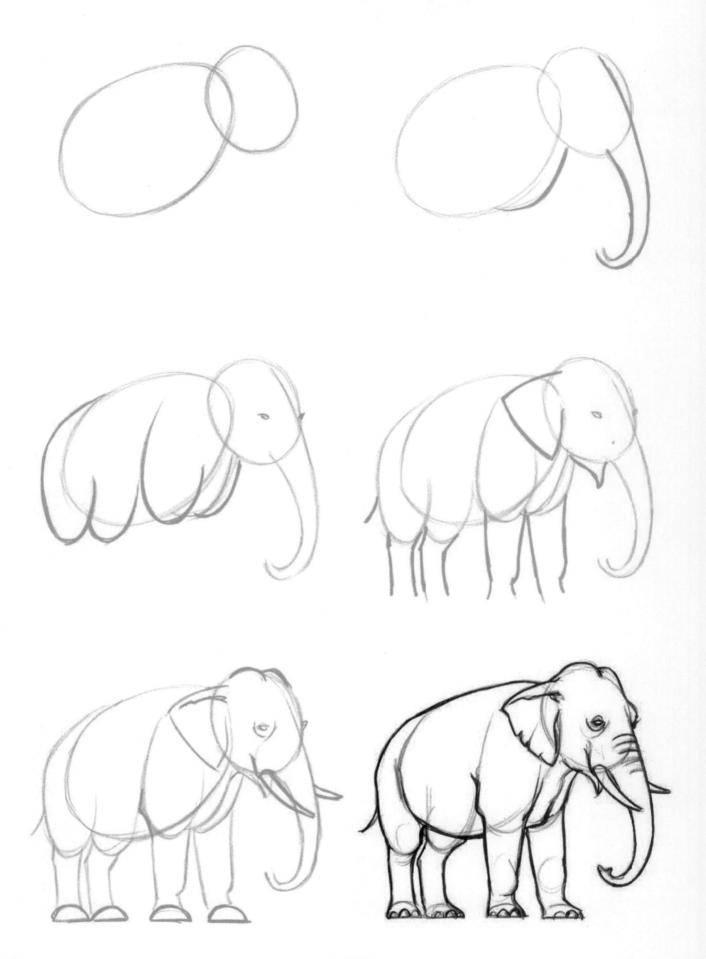

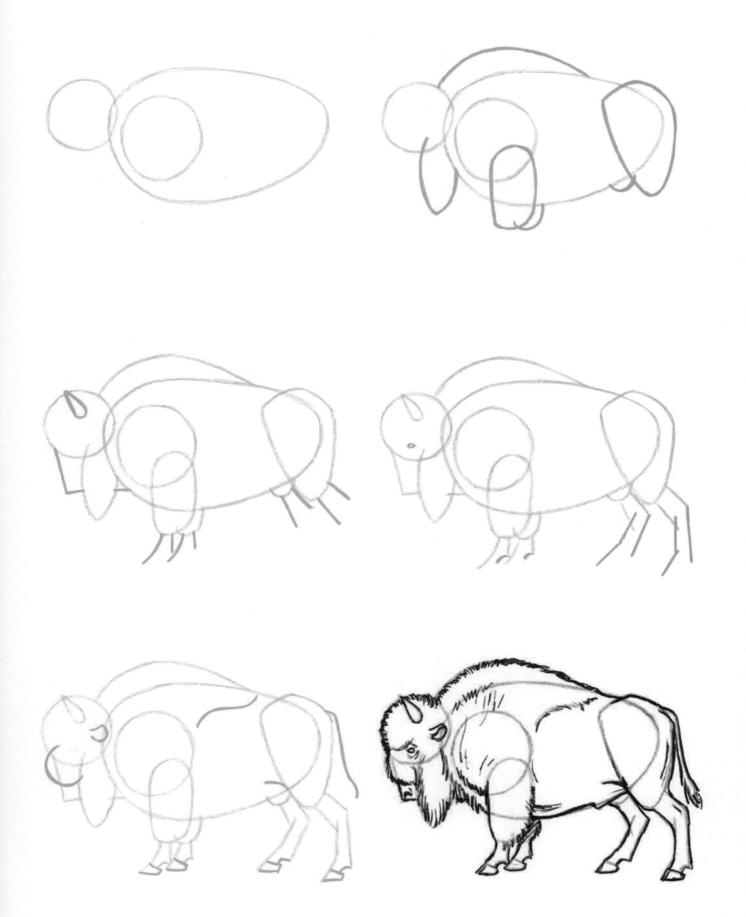

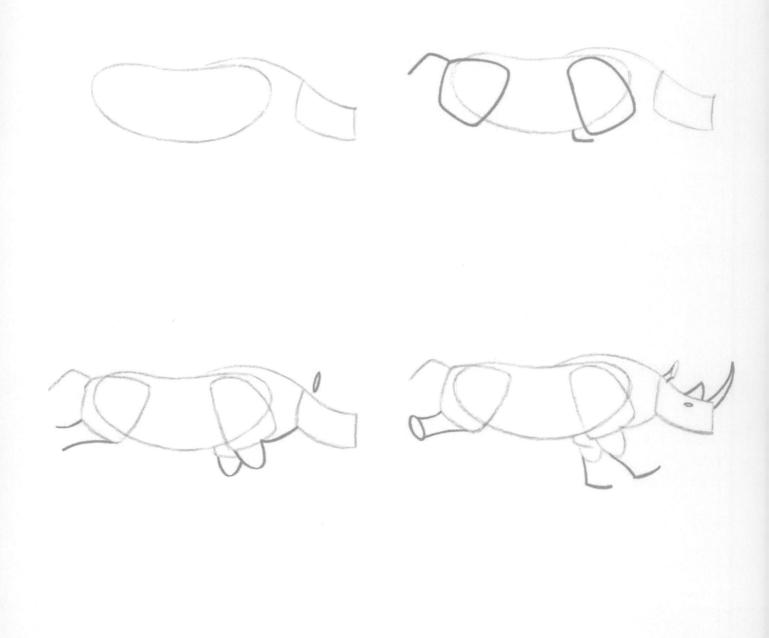

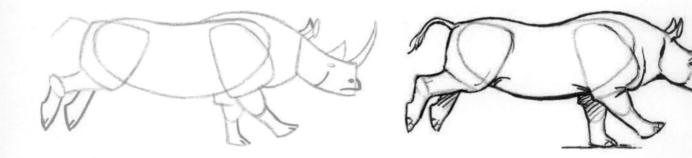

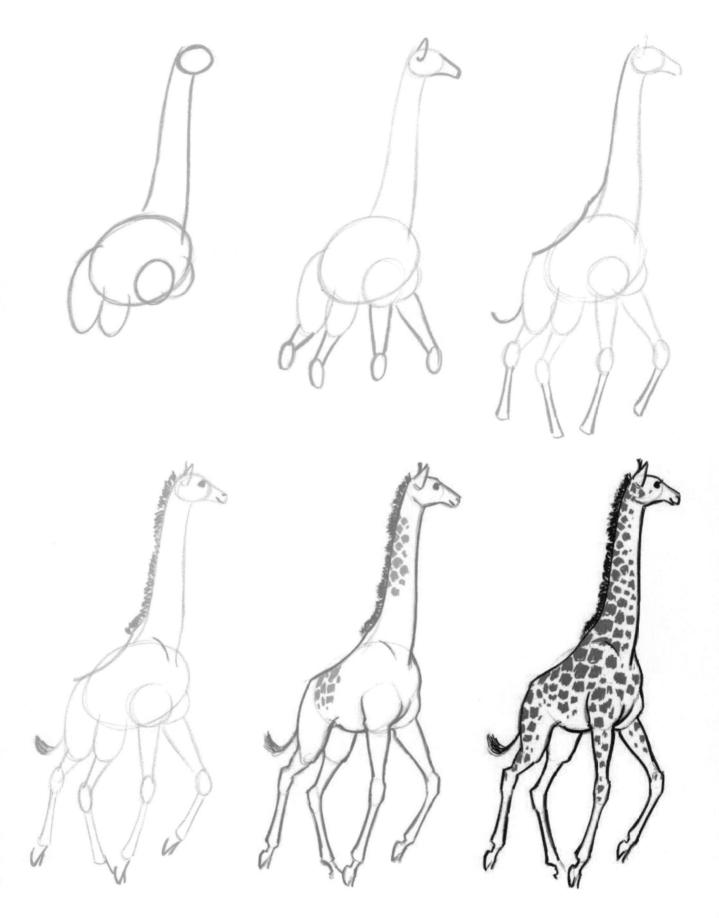

MAMMALS

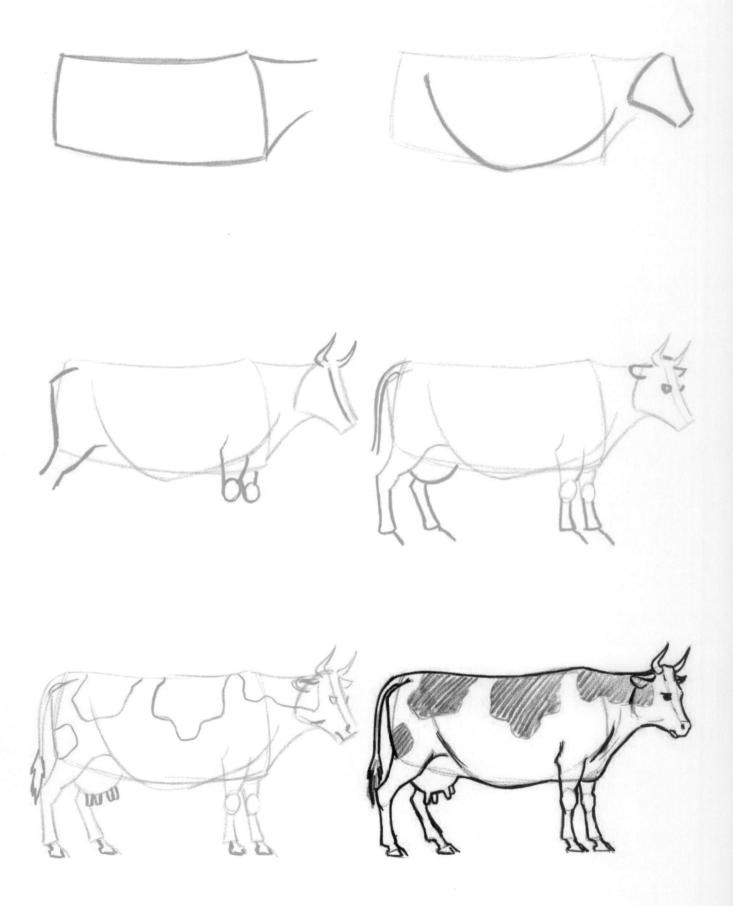

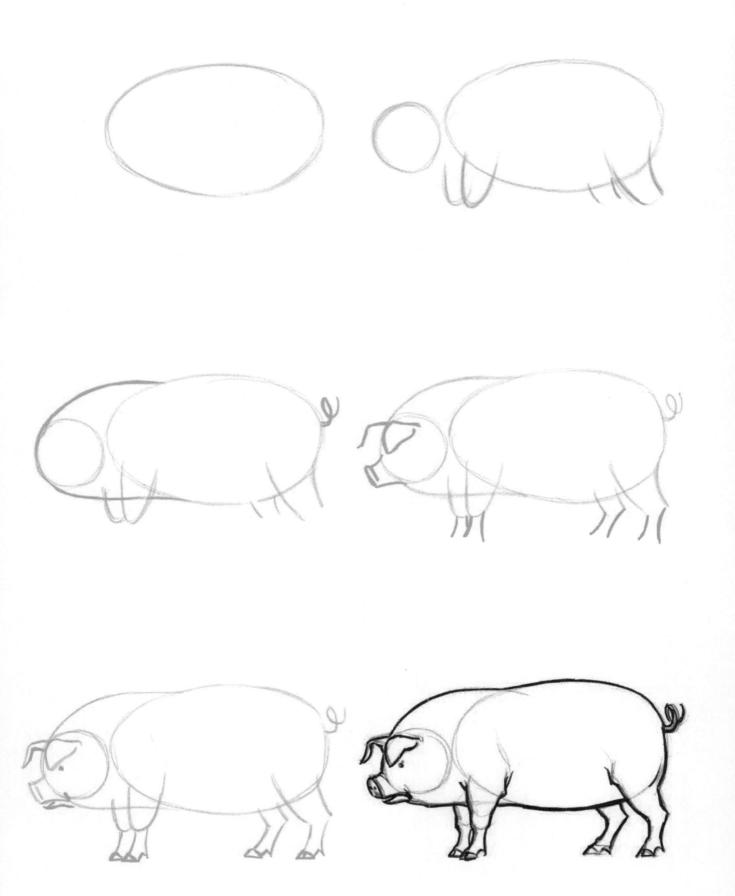

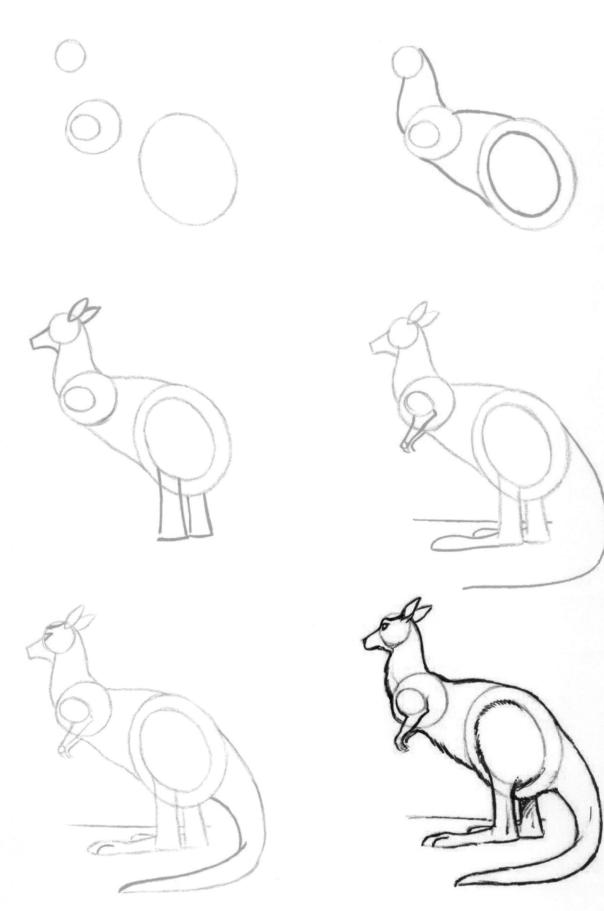

Tiny Critters

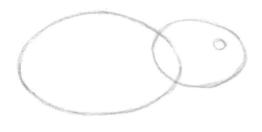

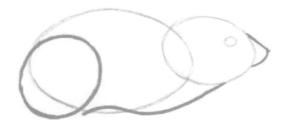

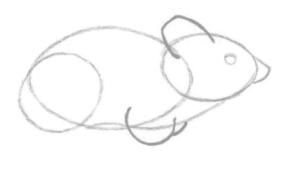

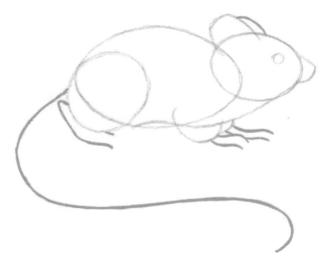

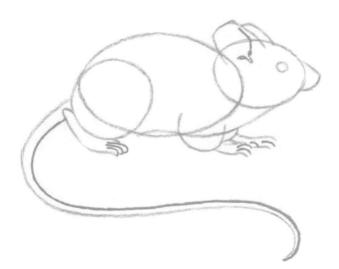

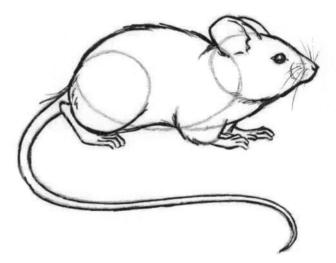

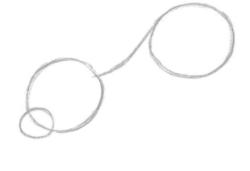

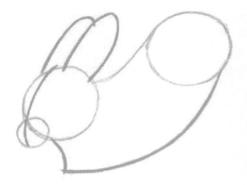

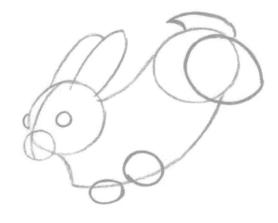

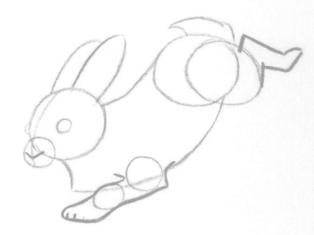

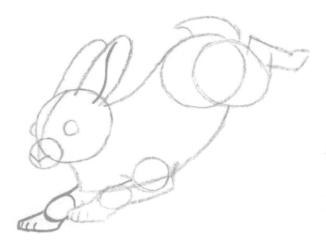

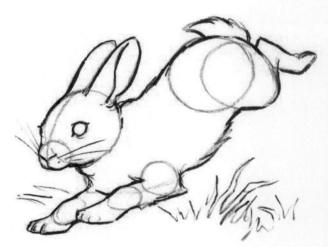

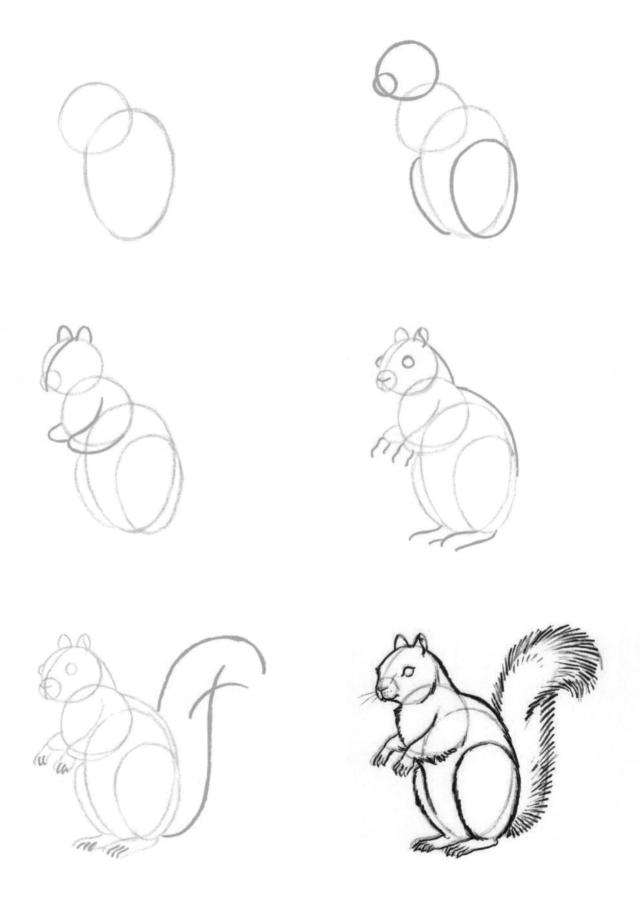

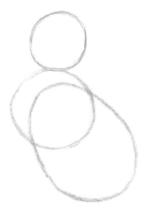

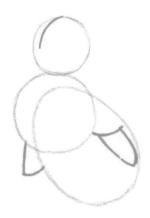

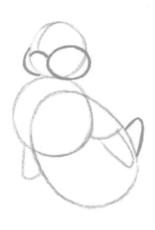

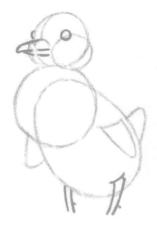

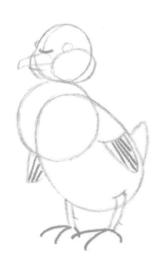

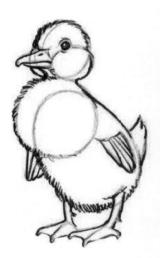

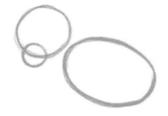

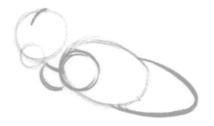

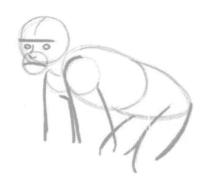

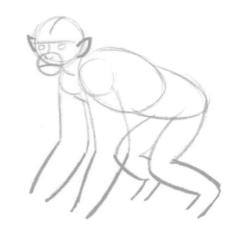

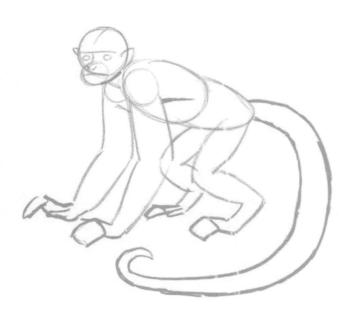

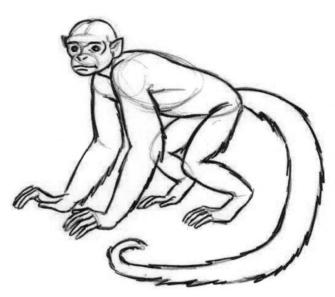

Animals from Long Ago

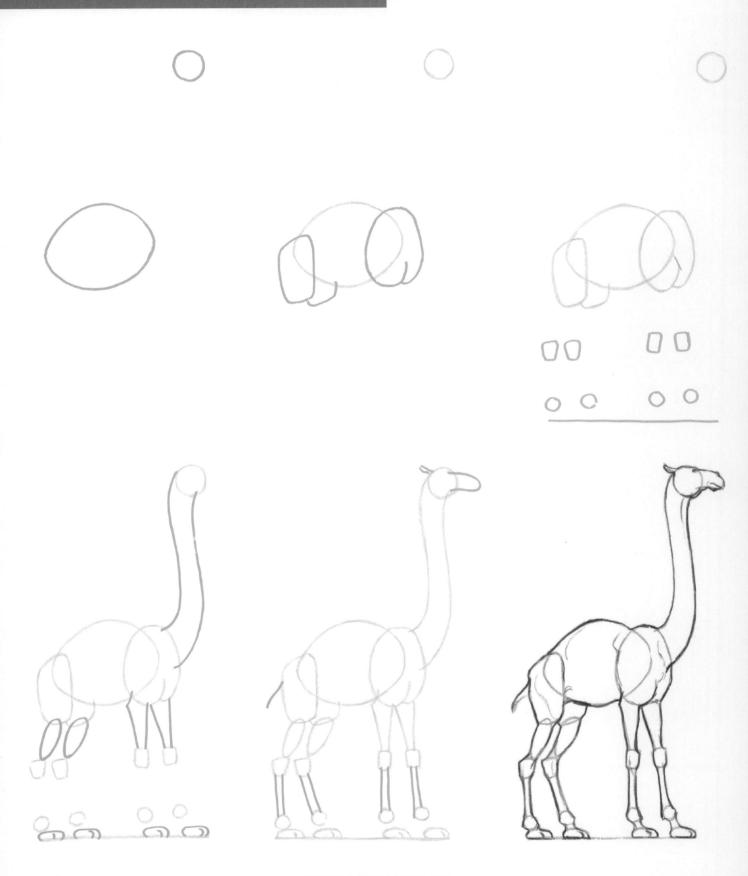

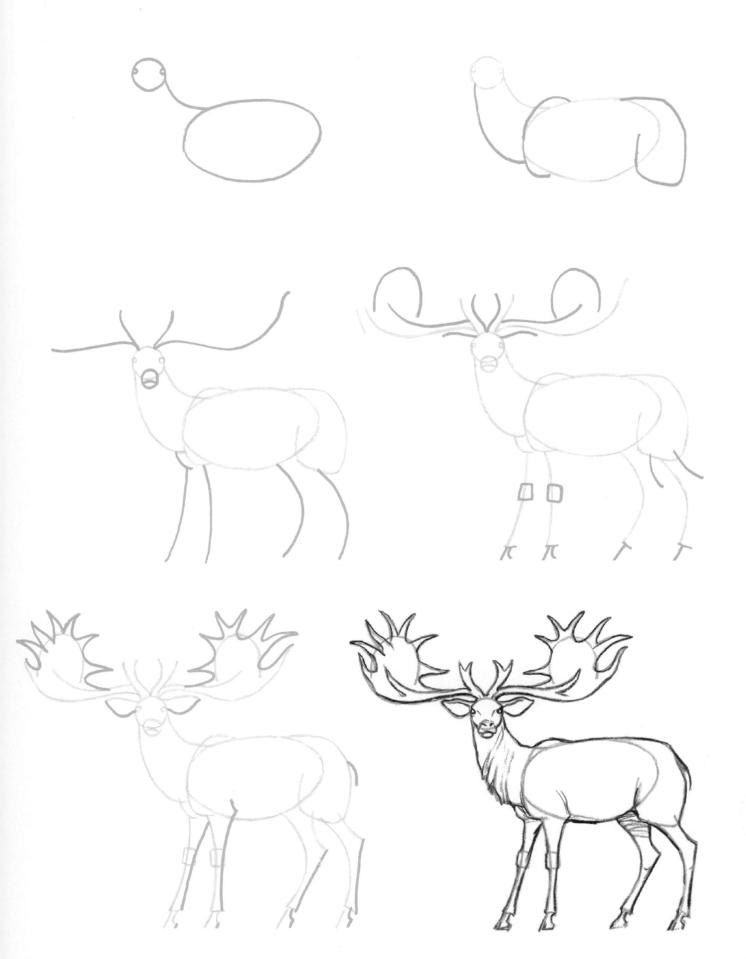

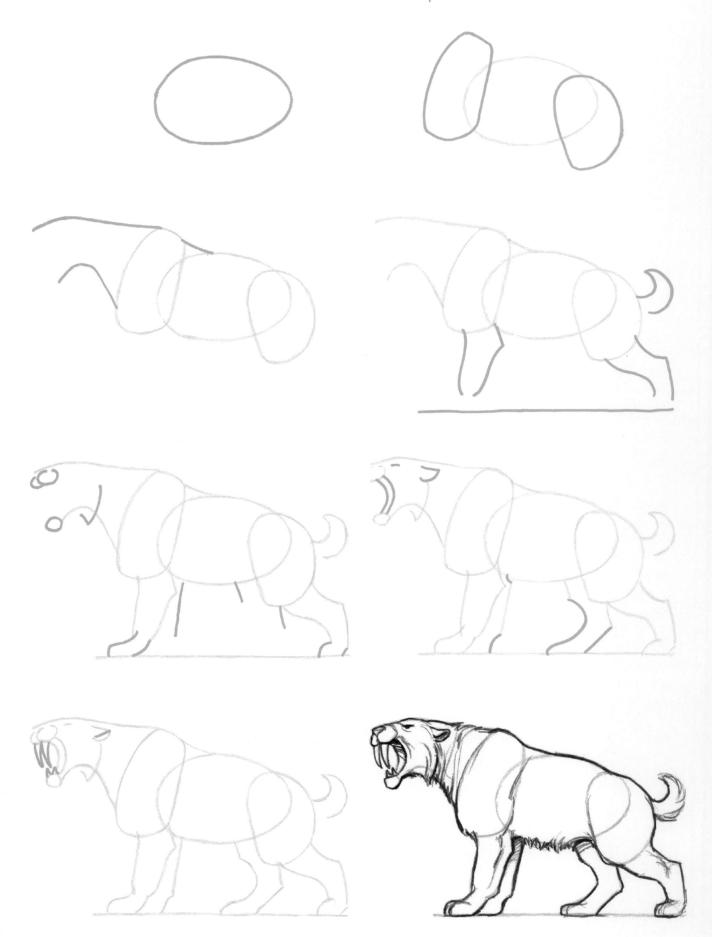

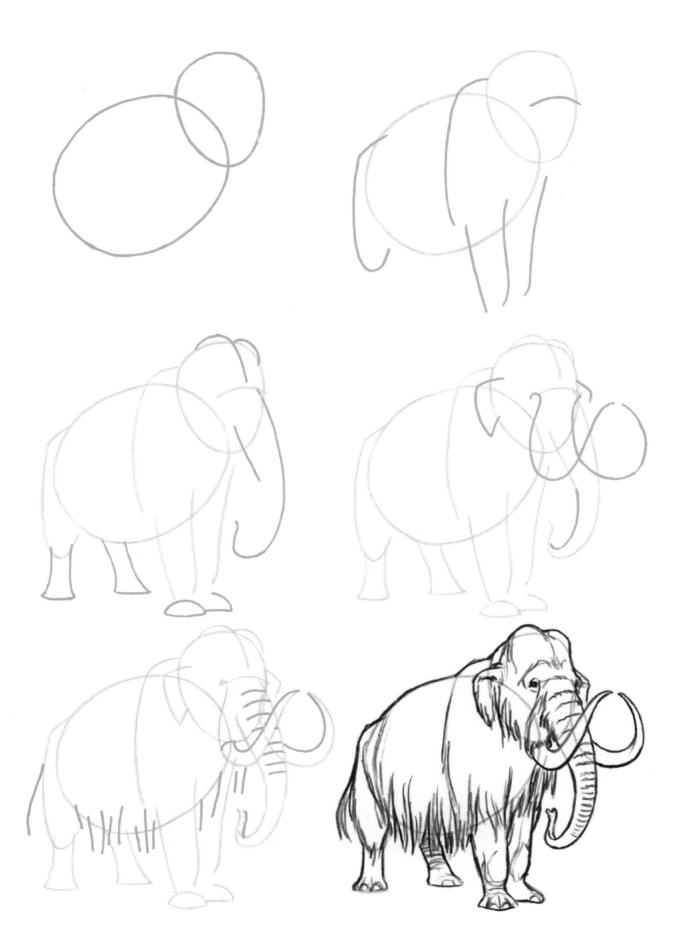

Experience all that the Draw 50 series has to offer!

With this proven, step-by-step method, Lee J. Ames has taught millions how to draw everything from amphibians to automobiles. Now it's your turn! Pick up a pencil, get out some paper, and learn to draw everything under the sun with the Draw 50 series.

Also available:

- Draw 50 Airplanes, Aircraft, and Spacecraft
- Draw 50 Aliens
- Draw 50 Animals
- Draw 50 Animal 'Toons
- Draw 50 Athletes
- Draw 50 Baby Animals
- Draw 50 Beasties
- Draw 50 Birds
- Draw 50 Boats, Ships, Trucks, and Trains
- Draw 50 Buildings and Other Structures
- Draw 50 Cars, Trucks, and Motorcycles
- Draw 50 Cats
- Draw 50 Creepy Crawlies
- Draw 50 Dinosaurs and Other Prehistoric Animals
- Draw 50 Dogs
- Draw 50 Endangered Animals
- Draw 50 Famous Cartoons
- Draw 50 Flowers, Trees, and Other Plants
- Draw 50 Horses
- Draw 50 Magical Creatures
- Draw 50 Monsters
- Draw 50 Outer Space
- Draw 50 People
- Draw 50 Princesses
- Draw 50 Sea Creatures
- Draw 50 Sharks, Whales, and Other Sea Creatures
- Draw 50 Vehicles
- Draw the Draw 50 Way